Visions
of
City
&
Country

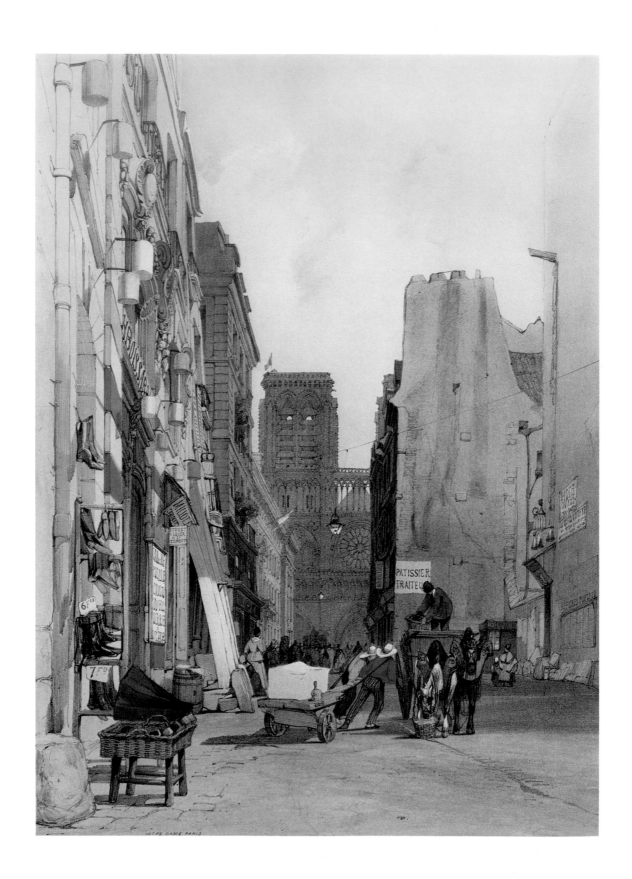

NOTRE DAME. PARIS.

Visions

of

City

&

Country

Prints and Photographs
of Nineteenth-Century France

BONNIE L. GRAD AND TIMOTHY A. RIGGS

Worcester Art Museum

The American Federation of Arts

This book was published in conjunction with the exhibition *Visions of City & Country: Prints and Photographs of Nineteenth-Century France,* organized by the Worcester Art Museum and The American Federation of Arts. Both the exhibition and the publication are supported by grants from the National Endowment for the Humanities.

MUSEUMS PARTICIPATING IN THE TOUR

National Gallery of Art, Washington

Worcester Art Museum, Worcester, Massachusetts

Ackland Art Museum, University of North Carolina, Chapel Hill

The American Federation of Arts is a national, non-profit educational organization, founded in 1909 to broaden the knowledge and appreciation of the arts of the past and present. Its primary activities are the organization of exhibitions which travel throughout the United States and abroad, and the fostering of a better understanding among nations by the international exchange of art.

Published by Worcester Art Museum
55 Salisbury Street, Worcester, Massachusetts 01608
and The American Federation of Arts
41 East 65th Street, New York, New York 10021

LCC 82-50258

ISBN 0-917418-69-7

AFA Exhibition 81-6 / Circulated October, 1982 – April, 1983

Design & Typography by Howard I. Gralla
Composed in the Sabon types by Finn Typographic Service
Printed by Eastern Press

Cover:
EDOUARD VUILLARD. *Across the Fields,* 1899. Color lithograph (FIG. 138)

Frontispiece:
THOMAS SHOTTER BOYS. *Notre-Dame, Paris,* 1839. Color lithograph (FIG. 35)

Contents

Foreword

IT IS with great pleasure that The American Federation of Arts joins with the Worcester Art Museum in organizing this exhibition and publishing its attendant catalogue. Initiated by the museum, it was first brought to our attention by the former director, Dr. Richard Stuart Teitz, who asked the AFA to explore the possibility of a national tour for the exhibition. Strong and immediate interest was expressed by the National Gallery of Art in Washington to open the exhibition and by the Ackland Art Museum of the University of North Carolina in Chapel Hill, where it is to be presented after Worcester.

Throughout the evolution of the project the AFA worked closely with the two curators, Dr. Bonnie L. Grad and Dr. Timothy A. Riggs. Neither the exhibition nor the publication would have been possible without their scholarly research and professional attention to all details.

On the AFA staff, I join with the curators in particularly emphasizing the contributions of Susanna D'Alton and Konrad Kuchel. Credit should also be extended to Jane Tai as Associate Director for Program, to Carol O'Biso and Merrill Mason as Registrars, and to Mary Ann Monet and Sandra Jamison for their work on the project.

I further wish to express our gratitude to all the lenders, both institutional and private, foreign and domestic, whose generosity has so enriched the exhibition and publication.

Finally, the entire project has been supported by two very generous grants from the National Endowment for the Humanities for its research and implementation. Both the AFA and the museums involved are deeply appreciative of this support.

WILDER GREEN
Director, The American Federation of Arts

Preface & Acknowledgments

THE OBJECTIVE of this book, and the exhibition it accompanies, is to define three successive visions of the landscape of city and country that were current in France between 1820 and 1900. The first is the vision of an unfamiliar territory, explored by the artist in search of picturesque architecture or dramatic scenery. The second is the vision of city and country as contrasting environments, the countryside a pastoral retreat from the unpleasant conditions of urban life. The third is a vision of city and country as complements, with each providing settings for pleasure and recreation. We have discussed these three visions as they appear in landscape prints and photographs, and related them to contemporary themes in literature and to the social, cultural, and geographical changes that were affecting the actual appearance and experience of city and countryside.

We have not kept to any strict chronological order in discussing the works in the exhibition. Its three sections overlap broadly, for ways of seeing do not change overnight and one vision does not drive out its predecessor. Alphonse Chigot's *The Stock Exchange* (FIG. 50) depicts an infernal city, while Gustave Janct's *The Bois de Boulogne (Grande Cascade)* (FIG. 117) depicts the same city as an Edenic playground. Produced the same year, these two prints belong to different visions and are discussed in separate chapters of our text.

We have chosen not to write a history of the art of landscape, but rather a history of attitudes toward city and country that are reflected in the art of landscape. Concerned specifically with the cities and countryside of France, we have included prints by foreign artists who worked there, but excluded landscapes of other regions by French artists. We have not attempted to deal with the entire range of nineteenth-century art: Neoclassical landscape from the beginning of the century and Symbolist landscape from its end are not represented, even though chronologically they overlap with types of landscape that we do discuss.

Furthermore, in limiting the exhibition to prints and photographs, we have in our discussion been concerned only tangentially with painting. Artists such as Courbet, Monet, Cézanne, and Van Gogh are obviously indispensable to a general history of landscape, but they will not be found here simply because their work cannot be adequately represented with prints. On the other hand, an exhibition of prints is better suited than one of paintings to bridging the gap between the history of art and social or cultural history. Prints (and photographs) were produced not only as independent works of art comparable to paintings, but also as illustrations to books, magazines, and newspapers and as advertising posters. In these situations, the print is often quite clearly dedicated to setting forth a particular point of view, or recording a contemporary event or a common social ritual. We have blended popular and documentary images, ranging from caricature to maps, with prints and photographs that are more clearly part of the fine-art tradition. It is our hope that in the selection, presentation, and discussion of these various types of prints we have been able to show how they all embody, overtly or more subtly, mental images of the city and the country.

The idea for this exhibition and catalogue grew out of a series of conversations between the two authors. Its major themes developed out of Bonnie Grad's research on nineteenth-century French landscape, and Timothy Riggs's familiarity with the history of prints suggested the form of an exhibition of prints and photographs. We have worked together in our research, constantly discussing the issues that arose as it progressed, and the result is something that neither of us could have achieved alone.

In writing the catalogue, our differing interests led to a division of labor. Riggs wrote the first half of the text, and Grad the second, with the division coming in the second chapter between "The Urban Maelstrom" and "The Pastoral Oasis" sections. To ensure a consistent and unified text we then went over the entire manuscript together, revising and editing, so that each of us has had a hand in shaping the whole.

From beginning to end of the project we have been helped by many individuals and institutions. Our thinking and our prose benefited greatly

from the sound criticism and judicious advice of Victor Brombert of Princeton University, Anna Concagni of Harvard University, Eugenia P. Janis of Wellesley College, Ann Keck-Henderson of the Worcester Historical Museum, William Sewell of the University of Arizona, and Richard Sieburth of Harvard University. We are also grateful to Adrienne Atkinson, Colles Baxter, Madeleine Fidell-Beaufort, Mary Ellen Birkett, John Conron, Robert Denommé, Robert Herbert, Douglas Johnson, Leo Marx, Michel Melot, Keith P. F. Moxey, Linda Nochlin, Carl E. Schorske, Grace Seiberling, Roger Shattuck, Jacquelynn Baas Slee, and Theodore Zeldin for consultation and suggestions. Our studies were facilitated by several Clark University student research assistants, and we are especially grateful to Linda Logan and Laura Tuchman for their work in this capacity. We extend our thanks to all the museums, libraries, and private individuals, both named and anonymous, who have lent prints and photographs to the exhibition; in particular we would like to thank Laura Byers, Sam Carini, Victor Carlson, Philip Dennis Cate, Elaine Evans Dee, Douglas Druick, Richard Field, Jay Fisher, Eleanor Garvey, Sinclair Hitchings, Colta Ives, Ellen Jacobowitz, Harold Joachim, Gerard Levy, Robert Rainwater, Bernard Reilly, Louise Richards, Andrew Robison, Elizabeth Roth, Mary Schmidt, Barbara Shapiro, Robert Sobieszek, Esther de Vecsey, Sam Wagstaff, and Eugene Zepp.

Funding for the project has been provided by the Worcester Art Museum and by grants from the National Endowment for the Humanities. At the Worcester Art Museum, Gaye Brown, Stephen Jareckie, and Stephen Lanier gave invaluable assistance in estimating costs and preparing the budget of the exhibition and catalogue, and the entire curatorial staff put up with Riggs's periodic and prolonged absences while working on the project. At Clark University the generous cooperation of Albert Anderson and Samuel P. Cowardin enabled Grad to take time off from her regular teaching duties. Lewis Cohen, Lora Ewing, and Wendy Magliozzi helped with the many final details of manuscript preparation, xeroxing, collating, proofreading, and the like. At The American Federation of Arts, Susanna D'Alton and Konrad Kuchel have patiently and cheerfully dealt with a long-delayed manuscript and endless complications regarding loans and photography. We are also grateful to Margaret Aspinwall for her perceptive and sympathetic editing of the manuscript and to Howard Gralla for a beautiful catalogue design.

Finally, we owe a special debt of gratitude to Gary Wolf, Bonnie Grad's husband. Above and beyond his continuous support, he shared his ideas in what must have seemed endless discussions, and offered thoughtful advice at times when a third voice was most valuable.

BONNIE L. GRAD
Clark University

TIMOTHY A. RIGGS
Worcester Art Museum

Visions
of
City
&
Country

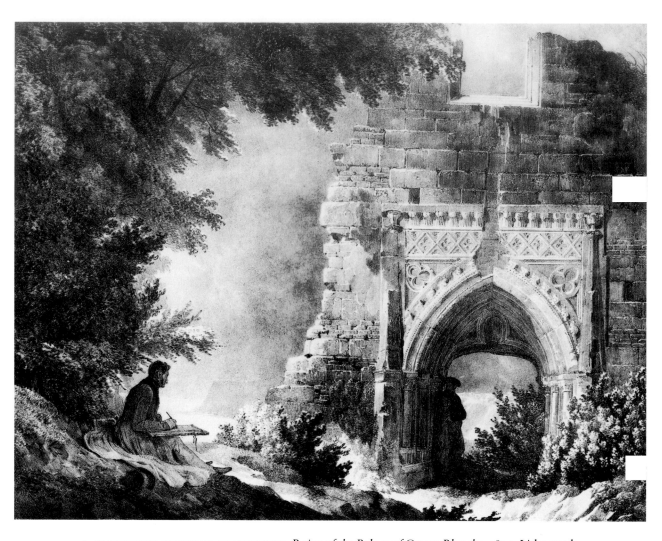

1. ALEXANDRE EVARISTE FRAGONARD. *Ruins of the Palace of Queen Blanche*, 1824. Lithograph

The Exploration of France

IN THE YEARS around 1820 a new movement in art and literature, whose
roots had been sprouting vigorously in England and Germany for over a
generation, blossomed forth in France with a luxuriance that made up for its
late appearance there. The movement was Romanticism, and it was to affect
profoundly every branch of art and literature. But no genre of art was to be
more dramatically affected than landscape. Breaking down the traditional
hierarchies of genre and medium established by the classical tradition, influ-
enced by developments in England and Germany, and aided by the invention
of a new and more flexible print technique, lithography, the Romantic move-
ment gave rise to an extraordinary abundance of topographical publications
depicting the cities and countryside of France. By their artistic excellence they
helped break down the barrier that the Classicists of the previous generation
had set between "artistic" idealized landscape and the realistic depiction of a
particular place.[1]

One of the first and by far the most ambitious of these topographic albums
was the *Voyages pittoresques et romantiques dans l'ancienne France (Pic-
turesque and Romantic Travels in Old France)*. Begun in 1819 with the aim of
documenting architectural monuments and scenery throughout France, region
by region, it was to continue until 1878, never completed and far outlasting the
Romantic movement that had sustained its early volumes. Its first twelve
volumes, issued between 1820 and 1845, contain some of the finest landscape
prints of the century, and it included some of the most important French
landscapists among its collaborators.[2]

To understand the spirit of the *Voyages pittoresques,* and indeed of the
whole Romantic attitude toward landscape, we may consider a print from
the second volume by Alexandre Evariste Fragonard, *Ruins of the Palace of
Queen Blanche* (FIG. 1). An artist, elegantly dressed, is seated on the ground
sketching a ruined Gothic archway. In the distance there is a faint glimpse of
the sea with a cliff rising from it and blending into the mist. There is no sign of a

road or path. Under the archway stands a second figure in a rougher, more picturesque costume, presumably the local countryman who has guided the artist to this remote spot. Both Fragonard and the artist he depicts have entered this world of forest, ruin, sea, and cliff as explorers – the urban costume of the artist clearly sets him off from his surroundings – and it is as an explorer that the Romantic artist depicts the landscape.

It seems paradoxical that in the early nineteenth century France could be thought of as unexplored territory, yet it was true not only in an artistic sense but also, to a surprising extent, literally. Certainly France was inhabited throughout, and inhabited by Frenchmen, not alien "natives." But in fact many areas of France were as little-known to a Parisian of the 1820s as the Indian-haunted forests of America – less-known perhaps, since the novels of James Fenimore Cooper and François René de Chateaubriand had brought the American forests to Parisian readers. Indeed when travelers and novelists of the early nineteenth century wished to describe the French peasant, it was often by comparing him to the American Indian. "There are Cooper's red-skins ... there's no need to go to America to observe savages," says a character in Balzac's novel *Les Paysans (The Peasants)*.[3] Throughout the nineteenth century successive governments were to attempt to "civilize" the inhabitants of the more remote districts, who frequently spoke dialects unintelligible to a city dweller, held to customs and beliefs unchanged since the Middle Ages, and were only dimly aware, if at all, of the nation of France that lay beyond the confines of their local region.[4]

If large portions of France were unknown territory to the city dweller, they were doubly alien to an artist who had been trained in the Classical tradition. For an art preoccupied with universal standards of beauty and harmony, derived from the ancient civilizations of Greece and Rome, and focused on man and his works, the idea of landscape art itself was slightly suspect unless it could be ennobled by association with religious, mythological, or historical events. The natural territory for such events was the landscape of Italy, especially as seen through the eyes of the great seventeenth-century landscape painters Claude Lorrain and Poussin. The accurate depiction of a particular place – topography – was considered unworthy of a serious artist, since it made few demands on the imagination and the intellect by comparison with a landscape invented by the artist.

For the Romantics, however, all the standards set up by the Classicist were called into question. Instead of believing in an absolute standard of beauty handed down from the past, the Romantic felt himself most successful as an artist when expressing his own temperament most directly. That being so, why should a French artist not depict the countryside of his own nation, the place which had formed his character? The fact that French architecture and scenery did not fit the Classical norm and that parts of France were wild and uncivilized was no discouragement to a temperament which valued the strange and exotic more than the conventionally beautiful. To the artistic explorer of France nationalism and exoticism were complementary, not contradictory.

Two men initiated the *Voyages pittoresques*: Baron Isidore Taylor (1789-1879) and Charles Nodier (1780-1844). Their first aim was to record in word and image the ruins and monuments of France from the Middle Ages and earlier periods which were fast disappearing as they were allowed to fall into decay or were quarried for building stone. But Nodier projects a mood in the preface to the first volume which is far from simply archaeological:

It is not as scholars that we are crisscrossing France, but as travelers curious to find interesting sights and avid for noble memories. Shall I say what inclination, easier to sense than to define, has shaped this journey through the ruins of old France? A certain melancholy disposition of thought, a certain involuntary predilection for the poetic customs and the arts of our ancestors, the sentiment of I know not what mysterious correspondence of decay and misfortune between these old structures and the generation which has just passed.[5]

It is clear that the monuments were to be seen not just as documents of archaeological or cultural history, but as the source of poetic and patriotic emotions in the modern viewer. Nodier's allusion to "the generation which has just passed," the age of Napoleon I which had ended disastrously at Waterloo, suggests another motive for the project. The territorial empire of Napoleon had vanished in 1815, but in rediscovering and documenting the glories of France's medieval architecture and history the artists and writers of the *Voyages pittoresques* were in effect conquering a spiritual empire for her. The fact that the buildings they recorded were often in imminent danger of destruction lent a military urgency to the task, and the province-by-province organization of the project carries out the analogy to a campaign. The artist in

Fragonard's print, alone in the wilderness and calmly carrying out his task, evokes the lonely sentinels in prints by Nicolas Toussaint Charlet and Auguste Raffet which glorify the Napoleonic Wars.

Both Fragonard's image and Nodier's preface radiate *enthusiasm,* a key word in the Romantic lexicon.[6] Archaeological documentation of the Palace of Queen Blanche would have been as well or better served by a dry rendering of the facade with a scale of measurement and a plan. Instead, Fragonard devotes half the area of the print to setting the monument in a context of dramatic unexpected contrasts: mist and clarity, nearness and distance, sunlight and shadow. The guide standing beneath the archway gives the scale of the building, but he is posed like a bandit in ambush.

Ruins of the Château Gaillard (FIG. 2) by Alexis Joly, also from the second volume of the *Voyages pittoresques,* sets the monument still more strikingly in the landscape context. The ruined castle is seen from the valley of the Seine, far below the crag on which it is perched, and a whole range of incidents suggest the peace and safety of the landscape: the hay wagon crossing the stream, the boats casually drawn up on the shore, the water birds in the foreground. All these set off the ruinous memento of past war, high above. The sky with its dramatically slanted clouds and the jagged silhouette of the ruin—thoroughly ugly by Classical standards—are formal equivalents for the mood of strife implied in the upper half of the print.

The value of lithography in producing evocative images rather than simple topographic documents was recognized by Nodier:

It presents unquestionable advantages for a work of this type. Freer, more original, more rapid than the engraver's burin, the bold crayon of the lithographer seems to have been specially invented to fix the free, original, and rapid inspiration of the traveler who takes note of his sensations.[7]

Lithography had another advantage: its comparative simplicity made it attractive to painters who might not otherwise have taken up printmaking. Unlike the etcher or engraver, whose techniques differed significantly from ordinary drawing, the lithographer simply drew with a crayon on a prepared stone surface as he would have on a sheet of paper. Taylor and Nodier seem to have made a distinct effort to secure the most talented artists available for their project, raising its status above what was normally accorded topographic

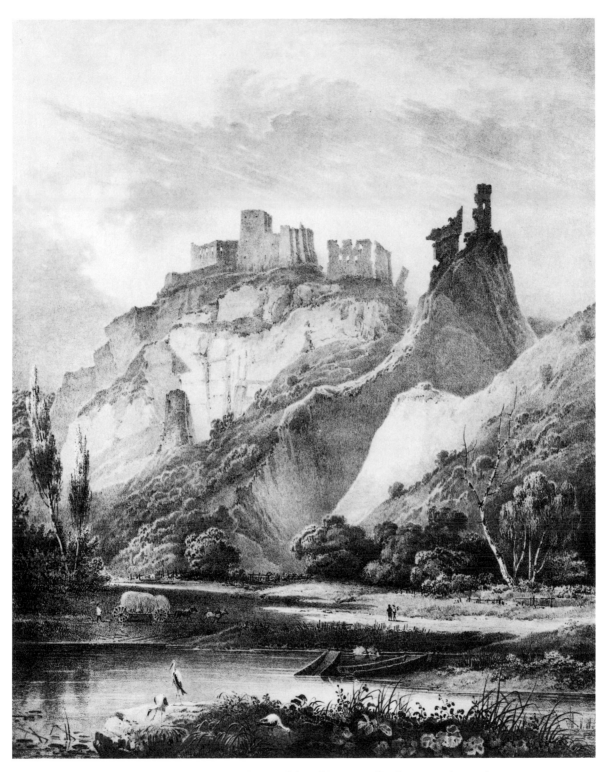

2. ALEXIS VICTOR JOLY. *Ruins of the Château Gaillard*, 1824. Lithograph

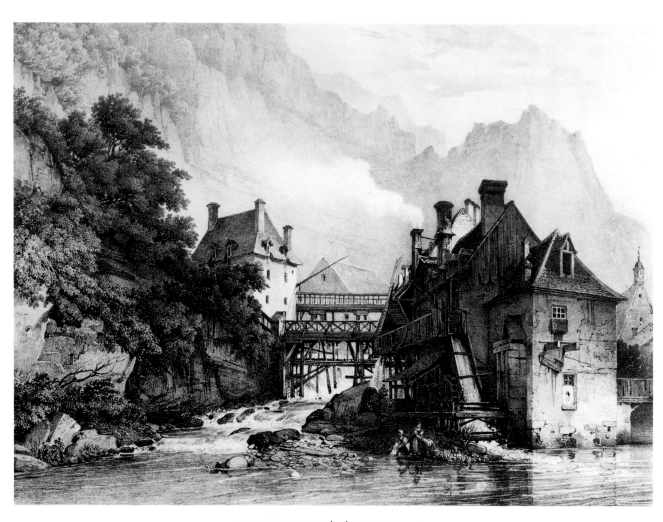

3. LOUIS JULES FRÉDÉRIC VILLENEUVE
Mills at the Headwaters of the Loue, about 1825. Lithograph

imagery in France. Indeed, they secured several prints by artists who were primarily figure painters: Ingres and Géricault, for example, each contributed a modest vignette to the publication. These prints are less important in themselves than as an indication of the artistic ambition of Taylor and Nodier. What is more significant is that overall the contributors to the *Voyages pittoresques* tended to be serious landscape or history painters, not hacks specializing in topography. Several were recruited from England, where the distinction between "fine-art" landscape and topography had broken down much earlier than in France: Thomas Shotter Boys, James Duffield Harding (FIG. 12), and Richard Parkes Bonington (FIG. 31), among others. The contributors included the two greatest landscapists of the Romantic era in France, Paul Huet and Eugène Isabey (FIG. 17).[8]

Nodier and Taylor deliberately selected Normandy as the first province to document in the *Voyages pittoresques*. Located reasonably close to Paris, it was an area particularly rich in medieval architecture, and it also included prehistoric monuments which because of their mysterious origin were interesting to Nodier. Still more important, it was disputed territory—because it had been held by the English during much of the Middle Ages, British scholars claimed its architecture as a monument of their culture, a claim that Nodier was anxious to refute. With these preoccupations the artists of the first two volumes concentrated on architecture, though placed within a landscape context. The prints by Fragonard and Joly are typical, and Nodier expressly warned the viewer against expecting picturesque sites unless they were the setting of notable architecture or of great historical events. (Joly's view of the Château Gaillard merited inclusion on both counts: a major example of military architecture, the castle had been built by Richard the Lion-Hearted but captured by the French in 1204.) The threatened destruction of Gothic architecture made its recording an urgent task, and Nodier felt that the depiction of the land could safely be left to future generations.[9]

In the next province chosen for documentation the situation was quite different. Franche-Comté, Nodier's native province, was relatively poor in architectural monuments but rich in dramatic mountain scenery. Accordingly Nodier's preface to that volume blandly ignores the precepts laid down in the earlier ones, and instead commends the artists who are "animated by the desire to express the marvels of a sublime nature."[10] In fact a change of attitude

21

is visible from this point on in the *Voyages pittoresques,* which takes it still farther from traditional topography. Rocks, crags, and waterfalls (FIGS. 12, 13, 17) are abundant in the Franche-Comté volume as well as in later ones, and alongside the major architectural monuments appear humbler types of building, charcoal burners' huts or water mills. *The Mills at the Headwaters of the Loue* by Louis Jules Frédéric Villeneuve (FIG. 3) is a notable example of this recording of anonymous architecture. Unlike *The Château Gaillard,* this is a landscape without historical associations or architectural distinction, and what has attracted the artist is simply the picturesque appearance of the subject.

This term "picturesque," which is so important a part of the title of the *Voyages pittoresques,* deserves careful definition, for it is a key factor in describing the type of landscape which the artistic explorers of France were searching for. The term *Voyage pittoresque* had been used in France at least as early as the 1750s but was originally applied to guidebooks which concentrated on pictures and other works of art. In the late eighteenth century, however, English art theory had begun to use the term in its modern sense, to describe certain views and types of scenery that did not fit the conventional standards of Classical beauty but were nevertheless attractive. While Classicism was the accepted style, picturesque subject matter was tolerated as a minor, playful alternative to true beauty, but the Romantics of the early nineteenth century were to take the concept much more seriously. Villeneuve's print is typically picturesque: a scene rendered interesting by the irregular silhouettes of buildings and the mountains behind them, the complicated asymmetrical structure of scaffolding, and the lively spouting of water through flumes and sluices. Villeneuve skillfully harmonized the disparate elements by organizing his composition in two undulating diagonals so that the jagged mountain ridge in the background is echoed by the silhouette of trees and buildings nearer by. The uncouth and dilapidated industrial architecture is thus likened to the natural grandeur of the mountain crags. To a Romantic eye, industry was not yet a blight on the beauty of the countryside, though Nodier's preface already questions the interest of industry for the artist.[11]

Although the *Voyages pittoresques* was intended to cover all of France, the volumes that were actually published deal mainly with remote to inaccessible parts of the country. Since the *Voyages pittoresques* was being produced in

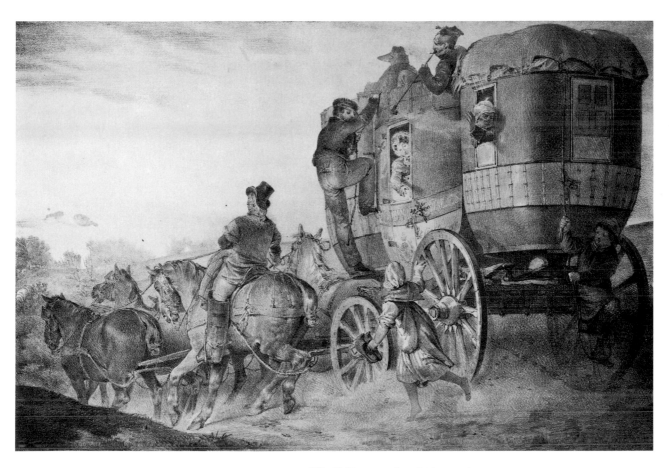

4. CHARLES AUBRY. *The Diligence*, 1823. Lithograph

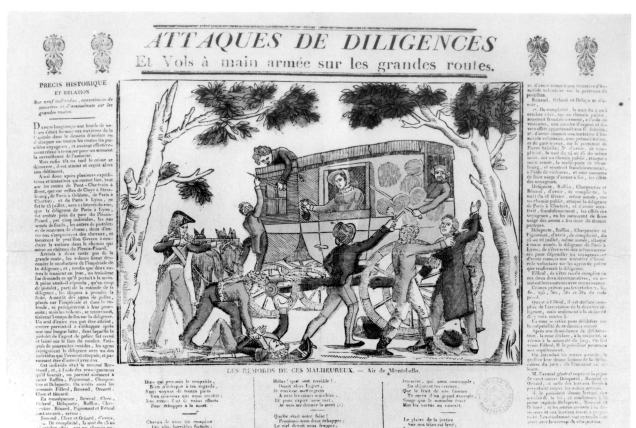

5. ANONYMOUS. *Attacks on Diligences and Armed Robberies on the Main Roads*, about 1823.
Hand-colored woodcut broadside

Paris, and since Paris was the center of French cultural life and by far the largest city in France, one could almost say that the aim of the publication was to show Parisians areas of their country that they would be unlikely to see in reality. Certainly few Parisians would have seen many of the views and monuments depicted in the *Voyages pittoresques*. Travel in the early nineteenth century was slow, uncomfortable, and frequently dangerous. A lithograph by Charles Aubry (FIG. 4) shows the standard means of transportation along the main routes between cities, the diligence or stagecoach. Aubry's point of view is mildly satirical rather than strictly documentary, but the basic features of this mode of travel are clear enough; the huge swaying coach moving slowly enough that children can run along beside it, the passengers peering out of uncomfortably small windows or sprawled on the roof. The image finds a prose equivalent in the contemporary tale of an English family traveling to Paris:

Figure to yourself the body of an old crazy coach, or waggon, like Noah's ark, with front and back seats, placed on four wheels, with the frame of a chaise . . . holding two persons who peep through ragged curtains . . . attached to the front of the heavy machine, and a place like the roost for fowls, denominated the imperial, *on the top of the vehicle, where . . .* Monsieur le Conducteur, *the guide and guard, reposes in state. . . . Leathern traces must be a luxury or a vanity; ropes being found here to answer just as well. . . . A French postilion is off and on his horse's back twenty times in the course of one stage, without ever stopping the vehicle. He is not surprised or dismayed at being called upon to repair accidents. . . . If a passenger calls, he dismounts and pops his head into the window as he runs by its side, leaving the animals to drag the coach at their own guidance.*[12]

Travel of this kind might be amusing, but it was hardly smooth or comfortable. French roads in the early nineteenth century were in very poor condition, and passengers might be called on to get out and walk over a stretch of road bad enough to upset a fully loaded diligence. The slow-moving vehicle was also an easy prey to highwaymen. A popular broadsheet of the early 1820s, *Attacks on Diligences and Armed Robberies on the Main Roads* (FIG. 5) describes a group of bandits operating in the immediate surroundings of Paris.

25

In the remoter parts of France the dangers increased. Once he left the main national roads, a traveler who was not wealthy enough to hire his own carriage might be reduced to going on foot, and the solitary walker in the countryside ran the risk of attack by bandits and even wolves.[13]

Danger and discomfort might not discourage a traveler, especially if young and healthy, but they made travel an adventure not to be undertaken lightly. The hero of Stendhal's *Memoirs of a Tourist,* written in 1837-38, is not a tourist in the modern sense but a man whose business requires him to travel around France and who takes the opportunity to see the major sights along his route. He is able to travel in his own carriage and for the most part is traveling on the main national roads and staying in good-sized towns, but even so he complains of the shortcomings of hotels and regrets that he has not provided himself with certain conveniences such as storage bottles for water and wine to make him more independent of the usual facilities for travelers.[14]

Even in the 1820s and 1830s the seeds of modern tourism were being sown, but the seed is one thing and the plant another. Thus there was a sea-bathing establishment at Dieppe as early as 1822, but even in the 1840s bathing was considered a medicinal treatment rather than a pleasure. Likewise there were numerous mineral springs and spas which were visited for the healthful quality of their water, but few enjoyed more than a local reputation; their patrons were not willing to undertake the difficulties of a long journey.[15] The very proliferation of books and suites of prints dealing with travel during this period suggests that there was more passive interest in pleasure travel than actual practice of it. The *Voyages pittoresques,* bound in massive folio volumes, was no guidebook, and its beautiful images of distant scenes were meant to preclude the need for travel as much as to encourage it.

Nevertheless, though the city dweller of the early nineteenth century did not travel long distances for pleasure, he was not shut up in a totally urban environment. Cities were small and compact, and the country came up to their gates and even within their walls. In the 1820s Paris was still far from occupying all the territory within the customs barrier erected in the late eighteenth century, and in 1828 when Henri Monnier produced a series of caricatures entitled *Six Districts of Paris,* he represented one district, Saint-Denis, by a thoroughly rural subject (FIG. 6). The city dwellers in the print enjoy a picnic

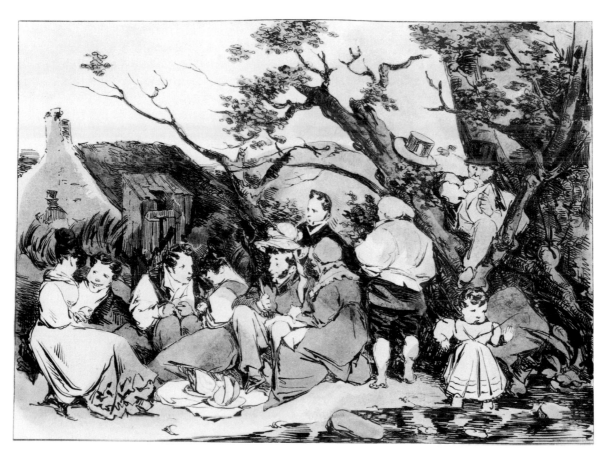

6. HENRI MONNIER. *Quartier Saint-Denis*, 1828. Hand-colored lithograph

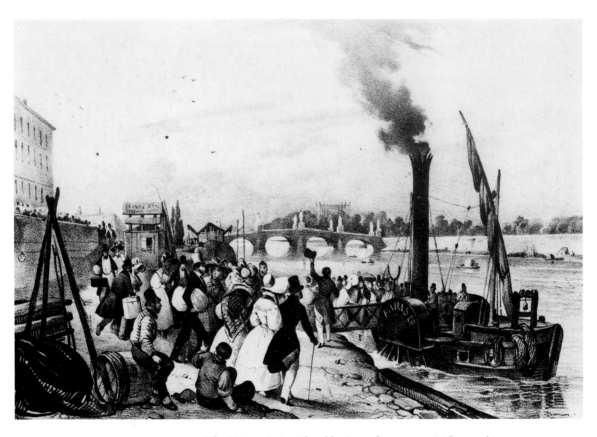

7. VICTOR ADAM. *The Trip to Saint-Cloud by Steamboat*, 1830. Lithograph

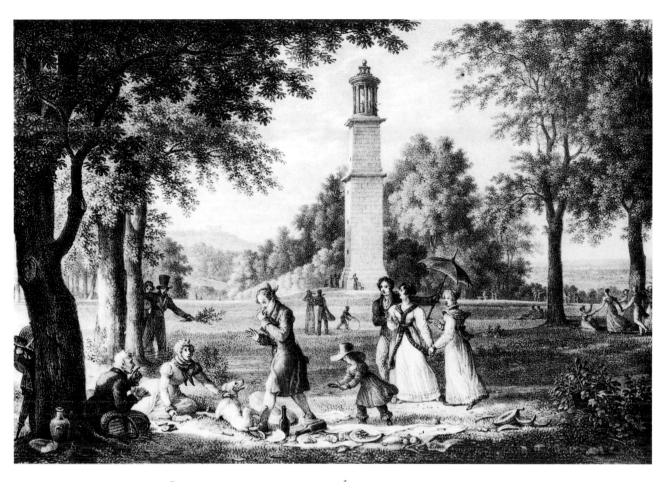

8. CHARLES LOUIS CONSTANS, after JEAN CHARLES DE VELLY
Afternoon – The Lantern of Demosthenes in the Parc de Saint-Cloud. Lithograph

which is almost a parody of the aristocratic *fêtes galantes* of the eighteenth century. The landscape behind them is more like a stage set than an actual tract of country and probably reflects Monnier's theatrical experience (the other prints in the series are equally stagelike). It assembles a few basic signs—cottage, trees, and a stream—to indicate a rural setting, and yet the dense crowding of the composition suggests the semiurban context of the scene even without the clue given by the title.

Beyond the customs barriers which marked the city limits of Paris (and which were nowhere more than two and one-half miles from the center of the city) was a countryside of farms and small villages, whose agricultural produce fed the Parisians. These were also the two great forests, the Bois de Boulogne and the Bois de Vincennes, as well as the parks and summer houses of the wealthier Parisians. These ranged from modest dwellings like the one on the Ile Séguin where Paul Huet spent the summer during his childhood,[16] to royal estates like the park at Saint-Cloud. This park was especially popular for holiday excursions; unlike the Bois de Boulogne which was still a hunting forest and which at least as late as 1800 was a refuge for criminals and vagabonds, Saint-Cloud offered a tamed and well-ordered nature, far enough from Paris to make a significant excursion, yet still readily accessible, especially after a steamboat service from Paris was inaugurated (FIG. 7). A series of lithographs by Charles Constans after Jean Charles de Velly shows the park at different times of day, dotted with sightseers and picnickers. Like the other prints in the series, *Afternoon—The Lantern of Demosthenes* (FIG. 8) combines an accurate topographic view with the humorous misadventures of a group of visitors to the park, a combination popular in both art and literature at the time. A story by Paul de Kock dating from 1831, for example, describes the ill-planned holiday of a Parisian family searching in vain for a village fete.[17] Comedy provides an excuse for the description of a kind of activity which was still not considered worthy of serious depiction.

The idea of contact between man and nature could be taken very seriously indeed, however. Already in the mid-eighteenth century the philosopher Jean Jacques Rousseau (Swiss by birth, but French by adoption) had proclaimed the inherent corruption of civilized life and the regenerating power of the natural world:

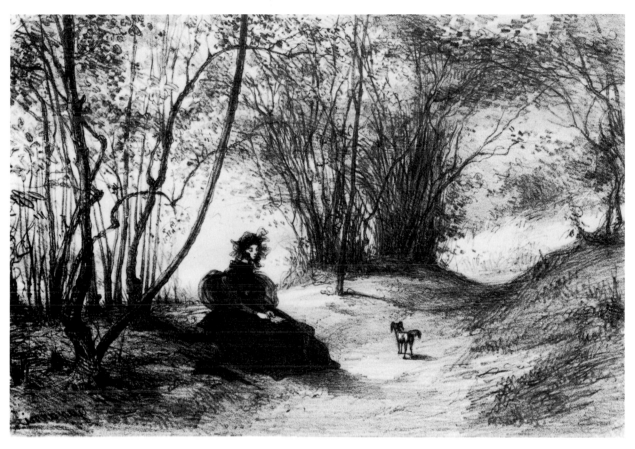

9. GAVARNI. *Solitude*, 1833. Lithograph

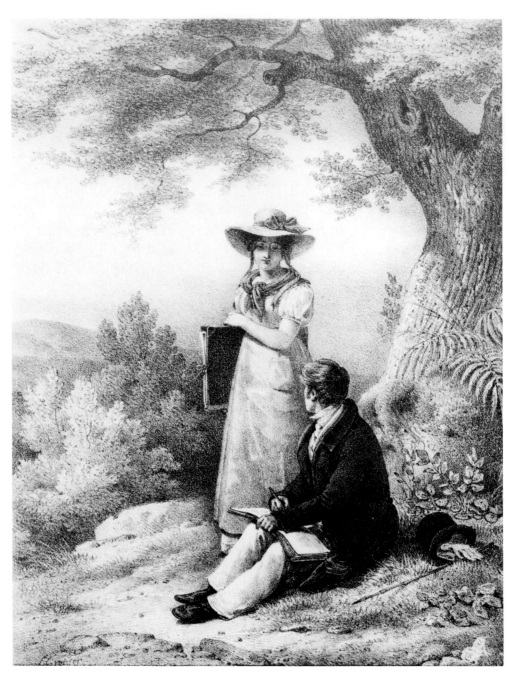

10. FRANÇOIS GRENIER DE SAINT-MARTIN. *The Amateurs*, 1826. Lithograph

Wandering deep into the forest, I sought and I found the vision of those primitive times . . . and by comparing man as he had made himself with man as he is by nature I showed him in his pretended perfection the true source of his misery.[18]

Rousseau's ideas strongly influenced the Romantics, and soon fashionable young men and women were following the lead of poets and philosophers in the quasi-religious contemplation of nature. Unlike the picnickers of Monnier and Constans, preoccupied with flirting, eating, or strolling, the young woman in Gavarni's *Solitude* (FIG. 9) might be in church. She has brought a book with her to the glade where she sits, but instead of reading she is absorbed in a dreamy reverie of the type that Rousseau described himself falling into in his solitary wanderings. The woman's delicate features and the transparent veils of her bonnet and sleeves bring her into harmony with the slim young trees and translucent foliage of the landscape. This is a place of security and tranquility, a landscape apparently untouched by man yet free from any of the dangers of a truly wild forest. The tiny dog standing alert alongside his mistress only emphasizes the benignity of a countryside where no stronger protection is needed.

The Amateurs (FIG. 10) by François Grenier de Saint-Martin shows another aspect of the vogue for nature. Landscape had been commonly used since 1800 as the basis of drawing instruction for amateurs,[19] and in this print, sketching is shown as an enjoyable outdoor sport. Grenier's couple, one suspects, are playing at the kind of exploration that the artists of the *Voyages pittoresques* actually practiced. They can hardly have wandered far from civilization in their fine clothes, and it is hard to say whether the young man is more interested in the landscape or his companion. But their setting hints at a broad stretch of wilderness, surveyed from a height of land.

Romantic landscape art developed against a background of interest in the picturesque architecture of the Middle Ages and in wild and exotic scenery, coupled with transportation which prevented most people from seeing these sights firsthand. The town dweller, whose own contact with nature was limited to a brief excursion in the immediate surroundings of his city, could explore by proxy the wonders of mountain and seacoast, forest and field, and the picturesque buildings of other cities as he looked at them in prints.

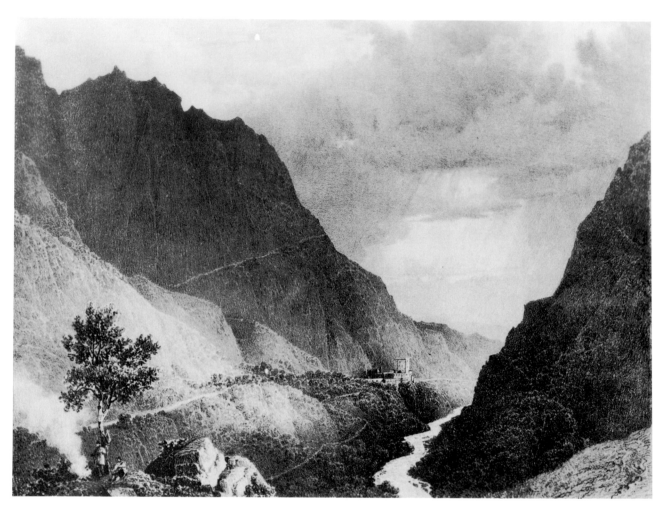

11. LOUIS JULES FRÉDÉRIC VILLENEUVE
The Fort de l'Ecluse, about 1825. Lithograph

To our eyes a rocky or snow-capped mountain peak is such a convention of Romantic scenery that it is rather surprising how small a part high mountains play in French Romantic art. Certainly there is a large group of works in the *Voyages pittoresques* that deals with mountain scenery, but that scenery is more various and less awe inspiring than one might expect. Until the sport of mountain climbing became popular in the mid-nineteenth century, the high passes and the mountain peaks were visited or even approached only on the rarest occasions. In addition, French landscape of the Romantic period was less influenced by the concept of the sublime than were German and English art of the same period. As used in the late eighteenth and early nineteenth century, the word sublime defined objects or experiences which communicated a sense of the infinite grandeur of the natural universe, and the feelings of combined awe and exhilaration arising from this sense. Mountains, waterfalls, and the ocean could all be sublime in their expression of vast size or power. French artists undoubtedly experienced the sublime, but a strong sense of form inherited from the Classical tradition inclined them, even in the Romantic period, to turn away from the formlessness of the infinite. The mountain scenery which became popular in France in the late eighteenth century, particularly through the writings of Jean Jacques Rousseau, is a countryside of upland valleys, pastureland, or woodland in the foothills of the Alps, with the mountains themselves appearing as a chain of peaks on the horizon. This is a landscape at the edge of human habitation; indeed one of its attractions for Rousseau was the simple pastoral society of its inhabitants. The aspects of nature which pleased him, pine woods, rocks, and rushing streams, are found already on the lowest mountain slopes.[20]

The mountains of Franche-Comté, the range of the Jura, are much lower than the Alps, but in his preface to the Franche-Comté volume of the *Voyages pittoresques,* Charles Nodier defended the Jura against the Alps; their limited scale corresponds better to the limitations of human emotions. Even as late as 1825 the awesome scale of the Alps could be felt as oppressive rather than inspiring.[21] Villeneuve's print of the *Fort de l'Ecluse* (FIG. 11) from the Franche-Comté volume of the *Voyages pittoresques* depicts a scene in the Jura mountains: the pass, guarded by a fort, through which the Rhone flows from

Switzerland into France. The subject of the print is not the mountains, though they form a dramatic setting for it, but the break between them, the strategic route that is one of the gateways to France. Long before mountain scenery was valued as beautiful or awe inspiring, the strategic value of mountain ranges as natural fortifications had been appreciated, and the two jagged ridges in Villeneuve's print suggest this primitive protective function.

In the same volume of the *Voyages pittoresques*, James Duffield Harding's *The Château de la Roche* (FIG. 12) depicts not so much a mountain as a gigantic crag, whose castlelike appearance is presumably responsible for its name. The sunlit valley of pastures and groves of trees from which it rises suggests the society of simple mountaineers evoked by Rousseau and Nodier. Indeed the print is a kind of parallel to Joly's *Ruins of the Château Gaillard* (FIG. 2), with the forbidding cliffs of the rock formation taking the place of the ruined castle as a contrast to the peaceful world below.

Fragments of mountain scenery rather than the great peaks themselves were a more congenial subject to the Romantic artist. The waterfall and the cave are two aspects of mountain scenery that had been adapted to garden and landscape architecture long before the nineteenth century, but the Romantic period saw a new enthusiasm for them in their natural state. A cascade, as an element of nature comparable in size to man-made structures, invites the same sort of contemplation as an architectural monument, and even in 1825 special provisions were being made for viewing *The Cascade de l'Abyme* (FIG. 13). The rustic scaffold alongside the falls seems to have been made solely to allow visitors to indulge in the pleasure Rousseau describes:

The amusing thing about my taste for precipitous places is that they make my head spin; and I am very fond of this giddy feeling as long as I am in safety. Supporting myself firmly on the parapet, I craned forward and stayed there for hours on end, glancing every now and then at the foam and the blue water, whose roaring came to me amidst the screams of the ravens and birds of prey which flew from rock to rock and from bush to bush, a hundred fathoms below me.[22]

In describing another cascade, Nodier carefully advised the reader how to approach it in order to see it to best advantage, and the accompanying lithograph shows it from the "correct" viewing point.[23]

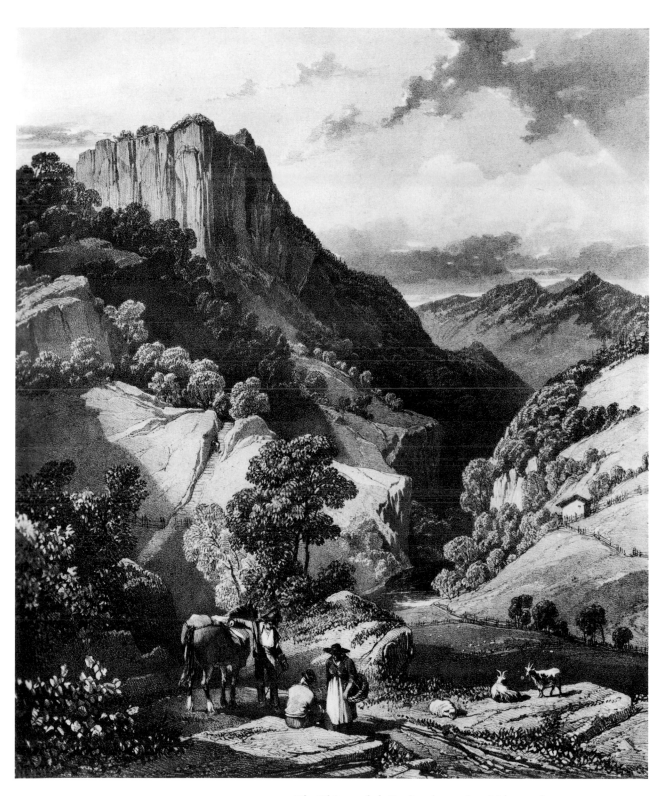

12. JAMES DUFFIELD HARDING. *The Château de la Roche,* about 1825. Lithograph

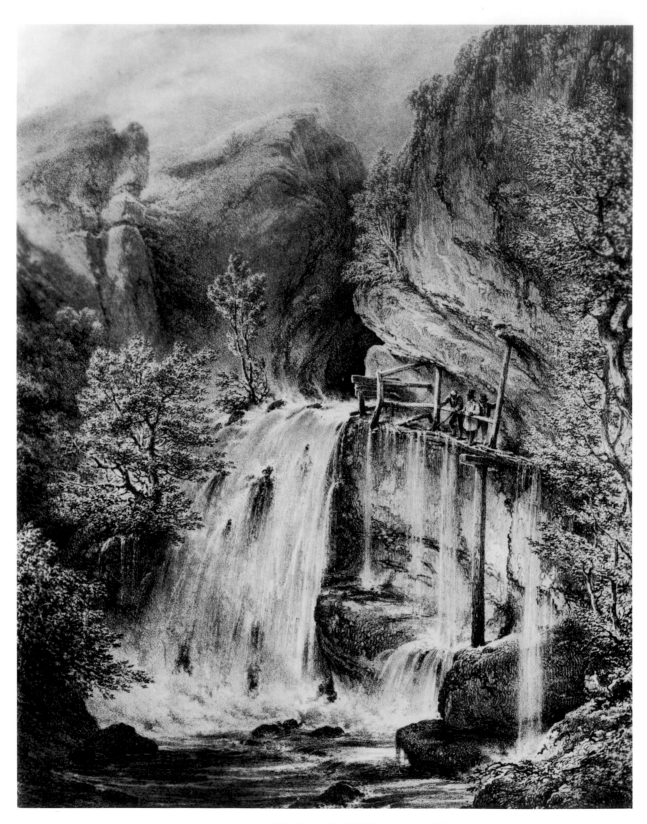

13. LOUIS ATTHALIN. *The Cascade de l'Abyme*, 1825. Lithograph

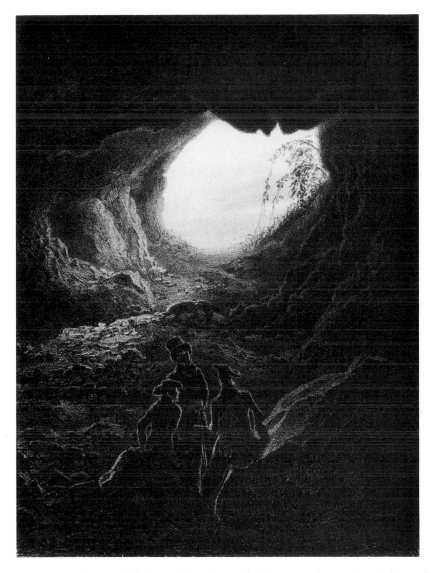

14. GAVARNI. *Grotte d'Elais near Bagnères in the Pyrenees,* about 1829. Lithograph

Subterranean caverns are less easily composed into a picture, which may be one reason they appear less frequently than the ubiquitous cascades in the *Voyages pittoresques*. Gavarni's lithograph *Grotte d'Elais near Bagnères* (FIG. 14) treats the motif of the cave more subtly than any of the prints of similar subjects in the *Voyages pittoresques*. Although the *Grotte d'Elais* lacks the fantastic stalactite formations of a limestone cavern, Gavarni lends it an air of mystery. As the viewer looks back toward the entrance from the interior of the cave, each irregularity in the surface of the rock is outlined in light, as are the three travelers who contemplate it.

In the volumes of the *Voyages pittoresques* dealing with Languedoc, the artists were confronted for the first time with a range of high mountains, the Pyrenees. In Léon Sabatier's *The Lac d'Oo near Luchon* (FIG. 15) the subject is once again not the mountain but the lake at its foot. Sabatier, however, has risen to the challenge of the spectacular mountain scenery. From the barren rocks of the foreground the landscape recedes and rises in a succession of crags and rock walls to the unnamed but awesome peak in the distance. Sabatier made no attempt to infuse his print with the lively movement of Atthalin's *Cascade de l'Abyme*, or even the dramatic lighting of Villeneuve's *Fort de l'Ecluse*, but his carefully organized composition provides a framework within which the vastness of this subject gradually makes itself felt. The lack of extravagance in his portrayal of the mountain landscape is striking, but also characteristic of French landscape at the time; whereas artists such as Delacroix were depicting human events with passionate intensity, and British artists such as Turner were infusing landscape with the same energy, French landscapists retained a certain sobriety in depicting even the most spectacular scenery. This is perhaps a corollary to the comparative dearth of nature poetry in French literature of the time. Mountain landscapes in particular seldom appeared in literature except as the background to human action; Alfred de Vigny's poem "The Horn" (1825), for example, is set in the Pyrenees, but Vigny offers only a summary reference to icy peaks and fertile valleys before getting on to the real subject, the death of Roland in the battle of Roncesvalles. For the French writer the most imposing subject was the grandeur of human thoughts or actions, not that of natural forces.[24]

The artists of the *Voyages pittoresques* were also restrained by their concern for topographic fidelity from developing the kind of expressive land-

15. LÉON JEAN BAPTISTE SABATIER
The Lac d'Oo near Luchon in the Pyrenees, about 1835. Lithograph

16. FRANÇOIS JOSEPH DUPRESSOIR and H. BERTHOUD
The Pic de la Fare in Oisans, 1839. Soft-ground etching and aquatint

scape found in Turner's work, but occasionally a more extravagant or fantastic landscape appears in prints designed for independent publication, or for publication in other books and periodicals. François Dupressoir's soft-ground etching *The Pic de la Fare in Oisans* (FIG. 16) depicts a particular place, but it appeared in the magazine *L'Artiste* without any accompanying text. *L'Artiste,* a magazine of art and literature, was in the forefront of the Romantic movement, and Dupressoir's vision is one of wild scenery—theatrically wild. The print suggests some of Turner's mountain views in its exaggerated perpendicular cliffs and swooping hillsides.[25] The way the curves of the landscape are followed in the cloud formations, leading to a kind of atmospheric whirlpool above the valley, and the gigantic block of stone which lies in the foreground as if tossed down hint at natural catastrophes of the past or future—storms, avalanches, or landslides. Unlike Turner, however, Dupressoir did not really gain in emotional power what he gave up in topographic accuracy. The sense of scale is weak; it is difficult to be sure whether the peak in the background is a gigantic mountain or only a small needle of rock, and to an eye familiar with mountain scenery the jagged contours seem not awesome but simply unreal.

Eugène Isabey's prints, less overtly dramatic than Dupressoir's etching, more successfully convey a vision of the mountain landscape. Isabey, only sixteen in 1820 when the first volume of the *Voyages pittoresques* was published, had the opportunity to learn from the early volumes when he produced a series of landscapes for the volumes on Auvergne. Like Franche-Comté, Auvergne is a mountainous region, and Isabey has given us the feeling of the country without selecting the mountain peak as a subject. The *Apse of the Church of Saint-Nectaire* (FIG. 17) is ostensibly not a view of mountains at all, but not even Harding's *Château de la Roche* is as successful at suggesting the sheer mass of ridges and shoulders. Where Harding showed a crag rising like a single monument out of the landscape, Isabey's print treats the whole surface of the earth as a piece of sculpture, putting the viewer among the mountains rather than merely showing them to him. By comparison Dupressoir's peaks look like stage flats, and even Sabatier's landscape lacks convincing scale. It seems as though we could measure Isabey's vista by walking through it from the ridge in the foreground to the rounded mountain beyond the church, whereas the vaster distances of the *Lac d'Oo* can only be apprehended intellectually.

Isabey's mountain landscape is not only more convincing spatially than those of other artists in the *Voyages pittoresques;* it is also more personal. In part this is due to the progress of lithography between 1825, when the prints of Franche-Comté were made, and 1832, when the first volume on Auvergne appeared, as well as to Isabey's boldness in using the lithographic crayon. The energy of his individual crayon strokes infuses a kind of movement into buildings and land surface alike—not the tumultuous whirlpool achieved by Turner and imitated by Dupressoir, but an undulatory movement that has been compared to the waves of the ocean.[26] One feels that topographic accuracy may have been sacrificed in some degree to the artist's personal style of drawing, but the result is a more accurate suggestion of what it feels like to be in the environs of Saint-Nectaire, on a bare, windswept ridge, than a strictly accurate copying of contours would have produced.

Victor Hugo, a friend of Nodier and an early subscriber to the *Voyages pittoresques,*[27] may well have been influenced by prints like Isabey's in creating his own drawings of fantastic landscapes. Without formal art training, Hugo manipulated ink blots and pen strokes in a manner not far from doodling. Isabey, in *The Church of Saint-Nectaire,* infused the description of a specific place with a particular mood. In *The Lightning Flash* (FIG. 18), an etching by Charles Courtry after a drawing by Hugo, the dramatic mood itself is the subject; the elements of landscape are little more than pretexts for the violent contrasts of light and dark that suggest a flash of lightning. Yet the spatial organization of the print is surprisingly similar to that of Isabey's much earlier lithograph. The comparatively sophisticated spatial arrangement of the land-scape, combined with the sheer vigor of the line, helps to explain why despite Hugo's amateur draftsmanship his print is far more powerful than the conven-tional Romantic fantasy of Dupressoir.

Mountains and sea have a number of points in common as subjects for the landscape artist. Both are harsh environments where dangerous storms occur, so that wind and weather play a large part in the traveler's perception of them. French artists of the nineteenth century did not usually depict the open sea any more than high mountain ranges, but the coast inhabited by fishermen had the same appeal—a simple life in contact with the grandeur of nature—that Rousseau had praised in the Alpine valleys. Because of marine travel and commerce the sea was more frequently traversed than the mountains, and its

44

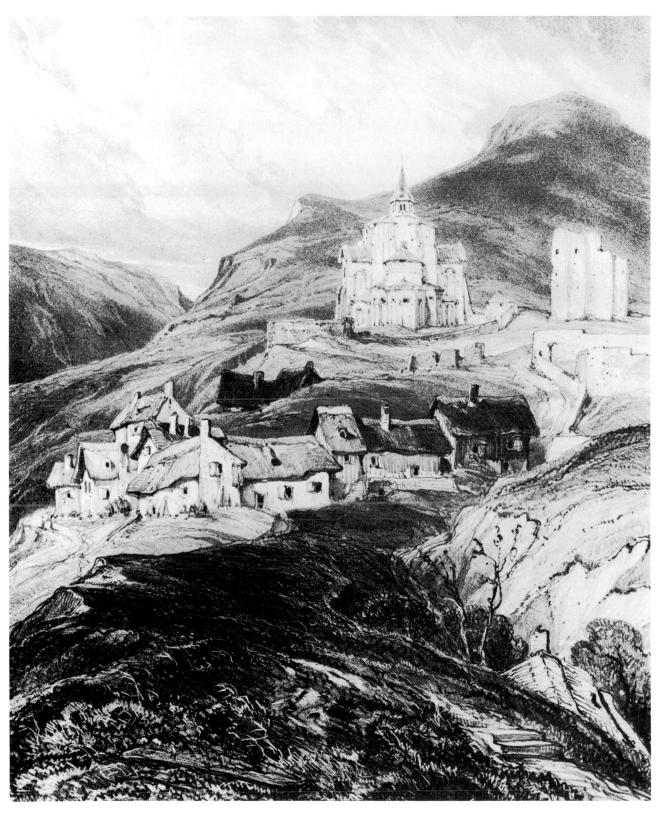

17. EUGÈNE ISABEY
Apse of the Church of Saint-Nectaire, Auvergne, 1831. Lithograph

18. CHARLES COURTRY, after VICTOR HUGO. *The Lightning Flash*, about 1868. Etching

terrors were more familiar to both writers and artists. The ocean's vastness made it an even more overpowering literary image. Hugo's poem "Oceano Nox" (1836) equates the ocean with the infinite, a gulf into which men vanish without a trace.[28] But even here it is the men themselves who give the poem its meaning; their lives, their death, and the fading of their memory in the place they once lived.

Isabey's many seascapes usually have some allusion to the men who live by the sea, whether sailors or fishermen. *The Environs of Dieppe* (FIG. 19), from a series of six lithographs with marine subjects that he produced in 1833, treats the coast much as *The Church of Saint-Nectaire* treated the mountains. Unlike the prints for the *Voyages pittoresques*, however, *The Environs of Dieppe* does not necessarily depict a specific site. Instead, it could well be a typical landscape of the Norman coast, a place that is like many around Dieppe but does not actually exist. It is instructive to compare this print with Villeneuve's *Mills at the Headwaters of the Loue* (FIG. 3), which combines the same elements of picturesque buildings, rocks, and rushing water. Villeneuve paid great attention to details of contour and texture, but his vocabulary of crayon stroke was limited, and as a result the overall impression made by the print is one of a rather muted rendering of heterogeneous picturesque detail. Isabey, by contrast, used rather similar undulating contours to describe rocks, waves, and buildings, but his range of crayon textures and of light and shade is far greater. His landscape appears less realistic in the topographic sense of transcribing a particular site, but more so in the sense of giving the feeling of what it is like to stand on the coast of the English channel on a stormy day.

The excitement that Isabey gave to the simple depiction of water and cloud made it unnecessary for him to seek out the most spectacular scenery for a landscape. *Low Tide* (FIG. 20) displays no cliffs or stormy weather, only a strip of beach and a cloudy sky. The print might be a transcription of the ambition of Isabey's English contemporary Constable: "It is the business of a painter not to contend with nature [by recording vast panoramic views] but to make something out of nothing, in attempting which he must almost of necessity become poetical."[29] With its beached boats alluding to the everyday life of coastal fishing, *Low Tide* has analogies with the landscapes of the Barbizon school and the pastoral or agricultural activities depicted in them (see the second chapter, "The Urban Maelstrom and the Pastoral Oasis"). But the

47

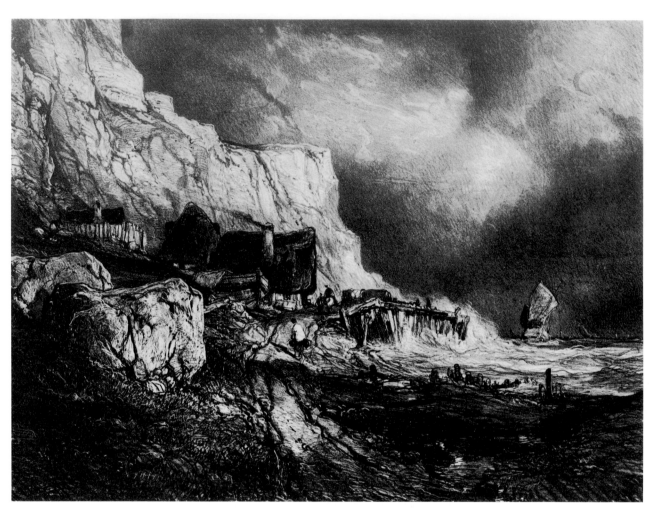

19. EUGÈNE ISABEY. *The Environs of Dieppe*, 1833. Lithograph

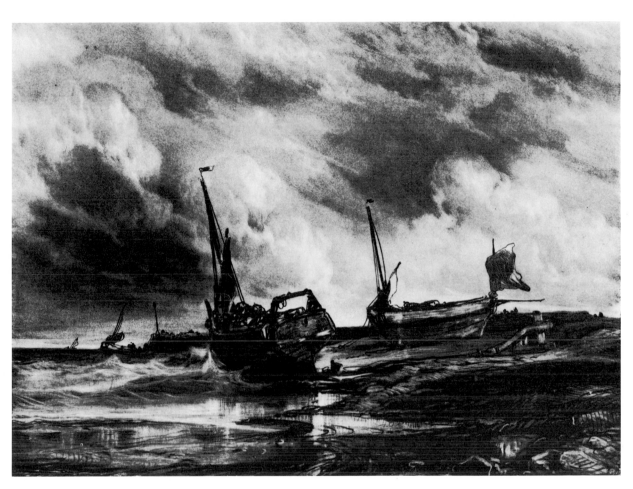

20. EUGÈNE ISABEY. *Low Tide*, 1831. Lithograph

21. ADOLPHE HERVIER. *Coastal Scene, Storm*, about 1843. Etching

presence of the ocean, the infinite expanse of sea emphasized by a tiny sail on the horizon, reminds the viewer of the heroic aspects of the sailor's life, and still more evident than in *The Church of Saint-Nectaire* the bare landscape and racing clouds convey the sense of a powerful wind rushing across the whole landscape. While the Barbizon landscape would emphasize peace and restfulness, Isabey's seacoast is charged with energy.

Just as *The Lightning Flash* seems to contain recollections of Isabey's mountain landscape, the little etchings of Adolphe Hervier seem to translate Isabey's coastal scenery into the realm of fantasy. Isabey's draftsmanship made analogies between buildings and land forms, but Hervier went beyond this to eliminate the distinction between earth and sea. In the print *Coastal Scene, Storm* (FIG. 21), a single contour swings from the storm-tossed boat at the left to the ridgepole of the nearest cottage, and the whole village, swaying like the boat, seems to be floating on the water.

Fantasies like those of Hervier and Hugo mark one path of development for French Romanticism, but it is not a well-traveled path. The Romanticism of Isabey, a subjective but comparatively temperate description of scenery that is wild but not extravagantly wild, is more significant for the future development of French landscape. This is still more evident in the depiction of forest and open country by Isabey's contemporary Paul Huet.

FOREST AND FIELD

The landscape of forest and field appears less often in the pages of the *Voyages pittoresques* than that of mountain and seacoast. As scenery, it was less inherently dramatic, and it was also more familiar. The forest, at least, was still a wild environment in the early nineteenth century, but unlike the mountains and the sea it was an environment habitually visited by the urban population for recreation—riding and hunting in particular. These had been aristocratic pleasures since the Middle Ages, and in the early nineteenth century the middle class was beginning to emulate them. Paul de Kock's family of shopkeepers, when they pass through the Parc Saint-Fargeau on their holiday, are able to hire horses and donkeys to ride through the woods.[30]

Most if not all the forests in the neighborhood of Paris were carefully managed for timber, firewood, and hunting. A map of the Bois de Boulogne, a typical hunting forest before its transformation in the 1850s (FIG. 111), has a surprisingly civilized air; the entire territory is crisscrossed by mathematically straight roads and avenues, meeting in starlike *ronds-points*. This cutting up of the forest allowed a huntsman to spot game more easily from a distance—by standing at the intersection of several avenues he could keep track of moving animals as they crossed the open spaces of the avenues.

The forest still retained, however, some of the dangers and terrors of a true wilderness. Its avenues might be straight, but most of the time they were deserted, and in between them the forest was dense and wild, a shelter for dangerous animals and dangerous men. As recently as the late eighteenth century the city of Fontainebleau had been judged a poor place to locate a criminal court because: "Placed in the middle of a forest, it is difficult and dangerous to approach, which would expose the witnesses and jurymen to the vengeance [of criminals or convicts]."[31] The forest of Bondy, just to the northeast of Paris, was proverbial for its brigands well into the nineteenth century.

In contrast to the urban criminals discussed in the second chapter, the brigands, poachers, and smugglers who peopled the forest were often shown as appealing figures by the Romantics, wild rather than evil.[32] Paul Huet's lithograph *The Smugglers* (FIG. 22) is wild and mysterious, but not threatening. The forest seems like a cavern, the sky totally obscured by the giant trunks and branches, but the impression is one of safety rather than danger; safety for the smuggler who is sheltered from the eye of the law. The trees arch protectively across the road. The smuggler himself, with his heavy drooping mustache and the simple tubular shapes of his costume, has a family resemblance to the giant trunks around him. If Huet's image is alarming at all it is probably because of this uncanny kinship between the human and the plant world, recalling all the medieval legends of wild men, dwarves, goblins, and other supernatural inhabitants of the forest. These mysterious beings are more associated with German art and literature than with French in the early nineteenth century, and it is significant that Victor Hugo addressed the German artist Dürer in a poem of 1837 which plays on the mysterious life of the forest:

52

22. PAUL HUET. *The Smugglers*, 1831. Lithograph

23. PAUL HUET. *Twilight*, 1829. Lithograph

A forest, for thee, is a hideous world,
Fantasy and reality blend into each other there.
There the ancient dreaming pines lean down, and the great elms
Whose twisted roots make a thousand deformed elbows;
And in that somber group, agitated by the wind,
Nothing is completely dead, and nothing completely alive.
The cress drinks, the water runs, the ash trees on the slopes
Beneath the horrible underbrush and the creeping climbing thorns
Slowly shift their knotted black feet.[33]

This image of the mysterious and uncanny forest is seldom so strongly empha-
sized, but it remains an undercurrent in French forest landscapes.

In contrast to the Germanic theme of the uncanny forest is another,
deriving in large measure from the thought of Rousseau: the forest as a place of
peace and religious contemplation.[34] The misanthropic hero of Chateau-
briand's novel *René*, spiritually unsatisfied by long hours of meditation in the
churches of Paris, decides to return to his native Brittany and buries himself in
the forests there;[35] ultimately he moves on to the still wilder and more solemn
forests of America. The idea of the forest as the natural place for meditation is
hinted at in Gavarni's *Solitude* (FIG. 9), and Huet's prints often show it in this
light.

Twilight (FIG. 23) is a variation on Gavarni's theme, the solitary woman
seated in a wild landscape. But whereas Gavarni's landscape is little more than
a backdrop to the contemplative mood of the figure, in Huet's print it is the
figure which contributes to establishing the mood of the landscape, reassuring
the viewer that it cannot be a wilderness in which she sits so calmly. (Indeed, it
is not clear that it is a forest at all, rather than a grove of trees in a park.) The
soft darkness of the foliage, however, enhanced by the choice of twilight
illumination, gives the print an air of religious, mystical reverie. The softness
and indistinctness of Huet's lithographs contrast with the clean sculptured
surfaces in Isabey's work. It seems almost as though Isabey were constitution-
ally predisposed to the bare landscape of mountain and seacoast, and Huet to
the intricate, indistinct landscape of interlacing branches and foliage. Cer-
tainly it is significant that Huet favored the intricate linear patterns of etching
and made some of his most successful prints in that technique, at a time when

55

24. PAUL HUET. *The Keeper's House,* 1833. Etching

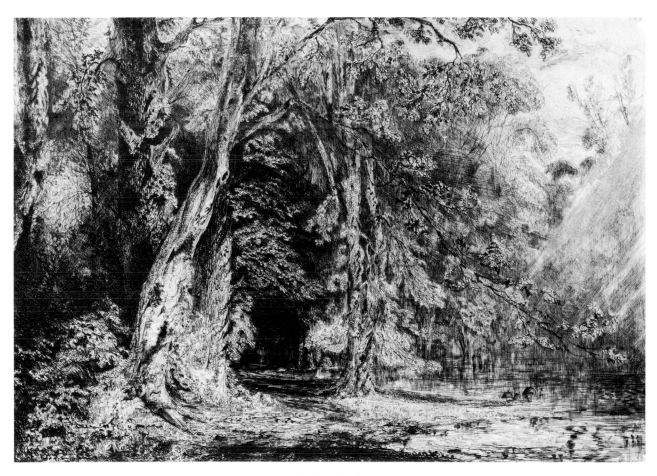

25. PAUL HUET. *The Flood at the Ile Séguin*, 1833. Etching

lithography was far more popular. *The Keeper's House* (FIG. 24) and *The Flood at the Ile Séguin* (FIG. 25) are both from a set of landscapes published in 1835 but *The Keeper's House* is based on a painting done almost a decade earlier and is one of the first French landscapes to raise such a humble subject to a monumental scale. (The print too is large and formal.) Like *Twilight* and unlike *The Smugglers, The Keeper's House* shows a landscape at least partly under human control: a clearing or an area bordering on the forest, where one of the men responsible for its maintenance lives. Just as Huet made analogies between the smuggler and the forest he passes through, here he unites the house with the forest, engulfing it in foliage. But in place of the wild and uncanny forest of *The Smugglers, The Keeper's House* implies a harmonious immersion of man in nature; the forester's activities are part of civilized society rather than a rebellion against it. Thus his house is a symbol of human control over the forest, at the same time that the vegetation which overwhelms it suggests the superhuman vitality of nature. Unlike the forces of mountain avalanche or storm at sea, the growth of vegetation is a vast but quiet manifestation of nature's power. In *The Flood at the Ile Séguin* Huet depicts still more clearly a natural world of immense but quiet forces. The Ile Séguin is an island in the Seine close to Paris where Huet's family had often lived during the summer when he was a child; only part of the island was forested and it had been farmland in the not too distant past. The etching, however, suggests a virgin forest of vast extent—not the cavelike forest of *The Smugglers*, but a natural cathedral penetrated by shafts of sunlight. It is an illustration of Huet's own description of the place:

By day, it was an enchanted place [une féerie]. *You walked amid the scenery for some superhuman opera; the rays of the sun rained hotly down in the center of the clearings, the light died away after a thousand struggles at the end of a low avenue.*[36]

This solemn landscape is penetrated by the floodwaters of the Seine, but even this manifestation of nature out of control is peaceful. Instead of the destructive power of a flood washing away the land, we see a silent, irresistible force which has magically brought a sheet of water into the heart of the forest and turned a clearing into a lake. Where in Isabey's landscapes the grandeur of

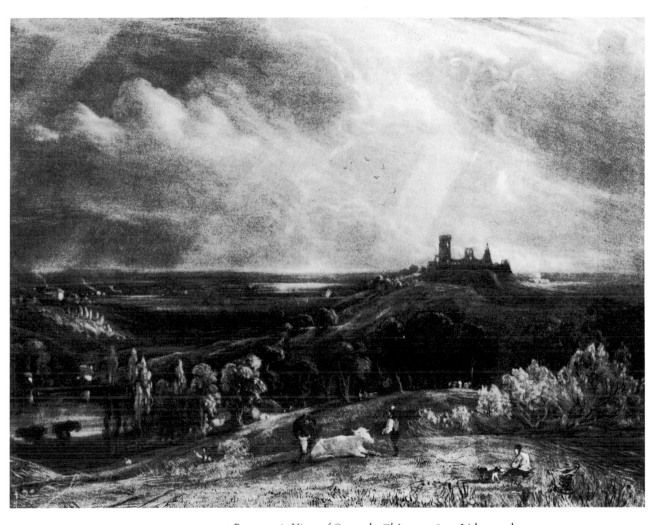

26. PAUL HUET. *Panoramic View of Coucy-le-Château*, 1833. Lithograph

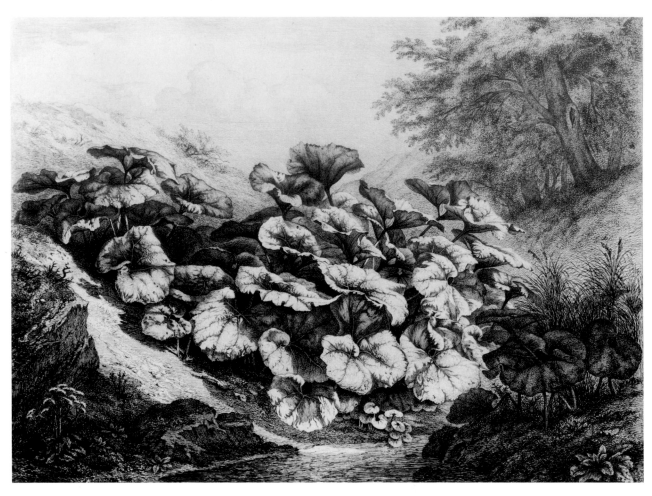

27. EUGÈNE BLÉRY. *Coltsfoot*, 1843. Etching

nature is usually emphasized by an implied threat of danger, Huet's suggests natural forces against which it is both futile and unnecessary to struggle.

In the *Panoramic View of Coucy-le-Château* (FIG. 26) Huet applied this theme of the peaceful grandeur of nature to a view of open country. The print is akin to many views in the *Voyages pittoresques*, but few of them would venture to push the ostensible subject, the ruined castle of Coucy, so very far into the background, and to suppress almost all detail in its rendering. The real subject of the print is the panorama of field and tree, hill and river, that is hardly more than punctuated by the gigantic tower of the castle keep, the largest in Europe.[37] It is this sweeping vision which distinguishes the print from the equally pastoral landscapes of the Barbizon school; Huet seems to have mounted into the air for his panoramic view. Like Isabey in *Low Tide* he obeyed Constable's dictum to make something out of nothing, for though the territory he showed is vast, it is devoid of "scenery" other than the distant castle.[38]

The *Panoramic View of Coucy-le-Château* is an example of the balance between topographic accuracy and awe of nature, which the most gifted artists of the Romantic period were able to achieve. Huet achieved this by ascending into the air and taking in a vast tract of country, but a similar effect could be produced by getting closer to the ground. *Coltsfoot* (FIG. 27) is one of a group of etchings by Eugène Bléry which depict common field plants in their natural setting. The plant is rendered with an accuracy that would suit a botanical illustration, but Bléry selected an extremely low point of view so that we see its upper leaves from beneath, and in addition he juxtaposed it to tiny, distant trees. Without any excursions into fantasy he has weakened the viewer's sense of scale, so that the small plant becomes a forest of gigantic leaves, and the small undulations of the earth's surface are transformed into hills and valleys. It is an effect familiar to any child who has put his face close to the ground in a garden or field and imagined himself only a few inches tall, and Bléry would only have needed to introduce such a tiny figure to turn his print into a fantasy. By refraining from this, he kept the image on the borderline between dream and reality and drew power from both realms.

This borderline position grew more difficult for the artist to maintain as the nineteenth century progressed. Occasionally an artist chose the realm of fantasy, the most notable example being the etcher and lithographer Rodolphe

Bresdin. Bresdin's most striking prints can hardly be considered physical landscapes; it would be more accurate to call them landscapes of the mind, depending little or not at all on observation of the actual world. *Stream in the Woods* (FIG. 28) is conventional by comparison with some of Bresdin's better known prints, the monstrous, skeleton-haunted landscape of *The Comedy of Death* or the mysterious jungle of *The Good Samaritan,* and might well be taken for the representation of some actual stream. Comparing it with Huet's *Flood at the Ile Séguin,* however, suggests that there is a fundamental difference between the Romantic vision of Huet and the fantastic vision of Bresdin. The networks of line which in Huet describe bark and foliage are nearly as intricate as those of Bresdin, but Bresdin's line seems endowed with a vegetable life of its own, crawling over the paper like ivy on a wall, sending little tendrils out into the margins, and only incidentally describing a wooded stream valley. The interlacing branches in the upper part of the print form much too regular a pattern to be a record of observed nature. What seems most likely is that Bresdin based his composition on the memory of some actual forest scene, but that in developing its microscopic detail he relied primarily on his imagination. Whether we consider him a belated Romantic or a proto-Symbolist, he is more an explorer of the spirit than of France.

The mainstream of landscape art developed in a different direction, turning away from the mystical and awe-inspiring aspects of nature. The landscapes of the Barbizon school were the outcome of this tendency in their pastoral tranquility, but so were the best prints in the later volumes of the *Voyages pittoresques,* which replace enthusiasm with an even-tempered objectivity.

Precision and technical control rather than enthusiasm are the virtues of Eugène Cicéri, the most distinguished artist of this later phase; significantly his best prints were often based on the drawings of other artists rather than his own direct experience of a landscape.[39] *Dolmen at Parc-ar-Dolmen* (FIG. 29), from the *Voyages pittoresques* volume on Brittany, uses the same formula as Fragonard's *Ruins of the Palace of Queen Blanche* — an ancient monument, an artist sketching it, and a local countryman acting as guide. But where Fragonard used every resource to heighten the excitement of exploration, Cicéri was committed to understatement. His viewpoint does not emphasize the masses of stone raised above the earth, but rather the way in which the

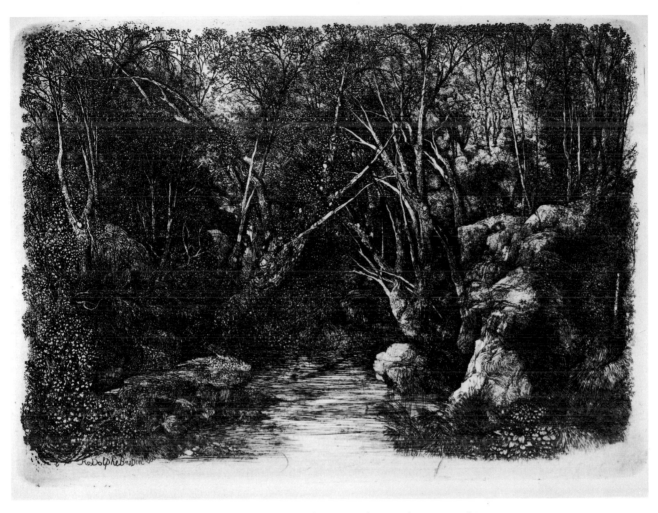

28. RODOLPHE BRESDIN. *Stream in the Woods*, 1880. Etching

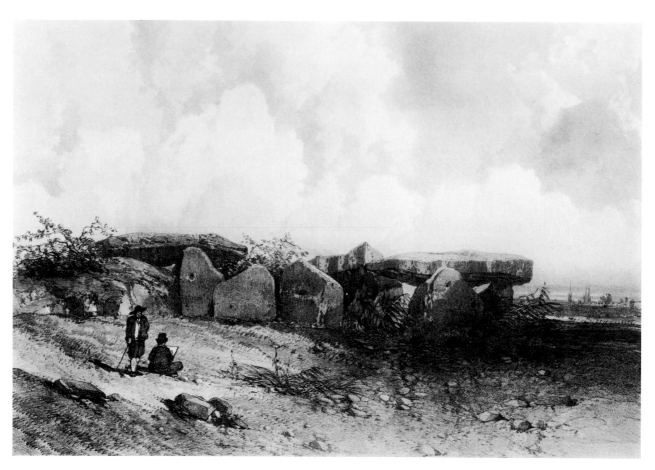

29. EUGÈNE CICÉRI, after A. MAYER. *Dolmen at Parc-ar-Dolmen,* about 1845. Lithograph

whole structure hugs the ground. His artist does not lean forward eagerly to capture the view, but sits cross-legged in an almost comic stolidity, and the guide stands patiently waiting, taking no notice of either artist or dolmen. In the 1820s Nodier had promised to give special attention to dolmens and other prehistoric monuments because of the mystery of their origin. But Cicéri's dolmen, in the clear night of midday, is far less mysterious than Fragonard's Gothic ruin. Cicéri seems to have renounced the artist's privilege of interpreting the landscape and returned to the documentary ideal of the topographer.

THE PICTURESQUE CITY

As the spectacular scenery of Romantic landscape was being superseded by the quiet, contemplative landscape of Barbizon art, the corresponding image of the city was evolving in a different direction. The Romantic vision of the city was to reach its fullest development not in a mood of enthusiastic exploration but in one of pessimism and horror, a mood which we shall examine in the next chapter and which is most perfectly exemplified by Charles Meryon. But the exploratory mood did produce some memorable images and many minor ones. The artists of the *Voyages pittoresques* devoted as much attention to towns as to the countryside, as one might expect given the project's initial and primary concern with architecture.

Cities and towns appear in two forms in the *Voyages pittoresques*. In one mode, the city is seen as a whole, set in its surrounding countryside and viewed from a distance. Eugène Cicéri's *General View of Quimper* (FIG. 30) is a late example of this, but it occurs already in the first volumes. Quimper is scarcely more than a church tower and a few surrounding buildings, seemingly a village rather than a city. But most cities in early nineteenth-century France were indeed small; apart from Paris only eight were larger than fifty-thousand inhabitants in 1816.[40] The distinction between a town and the surrounding country was still sharp. The city could be grasped as a single structure—more easily perhaps than a mountain range or forest.

The other mode of presenting the city in the *Voyages pittoresques* is, naturally, as the setting for picturesque architecture. Just as Fragonard had placed his rural ruin (FIG. 1) in a setting of forest and cliff, the artist who

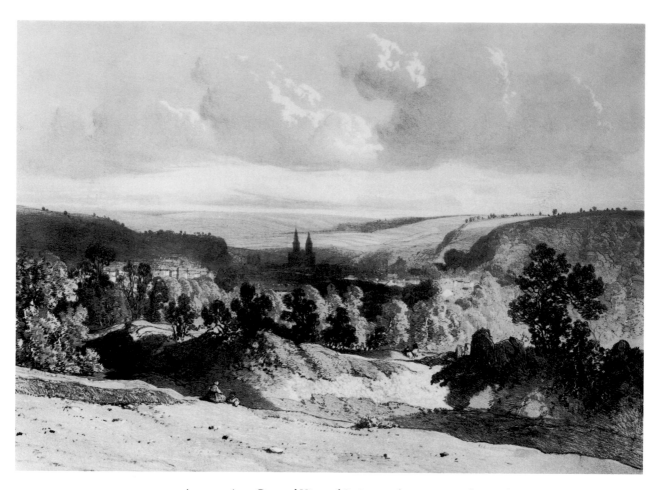

30. EUGÈNE CICÉRI. *General View of Quimper,* about 1845. Lithograph

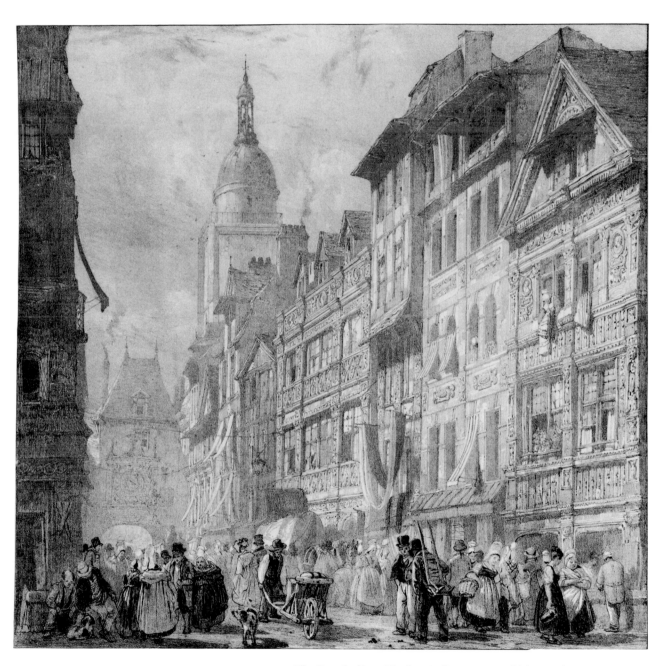

31. RICHARD PARKES BONINGTON. *The Rue du Gros-Horloge in Rouen*, 1824. Lithograph

depicted a cathedral or other urban structure frequently showed the buildings clustering around it. Often this was inevitable; the crowded houses and narrow streets of these still medieval cities meant that a large building could often be seen only as it rose above the housetops, or as a fragmentary facade at the end of a street.

Only occasionally, however, do these city views present a real sense of an urban environment. The English artists who worked on the project seem to have accomplished this more often than the French, and the finest example is Richard Parkes Bonington's *Rue du Gros-Horloge in Rouen* (FIG. 31). Like Isabey and Huet, Bonington was successful precisely because he avoided the extremes of the picturesque and dramatic. Indeed the theme of the *Rue du Gros-Horloge* is balance, beginning with the choice of a square format that emphasizes neither the vertical of an individual building nor the horizontal of a panoramic view. There is no single architectural focus: the most remarkable buildings (the tower and the arched gateway with the clock that gives the street its name) are pushed into the distance, and they are not large enough to dominate the print from that position. Instead they share equal attention with the carved facades of the houses nearer the foreground and above all with the busy life of the market. Bonington's figures are not mere staffage dropped in to enliven the composition, as one sometimes feels in prints from the *Voyages pittoresques;* instead they are part of the portrait of the street. Finally, there is a balance between the attention to architectural detail and the overall tonality of hazy sunshine which pervades the print. Without ceasing to be an effective topographic view, the *Rue du Gros-Horloge* has become an expression of urban life. Perhaps it was necessary, for such an image to be produced, that the artist was an Englishman for whom not only the medieval buildings but the everyday life of the French marketplace had the charm of exoticism.

With all this, Bonington's image is still strictly tied to the aims of the *Voyages pittoresques.* It is only because of the assemblage of medieval architecture in the *Rue du Gros-Horloge* that it is depicted, not from any desire to document urban life. The artists of the *Voyages pittoresques* deliberately passed over buildings and towns that were more recent. It is also significant that Paris, by far the greatest city in France,[41] was omitted altogether from the project. It would have been included, naturally, if the *Voyages* had ever been brought to completion, but it is probably no accident that Paris and the

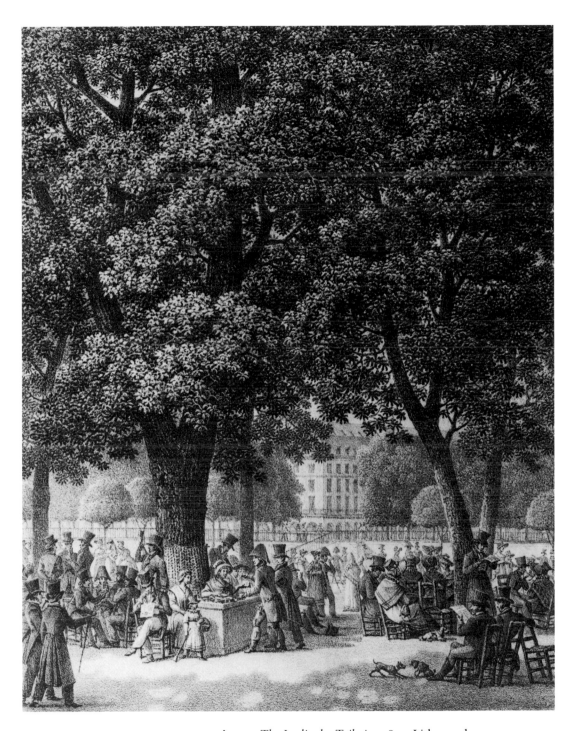

32. LOUIS BACLER D'ALBE. *The Jardin des Tuileries*, 1822. Lithograph

surrounding country were not high on the list of priorities; instead the more distant regions of France with their smaller cities were depicted.

There was no lack of prints and portfolios of prints dealing with Paris during the period 1820-40. Most are straightforward topographic images which do no more than reproduce the city's principal buildings and monuments, but an early (1822) series of lithographs by Louis Bacler d'Albe, *Promenades pittoresques et lithographiques dans Paris et ses environs (Picturesque Lithographic Walks in Paris and Its Environs)*, belongs to a different tradition. Rather than topographic views of major monuments, these are modest scenes of urban life, small views illustrating a walking tour of Paris. They are on the borderline between cityscapes and urban genre scenes, since Bacler d'Albe, as he stated in the preface to his series, took interest in everything:

everyone to his own taste; mine is to observe everything; people, animals, palaces or cottages interest me equally; a tree, a plant or a flower please me; a furious torrent or a limpid brook can awaken my emotions.[42]

The *Jardin des Tuileries* (FIG. 32) shows one of the few open spaces within the city of Paris that was available to the public. It can hardly be described as a Romantic landscape; Bacler d'Albe was sixty-one in 1822 and his art is a mingling of the clear, firm drawing of Neoclassicism with the late eighteenth-century picturesque tradition. The style is particularly well suited to a formal park like the Tuileries, where trees are neatly planted in rows, straight walls, railing, and chairs abound, and the earth is covered not with grass and plants but with sand. Despite the foliage which takes up a large portion of the composition, the spirit of the place is clearly urban. The print could serve as an illustration to the writer of two decades later who described the Tuileries as a sort of open-air reading room.[43] Bacler d'Albe's Paris is an enjoyable place to stroll, just as the people in his print are doing. The stroller is an explorer too in his own way — a more modest and less pretentious way than that of the artist who goes distances to record exotic sites. It is precisely the modesty of Bacler d'Albe's aim which makes his print successful.

Paris et ses souvenirs (Paris and Its Memories) is a series of lithographs dating from 1839 which takes a different approach, enlivening the straightforward topographic view with historical allusions. Thus a view of the *Pont du*

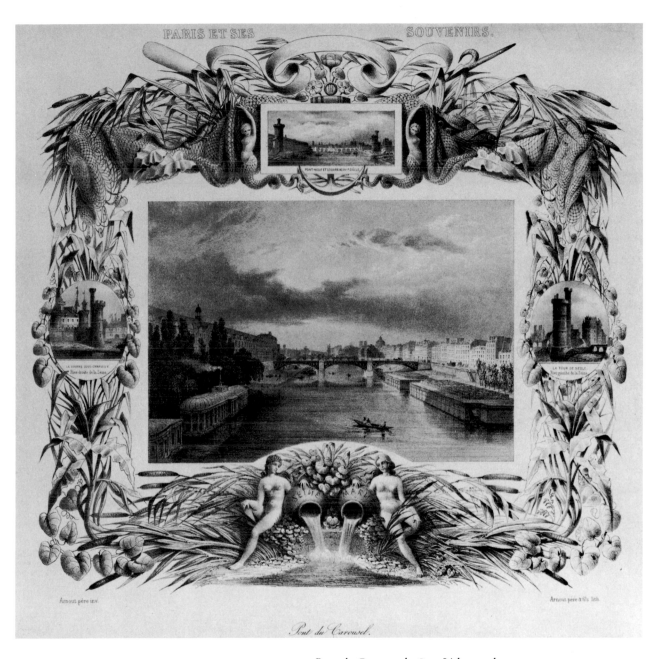

33. JEAN BAPTISTE ARNOUT. *Pont du Carrousel*, 1839. Lithograph

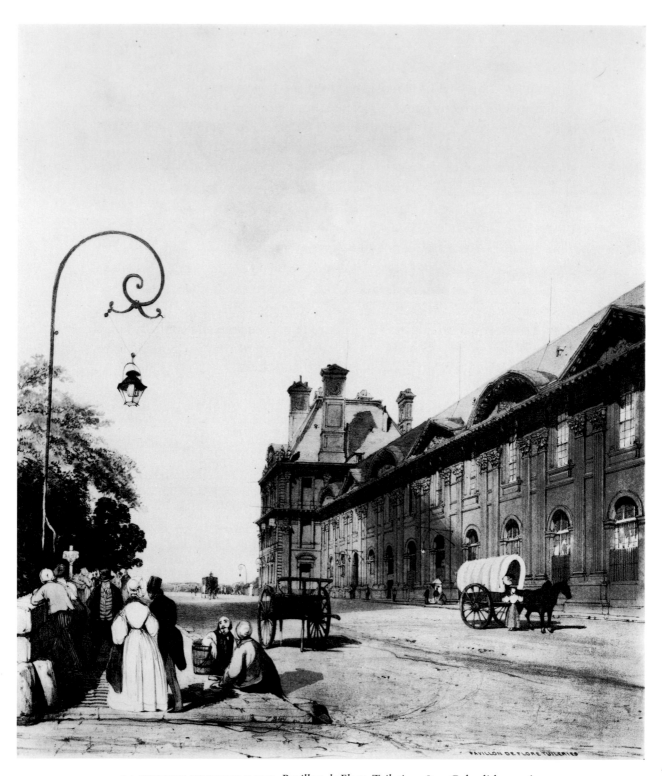

34. THOMAS SHOTTER BOYS. *Pavillon de Flore, Tuileries*, 1839. Color lithograph

Carrousel (FIG. 33) includes in its ornamental border views of the same area in the Middle Ages and the sixteenth century and allegorical figures of the Seine and Marne Rivers. The view itself is not particularly distinguished despite the sky animated by backlit clouds; the river, the floating bathhouses, and the bridge are all correctly enough depicted, but there is none of that excitement which infuses Joly's view of the Château Gaillard, for example. The excitement has been transferred from the image, an unvarnished, objective rendering of the scene as it was in 1839, to the border with its intertwined oars, fish nets and water plants, and historical medallions.

It was left to an Englishman to give Paris the equivalent of the representation that other French cities had received in the *Voyages pittoresques*. In 1839 Thomas Shotter Boys, one of the English artists who worked on the *Voyages pittoresques*, produced *Picturesque Architecture in Paris, Ghent, Antwerp, Rouen, etc.*, a series of color lithographs. *Pavillon de Flore, Tuileries* (FIG. 34) deserves comparison with Bonington's *Rue du Gros-Horloge*, even though Boys did not equal Bonington's delicacy of draftsmanship and control of light and atmosphere. The long gallery of the Louvre with the Pavillon de Flore at its end is the only building visible in the print, yet this is not simply an architectural study. What is most striking, indeed, is not the building but the broad street (the Quai des Tuileries) that runs between the building and the river, invisible at the left beyond the trees and parapet. Looking downstream from the Louvre, the print offers a horizon without buildings: the gardens of the Tuileries and beyond them the Place de la Concorde. Not long before, this had been the outskirts of Paris, and it was still the largest single open space in the city.

Even in the center of Paris, where buildings were denser and streets narrower, Boys chose his viewpoint and manipulated his perspective to maximize the feeling of light and spaciousness. The most densely crowded of his prints is *Notre-Dame* (FIG. 35), a view of the cathedral from the Rue Notre-Dame. Only a fragment of its facade can be seen down the narrow street and most of the print is taken up by the melange of shop fronts and house facades, so foreshortened that one can hardly make any judgment about their architecture. Yet by rendering only one side of the street in detail and barely sketching in the other side, Boys makes it seem wider than it is, and a generous view of the sky opens above the rooftops. The pale colors of Boys's prints,

73

suggesting delicate watercolor washes, help to prevent any feeling of darkness, density, or enclosure.

While Boys was exploring Paris, French artists were looking elsewhere; there were many small towns and provincial cities which were as exotic to the Parisian as mountain and forest. Above all the small coastal towns of Normandy appealed to artists. In an advertisement of 1838 the small port of Trouville announced the construction of new hotels, cottages, and a pavilion equipped with reading room, gaming tables, and the like, but boasted that it had lost none of the village simplicity which had in the past attracted so many artists and distinguished visitors.[44] *Harbor Scene* by Eugène Isabey (FIG. 36) depicts this kind of "village simplicity," a quay with fishing boats tied up and a background of picturesque old buildings. It presents an urban version of *The Environs of Dieppe* (FIG. 19), a typical, rather than a specific, picturesque coastal scene. It is worth noting that there is really no information about the size of the town shown in this print; it may be little more than a village or it may be a substantial city. Its interest for Isabey was simply in the particular corner shown: the combination of fisher folk, old buildings, rocks, and water which to this day attracts painters to fishing wharves from New England to Greece. Though Isabey may still have perceived the scene with the fresh eye of a discoverer, he established a type of picturesque scene that has survived to the present day, transformed from the explorer's vision to the tourist's.

A lithograph by Adolphe Hervier shows that there was another way of looking at a scene like this. *Cul-de-Sac at Trouville* (FIG. 37) contains the same basic elements as Isabey's print, but the effect is sinister rather than appealing. The houses are more dilapidated than Isabey's, and the crude props that hold them up make ugly slashes across the view of a more distant building and church tower. Isabey's fishing boats are tied up at a stone quay and in the foreground the low tide has exposed smooth sculptured rocks; Hervier shows us a rotting hulk and other trash on an oozy mud bank. The figures that inhabit this cityscape are grotesque and angular, and the technique of the print carries out the feeling of rot and decay. Instead of Isabey's firm crayon lines, Hervier gives us patches and smears of ink. The print makes it clear that there is a dark side to the picturesqueness of old buildings, that "village simplicity" is compatible with overcrowding and decay. Hervier was born the same year as Charles Meryon, and though stylistically the two artists have little in common,

74

35. THOMAS SHOTTER BOYS. *Notre-Dame, Paris,* 1839. Color lithograph (see color, frontispiece)

36. EUGÈNE ISABEY. *Harbor Scene*, 1833. Lithograph

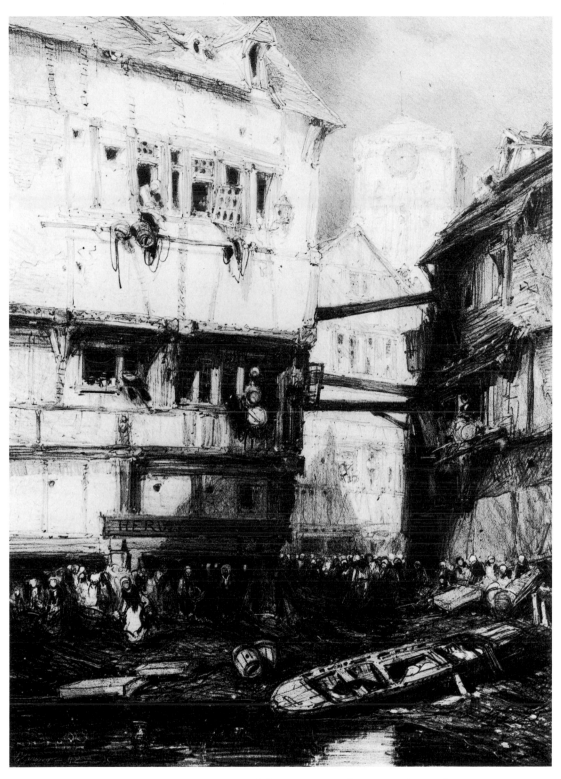

37. ADOLPHE HERVIER. *Cul-de-Sac at Trouville*, 1848. Lithograph

Cul-de-Sac at Trouville could take its place beside the urban images discussed in the next chapter.

TOURISTS AND EXPLORERS

The artistic decline of the *Voyages pittoresques* began long before the last volume was published in 1878. The very success of its aim was in part responsible; as more and more people became interested in the art of the Middle Ages, the excitement of discovering neglected treasures vanished. Already in the 1830s the spirit of the publication was shifting from Romantic enthusiasm to archaeological precision.

Even if this had not happened, a revolution in transportation would soon have altered the conditions that made even a relatively short trip an adventure. Railroads developed slowly in France; though the first was opened in 1821 the early lines were for freight only, and in 1837 when the first railroad out of Paris opened it still seemed more like a toy than a serious form of travel.[45] In a popular print of the time (FIG. 38) people of all classes gather to watch the trains crisscrossing the landscape, as if the spectacle were a parade or celebration. Nevertheless the print is accompanied by a text which soberly discusses the advantages of this new mode of travel, and the print itself shows the trains linking together symbolic images of city and country. When a network of railways was extended over all of France in the 1850s and 1860s, the travelers' experience of the landscape was radically changed. The distant parts of the country and their scenery became much more readily accessible to the traveler, but the very ease with which they could now be reached altered the significance of castle, mountain, or cavern. The traveler who had explored the landscape in search of new sights was replaced by the tourist who came to look at what others had already seen, described, and made famous.[46]

Romantic scenery became more widely popular than ever before, and images of it multiplied, but by the 1850s it had long ceased to be interesting to innovative artists and had become part of the common currency of popular art and illustration. In the *Atlas national illustré* of 1856, the map of each department of France is surrounded by appropriate vignettes. The *Département du Doubs* in Franche-Comté (FIG. 39) is accompanied by glimpses of

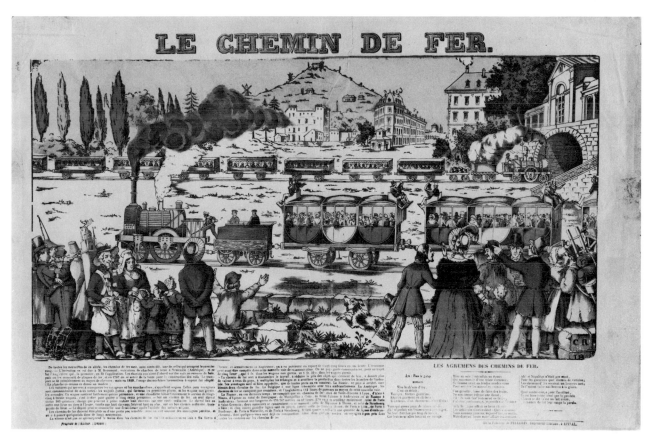

38. PELLERIN ET CIE (publisher). *The Railroad*, about 1837. Hand-colored woodcut

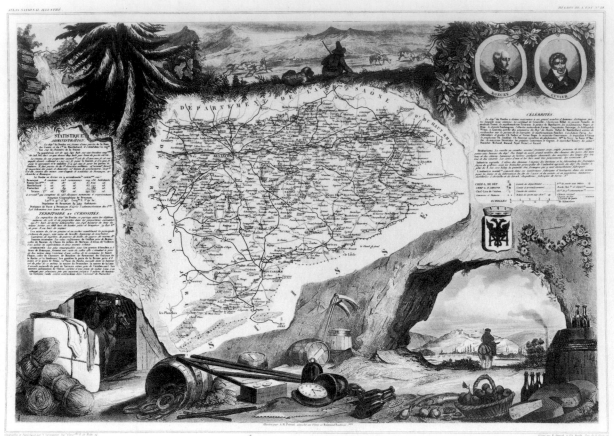

DÉPᵀ DU DOUBS.

39. E. GREZEL and CHARLES SMITH, after A. M. PERROT and RAIMOND BONHEUR
Département du Doubs, 1856. Engraving

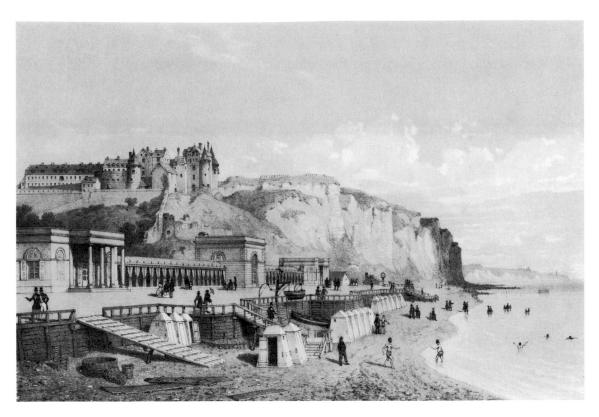

40. ADOLPHE MAUGENDRE
Dieppe, View of the Bathing Beach. Color lithograph with additional hand-coloring

mountain and forest that might have been extracted from the *Voyages pittoresques*, but they have become decorations, emblems of the local scenery, just as the goods at the bottom of the picture are emblems of local industry and manufacture. Compared to the *Voyages pittoresques*, the *Atlas national illustré* could almost be taken as a symbol of the change in travel; turning over its pages we cross the whole of France but catch only a glimpse of each province from our train window. The *Voyages pittoresques* trundles us slowly through the landscape and the journey is never done, but we see far more along the way.[47]

A view of Dieppe by Adolphe Maugendre (FIG. 40), probably dating from the 1850s, is another popularization of Romantic topography. Evidently part of a small portfolio of prints depicting the city and its environs and published there, the image lies halfway between the *Voyages pittoresques* and a picture postcard. It is an early example of tourist art, just as the landscape it depicts is an early tourist landscape: male bathers march boldly down to the sea and amuse themselves in the water, while in the distance a woman is carried into the water, presumably to be dipped for medicinal purposes rather than for pleasure. Castle and cliffs form a dramatic backdrop to the scene, but they inspire no more awe than the trim little bathing pavilion on the esplanade.

At the same time that Romantic scenery was becoming a convention of popular and tourist art in painting and printmaking, a group of artists in a new medium were rediscovering the landscape of France in the same spirit that had possessed the lithographers of the 1820s. It may seem paradoxical to compare the landscape photographers of the 1850s and 1860s to the printmakers of a generation earlier, rather than to those of their own time. But the history of photography does not follow the same course as that of painting, and in many ways the situation of photography in 1850 was similar to that of lithography in 1820. The invention had existed in one form or another for over a decade, and a large number of landscapes had been made using both daguerreotype and paper photography. But by 1850 technical improvements were making it possible for the first time in France to produce richly toned photographs on paper with consistent success.[48] Like lithography, photography was a new and more flexible means of reproducing images; unlike lithography it was also a wholly new way of turning the real world into an image, with a new set of advantages and limitations. For the photographer unexplored territory meant

82

41. ALPHONSE DAVANNE. *Cascade in the Pyrenees*, late 1850s. Photograph

not just the faraway and exotic, but the entire visible world. The dramatic landscape of the Romantics was only one among the many ways of approaching nature that photographers utilized. In the period between 1850 and 1870, some photographs suggest parallels to the Romantic art of the 1820s, others resemble the landscapes of the Barbizon school, and still others have affinities to early Impressionism. A comparison of *Cascade in the Pyrenees* (FIG. 41) and *Etretat—Côte d'Amont, the Cauldron* (FIG. 147), both by Alphonse Davanne, shows how a single photographer could touch Romanticism in one print and Impressionism in another.

Cascade in the Pyrenees takes advantage of a piece of spectacular scenery. The brilliant white of the waterfall draws us into the distance, past the fragmentary elements of the foreground and across the chasm that lies between us and the fall. Davanne has used the fact that his negative could not render the texture of the rushing water to set up a dramatic contrast between the white cascade and the black silhouettes of pine trees in the foreground.

Charles Nègre's projected album of photographs *Le Midi de la France* is analogous in some respects to the *Voyages pittoresques.* Nègre traveled to the south of France in 1852 with the aim of recording not only the architecture of the region but the land and its inhabitants. The spirit of his project was not far from that of Nodier and Taylor:

Being myself a painter I have worked for painters, following my personal tastes. Wherever I could dispense with architectural precision I have produced the picturesque; I sacrificed a few details if necessary in favor of an imposing effect suited to giving the monument its true character and to preserving the poetic charm that surrounds it.[49]

Nègre was willing to wait hours for the right effects of light and shadow on a building and to suppress details by retouching his negatives. In *Avignon—West Side of the Palace of the Popes* (FIG. 42) he produced a composition in broad masses of light and shadow, the massive verticals on the left balanced by the equally massive projecting wing at the right. The rhythms of light and dark in the photograph correspond to the rhythms of the building's architecture. The pattern of cast shadows at the lower right was evidently calculated to enliven what would otherwise have been too large an area of white. One can imagine Nègre patiently waiting for the right moment as the shadows crept across the

42. CHARLES NÈGRE. *Avignon – West Side of the Palace of the Popes,* 1852. Photograph

43. LOUIS ALPHONSE DE BRÉBISSON. *Ruins of the Château de Falaise*, 1851. Photograph

ground. The texture of the stonework is visible in neither the sunlit areas nor the shadows, and the result is a sensation of blinding Mediterranean sunshine, precisely the type of light natural to the south of France.

In *Ruins of the Château de Falaise* by Louis Alphonse de Brébisson (FIG. 43), a subject typical of the *Voyages pittoresques* is shown in a less Romantic vein. By the 1850s medieval architecture had been so extensively depicted in prints that it was no longer particularly exotic as subject matter. Brébisson was not depicting some faraway, inaccessible ruin but one of the sights of his native town, and he showed it as an everyday part of the landscape — a building like other buildings. The photograph's strong rendition of texture helps to unite the castle with its setting; the masonry of the castle, the rocks on the hillside, and the slate roofs of the houses below are clearly individualized, but equivalent in significance.

For Edouard Baldus, the construction of a major railroad line in the mid-1850s provided a challenge analogous to the documentation of vanishing architecture for the Romantics of the 1820s.[50] The railroad in Baldus's *Album des chemins de fer de Paris à Lyon et à la Méditerranée* is no longer the toylike novelty of the 1830s but a vital means of linking the nation together. The album glorifies the heroic feats of engineering represented by tunnels and bridges. Baldus did not attempt to make these structures look picturesque; instead he overawes the viewer with their mechanical precision and unrelenting linearity. For the *Viaduct at La Voulte* (FIG. 44) he positioned his camera so that the new bridge appears to span the entire town, its stern precision contrasting with the irregularity of the old buildings. Even when he was not depicting the railroad itself but views of the neighboring countryside, Baldus's compositions appear sometimes to have been influenced by the forms of railroad architecture. As he shows it, the city wall of *Aigues-Mortes* (FIG. 45) is not a poetic relic of the past but a triumph of medieval engineering, an architecture as functional as a railroad bridge. The endless horizontals that appear so often in his views of the railroad recur here, and Baldus emphasizes them by cropping the wall at the tower in the foreground, just where in reality it turns a corner. To the viewer, it seems that the wall must run on forever beyond the edge of the picture.

As a network of railroads spread out from Paris, linking it with formerly inaccessible regions, the high mountain peaks remained the last unexplored

44. EDOUARD BALDUS. *Viaduct at La Voulte*, about 1855. Photograph

45. EDOUARD BALDUS. *Aigues-Mortes*, about 1855. Photograph

territory within the borders of France. Mountain climbing developed as a sport in the mid-nineteenth century, in part no doubt just because it offered some of the challenges and dangers that had vanished from ordinary travel. When France annexed the province of Savoy in 1860, adding the Alpine range of Mont Blanc to its territory, nationalism provided an extra impulse to explore and depict mountain scenery, and during the 1860s several French photographers made expeditions there.[51]

Adolphe Braun's panoramic view, the *Station des Grands Mulets* (FIG. 46), is taken from a point halfway up Mont Blanc. This landscape of rock and snow is devoid of familiar landmarks; an alien world which man can penetrate only temporarily. Braun's composition, a huge serpentine band of white zigzagging between the darkness of rocks and sky, lacks the reassuring stability of verticals and horizontals, and accentuates the unfamiliarity of the landscape. Only the presence of a group of mountain climbers posed around a crude shelter orients us. Dwarfed by the landscape and yet triumphant in challenging it, they point up the photograph's theme of exploration, just as, compositionally, they provide a focus for the grand sweep of the composition and establish the scale of their surroundings.

By comparison with Braun's tumultuous composition, Charles Soulier's *Mont Blanc* (FIG. 47) is stable, almost classical. The horizontal format contradicts our stereotype of mountains as vertical elements of nature; the length of the mountain range is even more impressive than its height. Like Sabatier (FIG. 15), Soulier reveals the vastness of his landscape by leading us gradually up to it past a succession of ever higher ranges, but his progression is even more effective because of the photograph's magnificent control of tone and atmospheric perspective. Each range of rock, slightly fainter than the last, recedes further from us, and the line of cloud just in front of Mont Blanc itself is a final confirmation of its distance and size.

In the second half of the nineteenth century, even mountain climbing began to take on the trappings of tourism. In 1880, the shelter at the Station des Grands Mulets was no longer a simple hut, but a group of well-constructed cabins where the climber could find firewood, cooking facilities, a change of clothing, and a comfortable bed.[52] The climber of Mont Blanc, like the tourist in front of the Château Gaillard, could still experience awe and wonder, but his experience was no longer that of discovering the unknown.

46. ADOLPHE BRAUN. *Station des Grands Mulets, Savoy,* 1860s. Photograph

47. CHARLES SOULIER. *Mont Blanc, Savoy,* 1869. Photograph

Insatiable vampire l'eternelle Luxure —
Sur la Grande Cite convoite sa pature.

48. CHARLES MERYON. *The Vampire*, 1853. Etching and drypoint

The Urban Maelstrom & The Pastoral Oasis

WHILE THE ARTISTS of the *Voyages pittoresques* were exploring the picturesque aspects of both city and country, another vision of landscape was developing in which the contrast between city and country would be a major issue. Such artists as Théodore Rousseau and Charles Daubigny virtually ignored the city in their paintings and prints; and their depiction of the countryside as a pastoral refuge was a tacit rejection of the contemporary urban environment. For them the city was a place of trauma, turmoil, and despair, from which one escaped, if possible, to the country. The corresponding image of the city seldom appears in paintings, but it is abundantly described in literature and powerfully expressed in prints, most notably of Charles Meryon.

THE URBAN MAELSTROM

When Victor Hugo described Paris as a maelstrom in his novel *Les Misérables* (1862), the word was evidently meant to evoke awe and horror in the reader.[53] Like the legendary whirlpool, Paris was a vast and terrible force where the individual could vanish without a trace. Between 1830 and 1860, first writers and later artists came to visualize the city as inhuman, dangerous, and unstable. This conception arose in part because of actual physical changes taking place in the urban environment, but even more because the middle-class view of life in the city was changing. As more came to be known about the urban problems of poverty, crime, and hygiene, it seemed to the middle-class city dweller that an abyss was opening beneath his feet, and he read about it with a horrified fascination, whether in a factual report like A. J. B. Parent-Duchatelet's study of prostitution[54] or in a novel of crime like Eugène Sue's sensational *Les Mystères de Paris* (1842-43). The themes of violent drama and

93

horror, which early Romantic writers had found in distant times and places, were transferred to the here and now in the novels of Sue and Balzac. And Victor Hugo, who had depicted medieval Paris in his novel *Notre Dame de Paris*, turned his attention to the modern city in *Les Misérables*.

Meryon's etching *The Vampire* (FIG. 48) links the medieval to the modern city. At first glance its theme seems to be that of the prints in the *Voyages pittoresques* — the architecture of the Middle Ages in the context of its surroundings. Two Gothic monuments — the demon in the foreground and the Tour Saint-Jacques in the distance — rise out of a sea of rooftops and chimney pots. The inscription endows the carved demon with life:

> *That insatiable vampire, eternal Lust*
> *Above the great city, covets what will nourish it.*

Fantasies about demons and vampires are part of the stock-in-trade of Romanticism, but Meryon's image is firmly linked to the city of his own day. The vampire itself is not an ancient carving but a new one, added to the cathedral of Notre-Dame only in 1850.[55] Meryon's inscription links it intimately to the modern city below, an urban mass that stretches out to the horizon. The demon is not merely Lust as one of the Seven Deadly Sins of traditional Christian theology, but Lust as the presiding genius of the modern city.[56] Meryon was probably thinking of the reduction of sexual relations to commercial exchange, the world of prostitute and courtesan that novelists from Balzac to Zola emphasized as a central aspect of urban life. A much later print by Felicien Rops, *Satan Sowing Evil Grain* (FIG. 49), makes the same point still more blatantly. Rops's gigantic Satan strides across Paris and plants one foot firmly on the towers of Notre-Dame as he scatters naked women from his pouch. The Devil is not merely a bird of prey brooding over the city, he is its undisputed lord, and the church — traditional Christianity — is no refuge against his power.

The opening print in Meryon's projected set of etchings of Paris shows yet another demon, flying above the towers of the Palais de Justice.[57] Meryon ended the accompanying poem of twenty-one lines by declaring that:

> *The wicked creature,*
> *origin of Evil,*

94

49. FELICIEN ROPS. *Satan Sowing Evil Grain*. Soft-ground etching

has chosen his home
in our fair city.
It's really a serious matter,
and sadly I engrave
that to exorcise him
we would have to tear it down.[58]

The poem's tone is one of black humor, and it is an ominous prelude to a set of views of Paris, especially since it was meant to be followed directly by the more serious image of *The Vampire*.

Like Meryon's art, novels and stories about Paris in the first half of the nineteenth century seem to have been peculiarly haunted by demons and quasi-demons. An essay by Jules Janin, opening a collection of various writings about the city, invokes the devil Asmodeus who can lift up the roofs of houses and see what is going on inside them.[59] In the modern city where people live close together knowing nothing of each other's lives, such a power was irresistibly tempting to the imagination. Certain human characters seem to share Asmodeus's power: the arch-criminal Vautrin, who appears in several of Balzac's novels, has an almost superhuman ability to penetrate the lives of his associates and enemies and to manipulate them for his own purposes. In the novel *Splendeurs et misères des courtisanes* Vautrin's power takes on a sexual aspect as well, as he controls the wealthy Baron de Nucingen through the beautiful courtesan Esther. The operations of the police in Balzac, however, are equally reminiscent of the all-seeing Asmodeus, and it is appropriate that Vautrin ends his career by changing sides and becoming a police agent.[60]

Balzac and Meryon were obviously fascinated by the diabolical qualities that they found in the city. An English critic wrote that Paris is Hell for Balzac, but Hell is the only place to be.[61] As the center of French intellectual, political, and economic life Paris never ceased to be attractive. Even those who were bewildered by the economic and social upheavals that accompanied the rise of capitalism in the 1830s and 1840s were fascinated by Paris as the place where the transformation of society could be most clearly observed.

Industrial capitalism, as the force most responsible for that transformation, was easily seen as the presiding devil of the Parisian Hell, both by those

50. ALPHONSE CHIGOT. *The Stock Exchange*, 1857. Lithograph

51. FRÉDÉRIC BOUCHOT
The Elephant of the Bastille: "There is a monument that seems a bit useless."
"Useless! It provides housing for more than forty-five thousand rats!" 1844.
Hand-colored lithograph

who looked back to the stability of "before the Revolution" and those who looked forward to a socialist utopia. The French Revolution had broken down governmental regulation of competition and of relations between masters and workmen, and set the stage for a period of anarchic economic struggle in which fortunes could be gained and lost with bewildering swiftness.[62] Balzac's Baron de Nucingen, whose wealth is built on a series of cleverly arranged bankruptcies that ruin his creditors, is a more repellent figure than the avowed criminal Vautrin.[63]

The Stock Exchange by Alphonse Chigot (FIG. 50) brings us face to face with the demon of Capital. A parody of Jacques Callot's seventeenth-century etching *The Temptation of Saint Anthony,* the print shows a frenzied crowd of speculators besieging the Stock Exchange, lured on by Devils who fish for them with bags of gold as bait. The foreground presents a series of images of poverty and catastrophe, involving members of all classes of society, while the ragpicker in the center, flinging up one hand, appears to present the whole scene to the viewer. The ragpickers, who gathered the refuse of the city and made their living by reselling it, were symbolic not only of poverty and misery in their own lives but also of the decay of all material wealth and goods, since everything would eventually come to them as refuse.

The unrestrained expansion of the Capitalist economy was paralleled by the unrestrained expansion of the physical city. Paris's population fairly doubled between 1801 and 1846, from about 500,000 to over a million.[64] The increase, most of it accounted for by immigrants from the country in search of work, was fit into a city which still remained within its pre-Revolutionary boundaries. The empty spaces on the outskirts, within the customs barriers, soon filled up: the Quartier Saint-Denis, where Monnier had shown his picnickers (FIG. 6) in the 1820s, was largely built up by 1835.

For the wealthy, whether old aristocracy or newly rich capitalist, Paris held many pleasures. The wide streets, known as the Grands Boulevards, encircling central Paris on the right bank of the Seine were the territory of the fashionable world from the 1820s onward, and the luxury of the shops and restaurants along this chain of streets was proverbial. But this was only one small area in a city that as a whole was unable to cope with the rapid influx of people from the countryside. The urban facilities that improved most strikingly between 1820

and 1850 were those which benefited the middle and upper classes, not the poor immigrants. As Louis Chevalier has noted:

It was easier to build palaces, churches, mansions, theatres, markets and bridges than waterworks, sewers and cesspools, easier to adorn and even light the city than clean it, easier to embellish its face than to sound its depths.[65]

The governments of the Restoration and the July Monarchy had all they could do simply to finish some of the monuments planned and begun under Napoleon, and even these were not all carried out. The elephant of the Bastille (FIG. 51), a plaster mock-up for a colossal sculpture planned by Napoleon I, was left to deteriorate for two decades before finally being cleared away.[66] As the two gentlemen in the caricature observe, the elephant's sole function was to serve as housing for a vast population of rats, but Victor Hugo, in *Les Misérables,* gave the rats a human fellow tenant: the street urchin Gavroche makes his den inside the elephant. Hugo poetically contrasts the grandiose scheme of Napoleon with the unintended use that his project has found, sheltering a waif who is uncared for by any building or institution designed for the purpose.[67] On a more superficial level, Chigot's caricature contrasts the imposing building of the Stock Exchange (another construction of Napoleon) with the human refuse around it. The contrasts of splendor and disorder, extreme wealth and poverty, of the period 1820 to 1850, that are emphasized again and again in *Les Misérables* and in Balzac's novels were characteristic of a city where narrow streets and squalid housing filled the central district, juxtaposed with such ancient monuments as Notre-Dame and the Louvre and encircled by the brilliant and luxurious shops and theaters of the Grands Boulevards.

It is perhaps no accident that photographers rather than printmakers were the first to emphasize the unattractive or disorganized surroundings of urban monuments. The allseeing eye of the camera would not suppress ugly details, and while photographers could obviously minimize them by choice of vantage point, some of them may have made a virtue of necessity by including the context of a monument or even using that context as the primary basis for a composition. Hippolyte Bayard's photograph of the roofs of Paris (FIG. 52) dating from 1845 presents the same chaotic sea of chimneys and rooftops that would later appear in Meryon's *Vampire,* but here the roofs form the entire

52. HIPPOLYTE BAYARD
The Rooftops of Paris (seen from the Rue Castiglione), 1845. Photograph

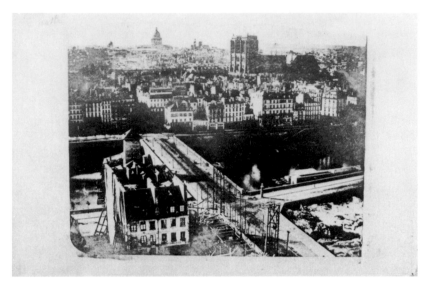

53. HIPPOLYTE FIZEAU
Paris, the Ile de la Cité. Heliogravure (Fizeau process) from an anonymous daguerreotype

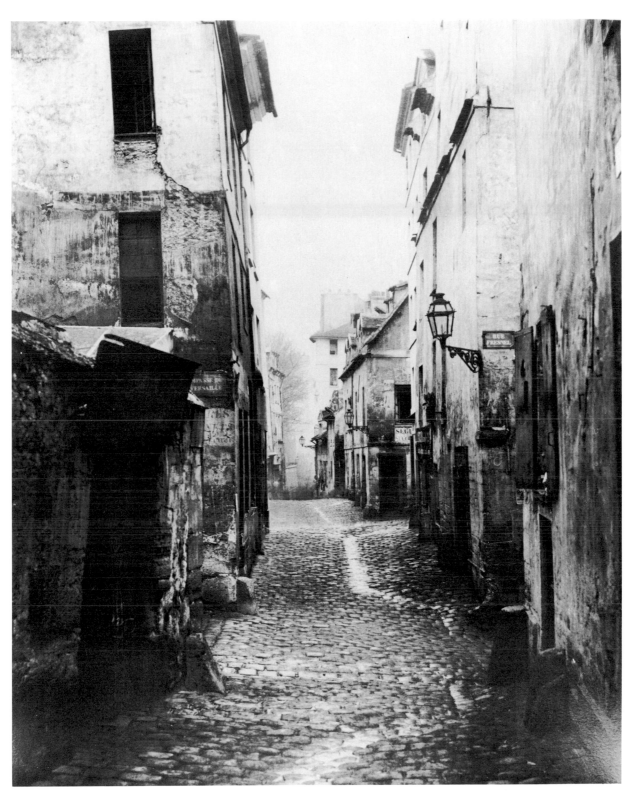

54. CHARLES MARVILLE. *The Rue Traversine*, about 1865. Photograph

composition, with only the minor accent of the Vendôme Column breaking the horizon. Bayard's photograph, while it suggests the vast expansiveness of the nineteenth-century city, actually represents the well-to-do district around the Place Vendôme. A tiny heliogravure by Hippolyte Fizeau after an anonymous daguerreotype (FIG. 53) shows the Ile de la Cité, the heart of Paris, which was now deserted by its former middle-class inhabitants and become an impoverished and dangerous neighborhood. In 1840 a government commission reported that "its alleys and dead-ends are the haunts of most of the released convicts who flock to Paris."[68] The heliogravure, which is taken from the Tour Saint-Jacques, looks back toward Notre-Dame, reversing Meryon's view in *The Vampire,* and shows the cathedral hemmed in by an ant heap of densely packed houses. The streets in districts such as this one dated back for the most part to the Middle Ages and were completely inadequate to the population density of the nineteenth century. For every hundred yards of spacious boulevard there were miles of streets like the Rue Traversine (FIG. 54). Charles Marville's photograph, one of several hundred taken in the 1860s to record streets that were disappearing as a result of the reconstruction of Paris, makes an attractive composition; Marville was sensitive to the picturesque qualities of the old Paris, as well as the amenities of the new one (see FIG. 119).[69] If we look closely, however, we can see the difficulties a street like the Rue Traversine presented to those who used it in the nineteenth century. It would have been well suited to a medieval city without much wheeled traffic, but a carriage would sway uncomfortably from side to side as it adjusted to the shifting tilt of the roadway. Without a sidewalk, the street gives no protection to pedestrians except for the precarious shelter of the stone blocks at the doorways and the corners of buildings. The only provision for cleaning the street is the central gutter, without drains. Early nineteenth-century accounts emphasize the filth that accumulated in such streets; in the narrowest ones the sun never penetrated to dry out the muck.[70] The comparative cleanliness of the Rue Traversine would have been exceptional in the 1820s, 1830s, and 1840s.

If the streets of central Paris were inadequate, facilities for water and sewage were even worse. The appearance of cholera in the city, in 1832, called dramatic attention to health problems, which the growing population and density of housing were exacerbating. In a caricature by Daumier (FIG. 55), the determined fisherman who stands in the water next to an open sewer is a

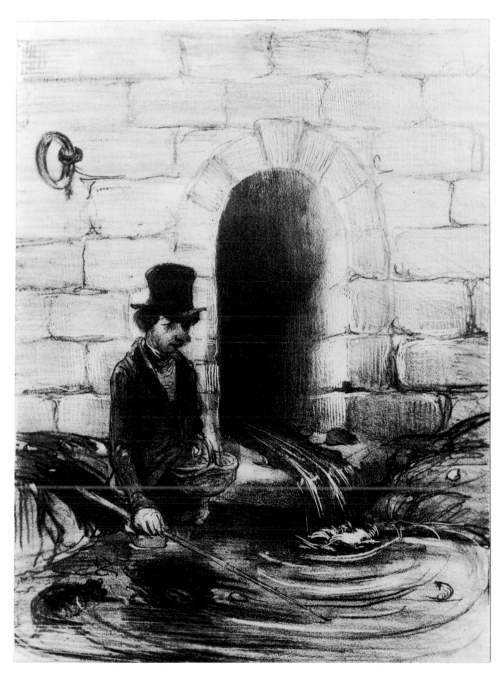

55. HONORÉ DAUMIER. *The Determined Fisherman*, 1840. Lithograph

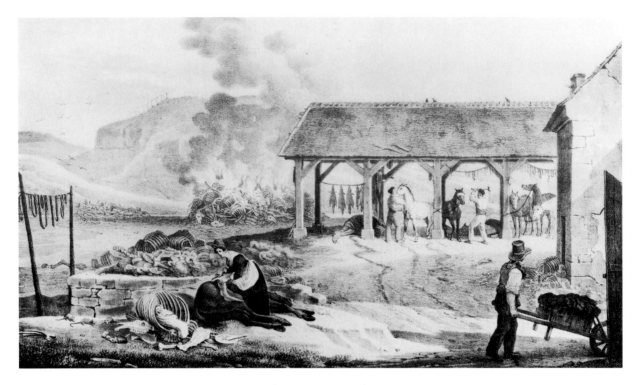

56. J. G. V. DE MOLÉON
Details of Some of the Slaughterhouse Operations at Montfaucon, 1828.
Hand-colored lithograph

figure of ridicule, but his condition is not much worse than that of the Parisian whose drinking water came from the Seine, pumped from the middle of the channel while raw sewage flowed into the river from both banks.[71]

One of the worst health problems was presented by the district of the Buttes-Chaumont and Montfaucon. From the Middle Ages to the eighteenth century this area just outside the customs barriers to the northeast of Paris had served as a place for executions. By the early nineteenth century, although there was no longer a gallows hung with decaying corpses at Montfaucon, it had been replaced by cesspools and horse-butchering yards that spread an even more noxious odor over the surrounding countryside.

As early as 1827 concern was growing about the unsanitary conditions in the slaughterhouses, and a report on them was made by a governmental commission whose secretary, A. J. B. Parent-Duchatelet, was to become the leading authority on sanitary problems.[72] An illustration to the report (FIG. 56) gives some idea of the primitive arrangements, although details like the burning carcasses in the distance, the baby sleeping in a horse skeleton, and the gigantic rats close by give only a faint idea of the horrors described in the report. The stone quarries, which were the district's other industry, likewise had a sinister reputation as the haunt of fugitives from justice.

Despite repeated studies and reports, no solutions were found to the pollution of the district; with an increasing population of both human beings and horses, the situation could only get worse. Ironically this area was adjacent to the regions that the city dwellers of the middle and working class habitually visited for fresh air on holidays—the villages of Belleville and Romainville, where Paul de Kock's shopkeeper and his family had gone for their country pleasures, were among the communities that protested most vigorously, though in vain, about the noxious odors from Montfaucon.[73]

The slaughterhouses and cesspits were shunned by most artists, but Auguste Péquégnot did manage to suggest the shadow that lay over the district in an etching of 1846 (FIG. 57). Péquégnot's is a vision of death rather than pollution; the white cliffs of the quarries rise like ghosts out of the desolate landscape, the skinny horses and circling birds evoke the tragic aspect of the slaughterhouses without emphasizing their revolting qualities, and the tall pole silhouetted against the sky would remind any historically aware viewer of the corpses and skeletons which had once dangled there.

107

57. AUGUSTE PÉQUÉGNOT. *Old Montfaucon.* 1846. Etching

58. ALPHONSE LEGROS. *The Brick-Works*, about 1860. Drypoint

The quarrying district of Montrouge, on the southern border of Paris, was less sinister than Montfaucon but equally desolate. *The Brick-Works* (FIG. 58) is one of a group of early prints by Alphonse Legros which depict this industrial landscape, neither city nor country. Rather than looking for a picturesque aspect to his subject, he seemed to delight in its bare ugliness, which is accentuated by the savage, scratchy draftsmanship of the print. The choice of such a subject, exceptional at the time, was in keeping with the sombre view of life in his later depiction of peasants (see FIGS. 96 and 97).

The unpleasant aspects of city life affected all who lived in the city, but pressed especially hard on the working class. During the first half of the nineteenth century workers were unable for the most part to form effective organizations to protect their rights, and thus were at the mercy of economic fluctuations.[74] The influx of workers from the country kept wages low, and the demand for housing gave landlords little incentive to improve or maintain their property. The poorest workers were forced into the most dangerous work and the most undesirable neighborhoods.[75]

Middle-class citizens were repelled by the horrifying conditions of extreme poverty that reports and novels depicted, and this feeling interlocked with another, a fascination with crime and the life of the criminal. To the middle class, poverty and crime seemed more intimately associated than in the past. The old stereotype of the criminal as a picturesque or monstrous villain detached from ordinary society, gave place to the notion of a criminal element permeating society and melting imperceptibly into the poorest of the working class.[76] In Sue's *Mystères de Paris*, unregenerate criminals rub shoulders with other characters who move back and forth between virtue and crime.

Urban crime was felt to be increasing in the first half of the nineteenth century, and urban conditions facilitated it; narrow, badly lit streets like the Rue Traversine offered countless opportunities for ambush and violent robbery. The typical form of this crime is shown in Daumier's *"What time is it, please?"* (FIG. 59) – street robbery like this, or the middle-class fear of it, is the theme of most of Daumier's cartoons of the 1830s and 1840s which deal with crime.

The theme of crime was the mainstay of a whole species of popular print, called the *canard*, which flourished from 1820 to 1850. A *canard* was effectively a one-sheet, one-story, one-issue newspaper, describing some sensa-

59. HONORÉ DAUMIER. *"What time is it, please?"* 1839. Lithograph

BANDE A L'ESCARPE DITE DES ETRANGLEURS.

Jugement rendu par la Cour d'assises de la Seine, qui condamne une Bande de redoutables scélérats, comme coupables, 1° d'avoir nuitamment arrêté et volé le sieur Argant en le saisissant à la gorge; — 2° d'avoir arrêté, et lui appliquant un poignard sur la poitrine, le sieur Baptiste Loin; — 3° d'avoir arrêté et volé une personne rue des Petites-Ecuries, en lui portant deux coups de couteau dans le dos; — 4° d'avoir arrêté, bâillonné et volé M. le marquis de Gastria, rue d'Anjou-Saint-Honoré; — 5° d'avoir commis un vol des plus audacieux chez un marchand de nouveautés, boulevard du Temple; — 6° d'avoir commis un crime avec une audace sans exemple, rue Olivier, — le frappant de plusieurs coups de couteau; — 7° d'avoir attaqué deux fois le sieur Nicolas, conducteur d'omnibus et de l'avoir frappé de plusieurs coups de couteau; — 8° d'avoir arrêté et volé le sieur Poterlo de Reims, rue de la tiquette, après avoir tenté de l'étrangler; — 9° d'avoir dévalisé un individu aux abords du canal Saint-Martin; — 10° d'avoir commis un crime sur la personne de Carteron, rue d'Anjou, au Marais; — 11° d'avoir commis un horrible assassinat en noyant un homme dans le canal Saint-Martin; — 12° d'avoir arrêté et volé M. Favre, médecin; — 13° d'avoir arrêté, bâillonné et volé une dame près des Invalides. — Noms et prénoms des accusés et leur interrogatoire. — Audiences des 26, 27, 28, 29 et 30 novembre 1844.

60. ANONYMOUS. *The Group of Bandits Called the Stranglers*, about 1843.
Woodcut broadside

tional event and illustrating it with bold woodcut illustration. Unlike earlier popular prints, *canards* were normally left uncolored and the stark black-and-white woodcut adds power to the frightening events that were usually depicted. One of the few forms of art directed specifically to the working class, the *canard* is comparable to popular literature like theatrical melodrama and the serial novels of Eugène Sue, where crime also has a prominent role.[77] But while Sue's *Mystères de Paris* gave a real insight into the landscape of crime and its new social form, the *canards* for the most part dwelt on isolated spectacular crimes of passion. *The Group of Bandits Called the Stranglers* (FIG. 60) is an exception, both because it deals with the new social crime — an organized band of robbers specializing in night attacks — and because its woodcut actually provides a kind of cityscape. Flanked by portraits of the gang and by trophies emblematic of the judge and the executioner, these two street scenes are all the more evocative for their crudity. On the left, walls of buildings hem in the victim on both sides, echoing his two assailants; on the right the black waters of the Canal Saint-Martin are about to receive the body of another victim. In both, the blank building facades, cutting off the sky and pierced with windows that are simply black spots, suggest an unresponsive environment from which no help can be expected.

The inability of urban society at this time to protect individuals over-powered by hostile forces is a factor in another form of violence. Suicide was felt to be increasing at an unprecedented rate in the early nineteenth century, especially among the working class. New immigrants from the rural areas were faced with a bewildering new world and tremendous difficulties in maintaining a stable life. Simultaneously they were disconnected from the communal support of family, village neighbors, and church which might otherwise have helped them.[78] But it was not only the poor who were deprived of the support of society; its indifference to the artist or poet is an incessant theme of nineteenth-century literature.

Perhaps the most famous artist-suicide in mid-nineteenth-century France was that of the poet Gerard de Nerval, who was found hanging in the Rue de la Vieille Lanterne in 1855. The macabre setting of the event, one of the narrowest and most sinister-looking streets of central Paris, provided Gustave Doré with the motif for a spectacular lithograph (FIG. 61). Nerval's writing continually evokes a Romantic world combining childhood memories,

61. GUSTAVE DORÉ. *The Rue de la Vieille Lanterne,* 1855. Lithograph

62. LÉOPOLD FLAMENG. *The Rue de la Vieille Lanterne*, 1859. Etching

legends, and dreams, and in his own life the boundaries between dream and reality broke down in periodic episodes of madness. Doré gives us a confrontation between ideal and sordid reality. Death carries off the soul of Nerval into an ethereal world evoking both the afterlife and the dreams of Nerval's fiction, but the actuality remains the poet's middle-aged, corpulent body, tongue protruding, dangling by a cord from a window grating. Nerval's death gave the Rue de la Vieille Lanterne a celebrity that caused at least two other artists to depict it. Célestin Nanteuil produced a more or less objective view of the street—its narrowness and darkness seem to have been dramatic enough without any romantic exaggeration. Léopold Flameng's etching (FIG. 62) was probably based on Nanteuil's print, for it was made several years after the Rue de la Vieille Lanterne had been destroyed. The print was published in 1859 as part of a series, *Paris qui s'en va et Paris qui vient (The Paris that Is Disappearing and the Paris that Is Coming to Be)*, and is a memorial not only to Nerval but to the street itself and the bad old Paris which was now passing away.

Flameng took for granted the street's main claim to fame and chose to emphasize the criminal activities for which it and neighboring streets were also notorious. Close to the spot where Nerval had died a violent robbery or murder is taking place, and the text which accompanies the print goes so far as to suggest that Nerval himself may have been the victim of a criminal rather than a suicide.[79]

Crime and suicide were everyday products of life in the city; revolt and revolution were rarer but more deeply disturbing experiences. At times, as in 1830 and in February of 1848, revolt was a protest in which workers and the middle class joined forces to overthrow an unpopular king and his government, but such unity could easily give way to antagonism as the two groups, their initial goals achieved, were unable to agree on the next step. The most traumatic confrontation between classes occurred in the June Days of 1848 when the workers, dismayed that the government newly set up in February was unresponsive to their needs and that a program designed to provide work for the unemployed was terminated, threw up barricades throughout Paris. To the middle class this revolt may have seemed the ultimate expression of the infernal city—a mass of unknown desperate figures associated with poverty, filth, disease, and crime rising up against civilized society. The revolt was brutally suppressed by army units brought in from outside Paris, and the

63. ADOLPHE HERVIER. *Barricade, June 1848.* Etching and drypoint

conservative reaction that it provoked was a major factor in the election of Louis Napoleon as president in December. (Two years later he would establish himself as the Emperor Napoleon III by a coup d'etat.)[80]

Most images of the June Days show the revolt from the middle-class point of view—the troops from the provinces putting down the rebellion with military precision. Adolphe Hervier's etching of a barricade on the Rue Saint-Jacques (FIG. 63) is an exception, a Goya-like evocation of the horrors of civil war, seen from the point of view of the rebels. Hervier's own political sympathies are not known, but the print suggests a mixture of sympathy for and revulsion from these haggard, emaciated figures, crouched on a barricade and trapped by the cross fire of an enemy invisible in the smoke. Hervier's figures are always ugly to the point of caricature, but what is merely quaint in his other images becomes shocking here. The kettle on the fire (presumably to melt lead for bullets) adds a macabre air of domesticity to the scene, in combination with the bottle stuck in the rocks behind and the dead or dying woman nearby. The glimpse of street and buildings at the upper left reminds us of the Rue de la Vieille Lanterne as seen by Flameng, or even the sinister cityscapes of the *canard*. The scene is infernal, but its inhabitants are the damned, not demons.

It is in Charles Meryon's prints that the negative vision of the early nineteenth-century city is most effectively transmuted into art. Meryon was exceptional among nineteenth-century artists, not for the bohemian existence he led, or even for his final surrender to madness, so much as for the single-minded concentration of his art. Denied a career as a painter by color blindness, he is one of the few major artists whose achievement rests entirely on his prints. He limited himself not only in medium but in range of subject matter: apart from a few reminiscences of early travels to the South Seas and to Greece, his etching concentrated on Paris, and not simply on Paris but on the very central area around the Ile de la Cité, just the area where urban overcrowding, poverty, and crime were most evident. Meryon's prints do not address these problems directly; unlike most of the works discussed up to now they are true cityscapes, not simply background to some horrifying event. But they portray an environment in which it is easy to imagine that event taking place.[81]

Calling Paris a maelstrom and comparing it to the ocean in its capacity to swallow up the individual without a trace, Hugo suggested an image of

64. CHARLES MERYON. *Collège Henri IV*, 1864. Etching

irresistible motion. Meryon's urban maelstrom is not like that; depicted with minute precision, his buildings and walls are crystalline in their motionless solidity. Even so, the *Collège Henri IV* (FIG. 64) suggests a gigantic whirlpool in the endless sea of house roofs which encircles the calm center of the old college and its courtyards. Whether deliberately or not, Meryon seems to have established an opposition between the sheltering world of the school and the engulfing sea of the city beyond.

The *Collège Henri IV* is a late work of Meryon, and its limitless panorama is not characteristic of his work as a whole. More usually, even when seen from above as in *The Vampire*, the view of the city is hemmed in — in *The Vampire* the Gothic monster, the birds, and the oval frame itself give this sense of constriction. More frequently Meryon's vantage point is from down on the ground, glimpsing a monument or simply an old building in one of the narrow streets of the old city. *The Rue des Mauvais Garçons* (FIG. 65) — The Street of Bad Fellows — invites comparison with Marville's *Rue Traversine* or Flameng's *Rue de la Vieille Lanterne*. Unlike Marville's photography, Meryon's etching is not simply an image of a potentially sinister street but a sinister image in itself. Commentators from Meryon's time onward have remarked on the contrast between the bright facade, briefly lit by the almost vertical rays of the sun, and the darkness behind the blank doorways and barred windows. The contour lines and shading, rougher and more irregular than is usual in Meryon's work, and the uneven patches of tone produced on the etching plate by foul biting[82] add to the seedy appearance of these house facades. Without choosing to present a nocturnal view or include a crime, Meryon makes the viewer believe that the street lived up to its name. He could afford to be ambiguous in the verse that accompanies the image, wondering whether it was silent virtue or crime which dwelt behind these facades and advising the viewer if he wanted to know, to go and find out before it was too late. (In 1854, when this print was made, the street was scheduled for demolition to make way for the Rue Gregoire-de-Tours.)[83]

Even when Meryon chose a view of Paris that would naturally favor a sensation of space and atmosphere, he seemed instinctively to avoid these effects. The Seine, running through the heart of Paris and surrounding the Ile de la Cité, introduced a broad open space even when the city was most densely overcrowded, and Meryon frequently took advantage of this fact to get a more

65. CHARLES MERYON. *The Rue des Mauvais Garçons*, 1854. Etching

66. CHARLES MERYON. *The Pont-au-Change*, 1854. Etching

complete view of buildings along the shore than would otherwise be possible. Eight out of the twelve large etchings in the set *Eaux-fortes sur Paris* (which includes most of his best work) are views from the river or the quays that border it. But he preferred the Seine where it is narrowest, divided by the island, and where the quays rise up sharply from the water or bridges arch over it, hemming it in. In *The Pont-au-Change* (FIG. 66) we are given a view straight up the river, potentially the same kind of view that Félix Bracquemond, twenty-five years later (FIG. 98), would turn into an urban apotheosis of atmosphere, rain and sunshine. But Meryon cut off the view into space almost immediately by the bridge, whose arches are blocked in addition by the floating bathhouses. At the right our view is likewise constricted by the steely horizontals of the quay and the massive walls and towers of the Palais de Justice above it. The surface of the river, screened by these two visual barriers, seems dull and cold rather than light and reflective. A balloon christened *Speranza* (Hope) rises into the sky, but the viewer is not up in the air with it; his vantage point is down on the surface of the water where a drowning man is ignored by the boaters who watch the balloon.

The message is a familiar one; illusory hopes and actual failure are the themes of works as diverse as Chigot's *The Stock Exchange* and Doré's *Rue de la Vieille Lanterne*. What is significant about *The Pont-au-Change* is that Meryon buried the events of his drama in a comprehensive cityscape which itself expresses the same message, in its contrast of open sky and sealed-off horizon at our eye level. The insignificance of the figures is in itself a statement about the city, one which the more Romantic images of Chigot or Doré could not make because they focused so closely on its human victims. Meryon's city is vast and indifferent; the tightly drawn, stony facades of buildings are more forbidding than the demons and other strange creatures that sometimes appear in the air above them. Meryon was gifted as few other printmakers have been (Callot and Dürer come to mind) with the ability to combine minute attention to detail with a control of broad masses. This enabled him to create a cityscape that is both desolate and intensely populated—the crowds that flow over the Pont-au-Change are vast but insignificant in relation to the long facades above the quay and the large expanse of water. The drama of the drowning man in the foreground, like the still more dramatic scene in front of

67. HIPPOLYTE BAYARD
The Pont Neuf, the Quays, the Baths "à la Samaritaine"
and the Tour St. Jacques, 1847. Photograph

the morgue (FIG. 68) is presented to the viewer, but we are too far off to help or even sympathize.

Meryon's work has been compared to the photography of his time, and he was unquestionably interested in photography.[84] The point of contact is not the sharp detail of his prints or the harsh contrasts of light and shade which give his works a superficially "photographic" look. Clarity of detail is characteristic of much topographic drawing and printmaking from the seventeenth century onward, and harsh contrasts are as typical of the etching medium as they are of early photography. Rather, the parallels are those of vantage point and composition. Similarities of this sort between Meryon's work and photographic views of Paris by Henri Le Secq have been noted by Eugenia Janis.[85]

Hippolyte Bayard was photographing Paris in the decade before Meryon began making prints of the city, and it is unlikely that Meryon knew his work.[86] Yet Bayard's photograph of the Seine and the Pont Neuf (FIG. 67) shows some interesting similarities to Meryon's later *Pont-au-Change*. On a stretch of the Seine only a few hundred yards downstream from the site of Meryon's print, Bayard selected a composition similar not only formally but in feeling. The quay with the row of densely packed houses above it stretches from edge to edge of the picture, and at the right, where a partial vista upstream might be opening up, the black silhouette of the bridge forms a visual barrier. The Tour Saint-Jacques, on the horizon, is an inexpressive block rising above the jagged roof line of a seemingly endless row of undifferentiated houses. The unpretentious view that Bayard selected is all the more striking when one realizes that from the place where this photograph was taken (evidently the middle of the Pont des Arts) a turn of his camera a few degrees to the right would have created a dramatic vista upstream, with the Ile de la Cité dividing the stream, the statue of Henri IV at the center of the Pont Neuf, and the towers of Notre-Dame rising in the distance. An upstream view such as this had been the logical one for Arnout's picturesque topography (FIG. 33) and would be again for Bracquemond (FIG. 98). Bayard's photograph lacks any of the overtly pessimistic symbolism of Meryon's work, but the image of the city presented here is nevertheless a stern and forbidding one.

The Morgue (FIG. 68), one of Meryon's most famous prints, is also the one which sums up most effectively the vision of the infernal city. This little building, where unidentified corpses found in the Seine and elsewhere in the

city were exposed to public view, is seen from across the Seine, but the sense of a compressed, hemmed-in view is much stronger than in *The Pont-au-Change*. From the narrow strip of water at the bottom of the image to the narrow strip of sky at the top, we are confronted by a series of flat walls of stone, some a little closer, some a little more distant, but all cutting off any real vista. At both sides of the plate the buildings run off the edge, so that there is literally no getting round them. The architecture is a stage backdrop for the minute drama of drowned man and grieving family that takes place on the quay, but unlike a normal stage set, it seems far more massive and real than the actors in front of it. The themes of urban existence that we have seen individually in other prints come together here: the overcrowding, implicit in the densely packed houses no less than in the figures along the quay; the indifference of the crowd and the isolation of the individual in the face of disaster (no one assists the grieving mother and child—she is detached both from the crowd above and from the gendarme who turns away even as he approaches her). The morgue was naturally associated with violent death in many forms; not only suicides but the victims of crime found their way to its tables. In a verse he wrote to accompany the print, Meryon specifically associated the building with poverty and revolution:

> *Come and see, passers-by,*
> *Like a charitable mother*
> *the city of Paris*
> *Always gives a bed and a table here*
> *to her poor children*
>
>
> *When the pitiless insurrection*
> *Roars across Paris*
> *Satan himself shudders*
> *the table is so full!*[87]

The thought of the decaying corpses exposed within the building (itself a former slaughterhouse) evokes the physical corruption and pollution of the city; stains run down the walls of the morgue from the windows, and at the bottom of the print, below the stairs, is the opening of a sewer emptying into the river. Below this again, on the river itself, are laundry barges where women

68. CHARLES MERYON. *The Morgue*, 1854. Etching and drypoint

can be seen at work in the dark, cavelike interiors, washing clothes in the polluted water.

Meryon's etchings of Paris have been compared to the prints of the *Voyages pittoresques*,[88] but comparing *The Morgue* and Bonington's *Rue du Gros-Horloge* (FIG. 31) suggests the gulf that lies between his vision of the city and Bonington's. Superficially the prints have a good deal in common: each gives a vew of a space of moderate size enclosed by buildings and filled with people, and Meryon's figures are only slightly smaller than Bonington's in relation to the size of the print. But Bonington's print exemplifies interaction; Meryon's, isolation. Bonington's composition is a funnel leading the viewer down the street toward the sunlight that gleams through the archway; Meryon's slams the door in our faces, so to speak, with its impenetrable facades. Bonington's figures wander up and down the street and converse with each other; it is easy to imagine them wandering in and out of the buildings, which themselves interact with the street by the awnings and banners that they display. Meryon's figures are isolated both from the viewer and from each other—by the river, by walls, and by the gendarmes who block the stairs. There is no visible street; it can only be guessed that there is one behind the parapet where the crowd gazes down. The reactions of the crowd to the tragedy are individualized but there is virtually no exchange of feeling among them—the crowd is an assemblage of individual solitudes. As for the buildings, figures appear at their windows but do not lean out into the world of the street as they do in the *Rue du Gros-Horloge,* and only one entrance to any building is even visible, the massive, tightly shut door behind a parapet at the top of the steps. There are, of course, other prints by Meryon where the street is not concealed and where buildings have visible entrances, but it is remarkable how frequently his point of view leaves the street to be guessed at—an invisible space behind a parapet or between two rows of housetops—and conceals doorways, making buildings into closed, inaccessible fortresses.

Meryon's career coincided with the transformation of the city that he was depicting. His series of prints *Eaux-fortes sur Paris* (which includes all the prints discussed here except for the *Collège Henri IV*) was produced between 1850 and 1854, during the presidency of Louis Napoleon and the first years of his reign as Emperor Napoleon III. By the time it was completed, the demolitions and reconstructions of Napoleon and his prefect of the Seine, Baron

Haussmann, were already beginning to make major changes in the face of Paris. Meryon's work met with little appreciation during the 1850s; only in the following decade, as it became increasingly clear that he had recorded a vanishing city, did his prints begin to find critical acclaim. In the 1860s and 1870s what might almost be called a Meryon school appeared, etchers who devoted themselves to recording the streets and buildings of Paris, both new and old. But these artists—Adolphe Martial, Gabriel Niel, and others—were disciples of Meryon only in their adoption of his medium and subject matter. Their work did not rise above mediocrity, and certainly it has none of Meryon's gloomy intensity. In any event, the Paris of the sixties and seventies was a new city and could no longer be seen with the same vision. Even Meryon's later work shows a falling off in intensity; in part this may be due to the mental instability of his later years, but it may also reflect a change in his own vision as the city changed around him. We have already noticed the exceptional, panoramic character of the late print, the *Collège Henri IV.*

Of all the later etchers of Paris, the most talented was Maxime Lalanne. An etching of 1863, *Rue des Marmousets (Old Paris)* (FIG. 69), shows clearly how little his vision of the city owes to Meryon. The harsh contrasts of white walls and black windows are there, but the buildings are picturesque rather than threatening. The Rue des Marmousets had a reputation as sinister as any street in central Paris: it was reputed to have housed a barber who slit the throats of his customers and whose neighbor, a pastry cook, made them into meat pies. Some impressions of Lalanne's print carry an inscription which tells this story. But it is a story of medieval criminality—the inscription says nothing of the fact that the Rue des Marmousets was part of the labyrinth of streets on the Ile de la Cité which were still notorious for poverty and crime in the nineteenth century. The etching does not even suggest the legendary crime of the inscription, in striking contrast to Meryon's *Rue des Mauvais Garçons,* where the image is far more sinister than the equivocal verse that accompanies it. Lalanne's houses are at least as dilapidated as Meryon's, but the verve of his shading gives them a quaint air, and they seem to lean back just to let light and air into the street. The street itself is narrow, admittedly, but halfway down it a cross street is flooded with sunlight, and the foreground appears to be a relatively spacious court or cross street. The view straight down the street ends in a complex of buildings which block our view but do not seem impenetrable, and

69. MAXIME LALANNE. *The Rue des Marmousets (Old Paris)*, 1862. Etching

70. MAXIME LALANNE
Demolition for the Creation of the Boulevard Saint-Germain, 1863. Etching

above there is a generous glimpse of sky. In contrast to Meryon, whose harsh lighting seems cold and gray even when it appears to indicate full sunshine, Lalanne described weather conditions with a precision that only the Impressionists would surpass.

One of Lalanne's finest etchings, appropriately, records the demolition of a group of buildings on the left bank of the Seine: *Demolition for the Creation of the Boulevard Saint-Germain* (FIG. 70). Here indeed there is a note of something sinister: the dark heap of refuse in the foreground and the silhouette of the house at the right. These elements are only foils, however, to set off the real subject of the print, the vast space opening up in the middle distance to make way for the new boulevard. The dilapidated house and the tower of scaffolding at the left are gateposts through which we look from the shadowed, ruinous foreground to the brilliant sunlight of the more distant facades. Although the distant houses are ruinous as well, Lalanne's delicate shading dissolves them in the sunlight—immaterial buildings that can easily be swept away if a new street or open space is wanted. The eternal stones of Meryon's city, against which the tiny figures of his tragic dramas are broken without affecting them in the least, are replaced in Lalanne's by a malleable city, whose structure is modified at will by those who populate it. To a Parisian of the 1860s, with demolition and construction all about him, Lalanne's vision would have seemed to correspond better to reality than Meryon's. As a final touch, Lalanne's vista is terminated not by a somber Gothic tower such as populate Meryon's horizons but by the dome of the Pantheon, a secular temple dedicated to great men and their achievements. Where Meryon had shown man vanquished by his environment, Lalanne implied that human genius is master of the urban maelstrom.

The city in transformation is embodied in Célestin Nanteuil's lithograph *Paris and Its Progress* (FIG. 71), an amorphous personage gathering railways, ships, and people of all nations into its embrace. Houses tumble and dance at the lower right, presumably arranging themselves along new streets. The turmoil of the picture's lower section blends easily into the Graces and cupids above who scatter flowers. The power of the maelstrom to engulf has been replaced by the attractive power of the magnet.

71. CÉLESTIN NANTEUIL. *Paris and Its Progress*, about 1861. Lithograph

72. CAMILLE COROT. *The Mill at Cuincy*, 1871. Lithograph

THE PASTORAL OASIS

*Paris—black, muddy, smoky Paris—made the most painful and discouraging
impression upon me.... The immense crowd of horses and carriages crossing
and pushing each other, the narrow streets, and the air and smell of Paris
seemed to choke my head and heart, and almost terrified me.*

—JEAN FRANÇOIS MILLET[89]

Since ancient times, the pastoral mode in art and literature seems to have arisen
whenever intense urbanization produced massive dislocation of populations,
creating alienation from the natural world and a sense of nostalgia for it.
Many who saw Paris as a place of poverty, disease, vice, and crime tended in
reaction to look upon the countryside as a haven of peace and purification.
Rural life, whatever its actual hardships, achieved a mythic status in the minds
of city dwellers, and this myth of the refuge of the country permeates much of
the landscape art of the mid-nineteenth century. The artists of the *Voyages
pittoresques* had seen France as explorers, selecting special views that a person
would travel to see. Many artists of the next generation chose instead the
scenes that someone living in the country might daily have before his eyes, that
is, if his were the ideal countryside: quiet pastures, groves of trees, farm
buildings, and peaceful rivers. Corot's *The Mill at Cuincy* (FIG. 72) well
illustrates the vision of landscape as an idyllic refuge. In contrast to the
panoramic views of Romantic landscape, Corot achieved a feeling of enclosed,
sheltered space and harmonious order. Everything about the print, from the
almost symmetrical placement of the trees on either side of the still water to the
loose, free-flowing draftsmanship, communicates relaxation and calm. Just as
the gloomy, harsh intensity of Meryon's city views is echoed in the uncom-
promising precision of his line, one could say that Corot's dream of a pastoral
refuge is embodied in the way this tranquil landscape emerges from casual
scribblings with a soft crayon.

The Mill at Cuincy derives from a period when Corot literally fled to the
peaceful countryside, at the time of the revolutionary Paris Commune in 1871:

The misfortune of our country has driven me to take cover under the vault of heaven and the thick shade of trees, and to find the best places for listening to the concerts of the birds.[90]

But the estrangement of Corot and his contemporaries from city life had begun many years earlier. It was to the village of Barbizon, in the forest of Fontainebleau, that artists first traveled in search of a quiet natural world. Théodore Rousseau had visited Barbizon in the late 1820s and rented a studio in 1837, settling there permanently soon after. The outbreak of cholera in Paris in 1849 encouraged Jean François Millet and Charles Jacque to change their permanent residences from Paris to Barbizon, formerly a seasonal retreat.[91] Other visitors included Jules Dupré, Charles Daubigny, and Narcisse Diaz. These artists, city-bred for the most part, came to be known as the Barbizon school. In both their art and their lives, the idea of a tranquil countryside was to serve as balm for a rapidly changing urban civilization.

The role of the pastoral ideal in the landscape of this period is made explicit in two images by minor artists who spent time in Barbizon, François Français and Charles Jacque. In Français's *The Landscape Painter* (FIG. 73) we see a painter at work in the countryside, seated under a tree in the company of a beautiful young woman. This is the plein air artist, painting within the very landscape he portrays. His companion holds an open book, and a lute rests at her feet while she seems to gaze off in reverie. On one level, her presence simply suggests that the pleasures of love are added to the beauties of nature; on another, she is a kind of symbolic muse, the artist's inspiration.[92] Français interpreted the landscape painter's life as a peaceful idyll in the pastoral tradition. Love, music, and poetry inspire the artist, who relaxes in the generous embrace of the natural world. Charles Jacque's *Pastorale* (FIG. 74) recalls the tradition literally, with a young shepherd and shepherdess who enjoy the ease of their idealized, leisurely occupation as they rest in the shade on a bank of earth.

In both images, the fictional dreamworld of pastoral is complete, for artist and for shepherd. Nature is friendly and protective; trees provide shelter and the sun is warm. Work is a pleasurable pastime, and life is the fulfillment of the dream of a "happiness to be gained without effort, of an erotic bliss made absolute by its own irresponsibility."[93]

LES ARTISTES CONTEMPORAINS

PARIS

73. FRANÇOIS LOUIS FRANÇAIS. *The Landscape Painter*, 1847. Lithograph

74. CHARLES JACQUE. *Pastorale*, 1864. Etching and drypoint

L'ORAGE.

Il pleut, il pleut, bergère,
Presse tes blancs moutons;
Allons sous ma chaumière,
Bergère, vite, allons;
J'entends sur le feuillage
L'eau qui tombe à grand bruit:
Voici, voici l'orage;
Voilà l'éclair qui luit.

Entends-tu le tonnerre?
Il roule en approchant;
Prends un abri, bergère,
A ma droite, en marchant;
Je vois notre cabane....
Et, tiens, voici venir
Ma mère et ma sœur anne,
Qui vont l'étable ouvrir.

Bonsoir, bonsoir, ma mère;
Ma sœur anne, bonsoir;
J'amène ma bergère
Près de vous pour ce soir.
Va te sécher ma mie,
Auprès de nos tisons;
Sœur, fais-lui compagnie,
Entrez, petits moutons.

75. CHARLES DAUBIGNY. *The Storm*, 1842. Etching

These two images are indebted to the conventional pastoral art of the eighteenth century, with its perpetually flirting shepherds and shepherdesses. And the debt is still more obvious in Daubigny's early etching *The Storm* (FIG. 75) which is actually the decorative frame to a popular eighteenth-century song. In song and image, the storm of the title is merely a sudden shower—a minor disturbance in a pastoral world which here becomes the excuse for the shepherdess and her sweetheart to take shelter in a convenient thatched cottage.

The real significance of Barbizon art becomes clear, however, when we turn from these images with their rococo allusions, to the more common, naturalistic style that characterized landscapes of the school. When the idea of the pastoral is removed from the realm of the decorative to the realm of the realistic, the myth gains a new vitality and is transformed from the level of conceit to that of belief.

In contrast to Jacque's idealized glimpse into the shepherd's world, Daubigny's *The Small Sheepfold* (FIG. 76) presents a seemingly realistic view which, nevertheless, subtly imbues the shepherd's life with an idyllic quality. This shepherd appears as an actual inhabitant of the land, who works to herd his flock past the fold. He must give constant attention to his flock; his dogs are his companions, a portable hut affords modest shelter. The flat landscape offers no diversion, in contrast to Jacque's inviting setting.

Daubigny has encouraged the viewer to accept this image as an objective view of rural life, but his treatment of the subject is not devoid of myth. To demonstrate the harmony of man with nature, Daubigny purposefully adopted the restful, stable horizontal structure of the seventeenth-century Dutch landscape tradition with its broad sweep of land and great open sky. Daubigny placed the shepherd and his flock against a wide swath of field, making them appear as the land's natural inhabitants. Furthermore, he chose a distance from the scene that permitted him to generalize about the shepherd's life. Although Daubigny presented the working shepherd as the central figure of this landscape, he omitted the sort of grim details of poverty and filth that might have been revealed through closer inspection, as in the late nineteenth-century description of a French shepherd's cabin:

about one meter high, dry stones, earth roof, a little straw to lie on; a small

76. CHARLES DAUBIGNY. *The Small Sheepfold*, 1846. Etching

77. CHARLES DAUBIGNY. *The Boat-Studio*, 1861. Etching

heap of potatoes; a sack containing half a loaf, fat, and salt. The man carried his wealth on him: a box with 3 or 4 matches and nothing else.[94]

We are close enough to the shepherd's hut in *The Small Sheepfold* to realize that his is not a fanciful pastoral life where a tree provides all the shelter needed, but we are spared any real experience of his poverty or life: we view the shepherd's universe as ideal.

Daubigny's *The Boat-Studio* (FIG. 77) reveals in close detail the life and work of the landscape painter, and contrasts with the prettiness of the lithograph by Français in the same way that *The Small Sheepfold* might be said to contrast with Jacque's *Pastorale*. Showing himself painting from the cabin of the boat that he converted to his floating studio, Daubigny made this print the central image in *Voyage en bateau,* an album devoted to his itinerant life on the rivers of France.[95] In place of the landscape as a setting for the leisurely work and diversion of Français's artist, Daubigny revealed the actual working environment he created, with the landscape beyond framed by the open end of his cabin. His studio is equipped not only with paints and canvases, but also with provisions for his extended travels on the Marne, the Oise, and the Seine. Supplies and utensils along with his mattress line the walls of this tiny one-room shelter, as portable as the shepherd's hut. The artist appears to live in relative independence, with a self-sufficiency which we imagine parallels that of his romantic shepherd.

The image we see is "realistic," as Daubigny takes care to remind us by including the word *realisme* etched across a painting that rests in the lower right-hand corner. Yet it has a mythic quality as well: on his boat, Daubigny floats freely from place to place, as the shepherd travels from pasture to pasture, and peruses the vistas opening before him. The landscape outside appears filled with light, which streams into the cabin onto his painting. Silhouetted at his easel, Daubigny seems to play an almost intermediary role in the translation of the natural landscape into an artistic image. He is the contemplative beholder, transferring to two dimensions the beauty before him, and this print seems a virtual manifesto of the landscape painter's life and art.

Thus, while Français and Jacque depicted charming scenes of artist and shepherd at leisurely work, with obviously idyllic overtones, Daubigny and

the landscapists of his generation would more often present images of apparent reality, where the stereotypical pastoral world was infused with a new power and vision and where the landscapist himself often became the implicit inhabitant of the pastoral world. At a time when the insecurity and poverty of rural life were driving thousands of peasants, shepherds, and farm laborers to towns and cities in hope of a better life, the Barbizon artists nevertheless depicted the countryside as the place that offered a better life, one that they themselves chose.

The landscape artist, whom we might see as a metaphorical shepherd (of the ideal rather than real type), was not dependent on the material conditions of the landscape, but rather retreated to the country with the support of urban culture and society. Of course, the actual conditions of his life might vary considerably. Corot enjoyed a life of ease in the country, supported by his wealthy parents, free to travel or to reside at the family country house in Ville d'Avray. Daubigny and Jacque worked as commercial printmakers during the 1840s to finance their painting, their travels, and their summer retreats to the country. Rousseau and Millet depended on their painting for a living and experienced financial difficulties when their work did not sell. The hardship of Millet's life, in particular, might be noted in assessing his deep sympathy for the peasant, while the ease of Corot's life, as we shall see, may relate to his most idyllic of visions.

Yet despite the differences in their material conditions, all these artists were able to benefit from the best of two separate worlds. They depended on the city both as a source of their own cultural background and as the market for their art, but they chose not to live amid its gray, decayed, and overcrowded surroundings. In the countryside they could wander about freely, seeking out its most beautiful scenes, while the peasant who lived there was tied through his labor to particular fields or woods. Above all, they could contemplate the forms of the landscape without worrying whether its productivity would or would not keep them alive through another year. Their unique position in the countryside allies them with the classical "literary shepherd," Virgil's Tityrus, who is

spared the deprivations and anxieties associated with both the city and the wilderness. Although he is free of the repressions entailed by a complex

civilization, he is not prey to the violent uncertainties of nature. His mind is cultivated and his instincts are gratified. Living in an oasis of rural pleasure, he enjoys the best of both worlds—the sophisticated order of art and the simple spontaneity of nature.[96]

Daubigny's *Voyage en bateau* pictures the artist and his companions—who frequently included his son Karl and "Père" Corot—as aquatic gypsies, living a carefree life in their boat and enjoying their meals of freshly caught fish. *The Cabin Boy Fishing* (FIG. 78) depicts the river as a virtual land of Cockaigne, where fish wait their turn to be caught.[97] The real peasant fisherman, who did not even eat his catch but sold it for cash,[98] might well indulge in such fantasies of living off the land. However, Daubigny's fishing (and the chicken-farming of Charles Jacque) is more nearly akin to the hunting of Gavarni's *Monsieur Gontard* (FIG. 79), "a wealthy landowner who has been hunting since dawn." Unshaven and disheveled, M. Gontard could be mistaken for a poacher, but he is simply indulging in the pleasure of roughing it, a pleasure unfamiliar to those who know only that life.

By the middle of the century, a comfortable pastoral existence had become the popular conception of the landscape painter's life. Hippolyte Taine, describing painters in the Forest of Fontainebleau, observed wryly that after rising and breakfasting,

each [artist] goes off in his own direction, and once in the forest they either work or sleep—and I am inclined to think that the latter is their primary occupation.[99]

Daumier's satirical print *Landscape Painters at Work* (FIG. 80) might be an illustration to Taine's text. Yet beyond its obvious humor, Daumier's print suggests a certain truth: relaxation and contemplation of the landscape would seem to be the necessary prelude to creating the restful art of a Corot or a Daubigny.[100] Despite the precise observation, careful hand, and infinite patience required of the naturalistic landscapist, his work had, at its beginning and end, a calm and inspiration devoid of any sense of labor.

Seeking scenes of quiet contemplation meant for the artist excluding some of the hard facts about rural life. One obvious solution was to focus on the landscape—and only the most peaceful portions of it—while minimizing or

78. CHARLES DAUBIGNY. *The Cabin Boy Fishing*, 1861. Etching (not in exhibition)

79. GAVARNI
M. Gontard . . . wealthy landowner . . . has been hunting since dawn, 1839. Lithograph

altogether ignoring the role of the people who lived in it. The other was to show rural life in such a way that it appeared idyllic in its changeless peace, or at least heroic in its stoical acceptance of unavoidable hardship. A great deal of Barbizon landscape falls into the first category, but much of the work of Millet and Alphonse Legros falls into the second.

Jules Dupré's lithograph *Pastureland in the Limousin* (FIG. 81) is a working landscape with cows grazing and a cowherd barely noticeable in the distance, but the calm mood of a sunny day in a quiet countryside makes more of an impression than any activities taking place in the print. The most active element in the composition is neither human nor animal, but the group of trees which rises with a majestic sweep from the flat land. Pastoral calm is qualified only by a sense of the grandeur of nature that recalls Romantic landscape.

The Plain of La Plante-à-Biau by Théodore Rousseau (FIG. 82) is divested of Romantic overtones. The bare plain punctuated by rocks and scrubby trees is not scenery as is Dupré's lush grove. And, instead of trying to ennoble the scene, Rousseau simply depicted it with loving care, using a hard dry line throughout but rendering all sorts of textural variations by subtle changes in his shading. It is as if he were emphasizing that even in a superficially monotonous plain every rock and clump of grass has its own individuality and quiet beauty.

River scenery, which became one of Daubigny's main landscape themes,[101] was especially well-suited to images of pastoral calm. Whereas for the Romantics water had been an elemental force, expressing its power in cascades (FIGS. 13, 41) or stormy seas (FIGS. 19-21), for the pastoral artists it was a vehicle for relaxation and regeneration, typically shown in the form of quiet ponds or slow-moving streams. Daubigny's *The Iles Vierges at Bezons* (FIG. 83), a placid stretch of water with banks screened by trees while its surface reflects the open sky, combines shelter with spaciousness and invites solitary reverie.

A contemporary critic, describing Daubigny's paintings, suggested that they evoked the same feelings which would arise from viewing the actual scene:

M. Daubigny transports me so easily, and to my contentment, every time I stop in front of one of his paintings. One may journey with pleasure into this one, at the bank of this fresh water, where the cows bathe in the evening. Night falls, the thrushes utter their last cry, the nightingale sings....[102]

80. HONORÉ DAUMIER. *Landscape Painters at Work*, 1862. Lithograph

81. JULES DUPRÉ. *Pastureland in the Limousin, 1835.* Lithograph

82. THÉODORE ROUSSEAU. *The Plain of La Plante-à-Biau*, about 1862. Cliché-verre

83. CHARLES DAUBIGNY. *The Iles Vierges at Bezons*, 1850. Etching

Although etching could not equal the sensuous verisimilitude of oil paint, *The Iles Vierges at Bezons* does indeed transmit the feeling of a peaceful backwater on a summer day.[103] Cool shadows alternate with luminous sunshine and though the trees cut off our view into the far distance, the stream seems to lead us on into the midground. Daubigny's river makes an interesting contrast with Meryon's. *The Pont-au-Change* (FIG. 66) is a wide panorama that nevertheless suggests enclosure; *The Iles Vierges* is a small, fragmentary view that nevertheless suggests space and freedom.

If etching could not capture the sparkling freshness of water as effectively as oil paint, photography was a medium ideally suited to the task. Achille Quinet's *Riverscape with Poplars* (FIG. 84) shows the river at a tranquil moment, reflecting the light of the sky and the poplar trees that line its bank. This seemingly objective description of nature is just as distilled and selective as that of the printmaker and painter, and in fact it bears a striking resemblance to Daubigny's riverscape paintings of the 1850s.

The photographer Ildefonse Rousset was directly influenced by Daubigny in both his subject matter and in his artistic life. To travel at leisure on the River Marne, Rousset also outfitted a boat as a studio for his photography and produced his own response to *Le Voyage en bateau,* publishing in 1865 *Le Tour de Marne* in collaboration with the writer Emile de la Bedollière. Admiring the "luxuriant and poetic" landscape of the Marne, la Bedollière found

a charming river, sprinkled with islands whose vegetation rivals that of the tropics, bordered with laughing villas, and dominated by coasts with a view stretching over an immense horizon.... The great trees reflected in the water that bathes their roots, the forests adorned with reeds, the multitude of aquatic plants, give to the banks of the Marne, spared from tow paths, the aspect of a virgin nature, of which civilization has few examples left, above all in the great cities.[104]

In *The Islands and Wood of Chènevières* (FIG. 85), the presence of humans only serves to reinforce the feeling of a pristine and generous nature. The washerwoman and the fishermen appear to belong in the landscape, to be its natural denizens, as did Daubigny's shepherd in *Sheepfold.* The very luxuriance of nature convinces us that they are, indeed, blessed by its bounty.

84. ACHILLE QUINET. *Riverscape with Poplars.* Photograph

85. ILDEFONSE ROUSSET. *The Islands and Wood of Chènevières*, about 1865. Photograph

86. ANDRÉ GIROUX. *Cottage with Ducks,* about 1855. Photograph

In such a context, we are less aware of the washerwoman's backbreaking labor than of the water's cleansing function, and of its symbolic role as purifier.

It is significant that this tranquil river imagery became popular in mid-century Paris.[105] By the early 1850s, the Seine itself was so polluted that Napoleon III launched a major search for new sources of fresh, abundant water. Typhoid and cholera were endemic in the sprawling, congested city, and water was needed not only for bathing and drinking, but for fire fighting, street cleaning, and sewage disposal. The authorities were faced with the need to locate new sources of water, and also the immense problem of distributing it throughout the city.[106] Medical research at this time was focusing with a new vigor on the curative qualities of water; the Paris Society for the Medical Study of Water was established in 1853.[107] The search for fresh sources of water would bring about the discovery of mineral springs such as Evian in 1853, and of Perrier in 1863, names still familiar to those wishing to buy pure drinking water.

In fact, however, water in the countryside was not as abundant or as pure as the alluring riverscape images suggest. The peasant often had as much difficulty as the city dweller in locating pure, fresh, or abundant water.

The peasant got his water where he could. Water from springs, rills, rivulets... was only as available as proximity made it. More often the peasant relied on a pond or well whose stagnant waters were used by the whole community for bathing, for laundry, and for steeping hemp, and where communal sewage generally oozed in when it did not flow.[108]

André Giroux's *Cottage with Ducks* (FIG. 86) is a photograph very much in the manner of Daubigny's rural scenes, but the stagnant water in the foreground is far less appetizing than the water in the riverscapes we have just observed. Traveling by water, Daubigny and Rousset naturally saw landscapes where it was abundant, and their art implies the universality of this abundance. Giroux's landscape is more typical of actual conditions in the country.

Unlike the riverscape, the forest landscape in Barbizon art had significant precedents in Romanticism. *Tall Timber* (FIG. 87), a landscape by Karl Bodmer with a faggot gatherer added by Millet, recalls in some aspects Huet's awesome forests (FIG. 25). Tall, old trees, with trunks and branches that twist

157

and turn, stretch upward beyond the edge of the vertical composition. Layered one over the next, the trees form a dense, dark, impenetrable forest, a continuous network of active lines that keeps our eyes from relaxing for very long in any one spot. The peasant with his bundle of sticks only accentuates the awesome height of the trees.

The pastoral vision of the forest seldom emphasizes its immensity in this way. Rather, it presents us with a peaceful glade, appropriate to solitary contemplation. Gustave Le Gray's *Forest of Fontainebleau* (FIG. 88) is an inviting, accessible forest. A screen of dark trees stretches across the composition, the eternal pillars of nature. While the upward movement of the trunks creates a feeling of aspiration, it is balanced by the horizontal format which calms and stabilizes: we are inspired, but not overwhelmed. We sense a permanence, rather than the unsettling flux of Bodmer's twisting trees. Light, space, and air suffuse this glade, and the beholder is invited to enter and to find peace, beckoned by the path leading into the forest proper, and guided there by a tiny sign visible in the midground. This marker signifies the cultivation of this garden, and emphasizes that Le Gray was not the discoverer of this landscape, but a vistor drawn to a forest whose beauties had already been charted, as well as painted.

The man responsible for marking rocks and trees in that forest was Claude François Denecourt. A self-educated man with liberal political convictions, Denecourt was bitterly disappointed by the aftermath of the 1830 and 1848 revolutions, and consoled himself with endless rambles through the Forest of Fontainebleau. As the forest gradually became an obsession for him, he began to give names to favorite trees, rocks, and other landmarks, to lay out trails, and to publish guidebooks interpreting their beauties to the general public.[109] Already by 1848, when the hero of Flaubert's *A Sentimental Education* (1869) visits Fontainebleau with his mistress, they are able to hire a carriage for a guided tour of the forest:

The trees became larger, and the driver from time to time would say: "There are the Siamese Twins, there is the Pharamond, the Bouquet-du-Roi . . ." never omitting any of the famous sites and sometimes even stopping so that they would be sufficiently admired.[110]

Le Gray's photograph, then, depicts a landscape already in transformation

87. KARL BODMER and JEAN FRANÇOIS MILLET. *Tall Timber*, about 1851. Lithograph

from unadorned nature to a tourist attraction, although the photograph itself barely hints at this.

The purest expression of the pastoral in French landscape of the mid-nineteenth century is found in the work of Camille Corot. His paintings of dancing nymphs in forest glades are an obvious evocation of the pastoral ideal, but a subtler expression of it can be found in the *cliché-verre* prints that he created between 1854 and 1874. Corot took advantage of the spontaneity of this simple process (drawing directly on a glass plate coated with collodion, and then printing it like a photographic negative) to develop a loose and fluid style of draftsmanship and a freedom of expression unparalleled in his painting.

The dream of Arcadia is intrinsic in these prints, whether or not the subject matter makes it explicit. The actual landscape almost vanishes, as the artist distances himself from anything that might disturb his ideal of calm. *Horseman and Man on Foot in the Forest* (FIG. 89) is so generalized in texture and abstract in shape that it lacks any specific reference to time or place. The landscape is in essence a visual field of freely scratched lines, blots, and undelimited blurs. *The Gardens of Horace* (FIG. 90) is a classical subject theoretically located in Italy, but in style, feeling, and type of landscape it is virtually indistinguishable from other *clichés-verres* specifically linked by their titles to the Forest of Fontainebleau.[111] Graceful fluid lines flow from tree to tree, and from tree to land, blending one into the other without interruption. Textural homogeneity smoothes over the disorderly variety of the actual material world to communicate harmony that unites all of nature. The line is so relaxed and so beautifully natural that it draws the beholder into contemplative quiet. The landscape is defined by the state of dream, by "a reverie hypnotized by the far away."[112]

Corot's evocation of Horace points up the parallels between his own life and that of the ancient Roman poet. Given a villa outside Rome as a retreat, Horace had the opportunity, as one historian noted, "to enjoy something very near to the Arcadian life of pastoral convention."[113] Corot, as we have seen, was also enabled to live in the country, free from financial worries, contemplating and enjoying the landscape; the creation of art was as leisurely a pastime for him as was the poetry and music of the legendary shepherd. Where

88. GUSTAVE LE GRAY. *The Forest of Fontainebleau*, about 1855. Photograph

89. CAMILLE COROT. *Horseman and Man on Foot in the Forest*, 1854. Cliché-verre

90. CAMILLE COROT. *The Gardens of Horace*, 1855. Cliché-verre

91. THÉODORE ROUSSEAU. *Oak Tree Growing among Rocks*, 1861. Etching

Daubigny or Jacque produced prints as a necessity, Corot's *clichés-verres* were for private pleasure, a relaxed by-product of his untroubled life.[114]

Corot's *clichés-verres* transform the forest into a dream, and even Le Gray's photograph, although it depicts a specific place, seems to express an idea of the forest in general. Other forest landscapes of the same period confront the viewer much more directly with the material reality of the forest as an environment. Although Théodore Rousseau's etching *Oak Tree Growing among Rocks* (FIG. 91) is not minutely detailed, we are immediately aware of the different textures of bark, earth, and stone. Further, we sense the individuality of the scene depicted; one stone or tree is not like another. (In contrast Le Gray's trees all seem much alike in their graceful curves.) By catching and focusing our attention, the specificity of objects diverts us from the kind of dreamy reverie that Corot and Le Gray invite us to indulge in. The rich variety of texture in a photograph by W. H. Harrison (FIG. 92) has the same effect; we are acutely aware of the physicality of dry underbrush and prickly twigs. One might be tempted to say that Rousseau and Harrison present a less alluring vision of the forest than Corot and Le Gray, but while it is less idyllic, it has an allure of its own. Both Rousseau and Harrison show the heritage of Romanticism in their compositions, Rousseau in the dramatic lighting which illuminates rocks and trees in the foreground and silhouettes them in the background, Harrison in the picturesque outlines of the gnarled trees he has selected. But it is a tamed and chastened Romanticism, inviting us not to adventurous exploration but to a quiet ramble through the woods.

Henri Le Secq's *Rocks at Montmirail* (FIG. 93) breaks more sharply with Romanticism than the works of Rousseau and Harrison. Without dramatic lighting or picturesque contour, the rounded masses of rock in the foreground are given the aesthetic dignity of sculpture, contrasting dramatically with the delicate verticals of the distant trees. For Le Secq the landscape is a repository of form, and aesthetic contemplation takes the place of reverie.

The most severe tension between pastoral myth and rural reality came not in depicting the landscape but in describing the life and work of those who made it their home. The peasants of nineteenth-century France lived in conditions at least as bad as those of the urban poor. Disease, malnutrition, unemployment, ignorance, isolation, uprooting: this was far from an idyllic world.

92. W. H. HARRISON. *The Forest of Fontainebleau,* about 1875. Photograph

93. HENRI LE SECQ. *Rocks at Montmirail,* about 1853. Photograph

Charles Jacque's *Cottage* (FIG. 94) suggests this seamier side of peasant life, for it draws primarily from the picturesque tradition, where rustic decay had its own special charm. Jacque's cottage is in a state of disrepair, with its thatched roof frayed and everything ragged at the edges. Ominous-looking birds perch atop a pole, presiding over the disorder. Jacque does not, however, invite us to consider the actual conditions of life that prevailed in such a dwelling. Poorly constructed and poorly insulated, often without windows (since windows were taxed), the cottage of a poor peasant housed humans and animals together. Old and young, sick and healthy shared the same beds, the same dirt, and the same parasites.[115]

Poor diet, poor living conditions, and nonexistent medical care made chronic bad health the lot of the rural population, as was shown by the high proportion of young peasants found to be physically unfit for military service.[116] Yet even in the work of Millet and Legros, the two artists most devoted to prints of rural people, such realities seldom appear. More often we see vigor and fortitude in the face of unremitting toil, and a suggestion of self-sufficiency and of harmony with the land.

Millet is the artist best known for depicting in an apparently unadorned manner the actual inhabitants of the French countryside. For Millet, work and its difficulty, rather than the contemplation of beautiful scenery, defined man's basic relationship to nature. From 1849, when he moved to Barbizon permanently, he devoted his art almost exclusively to this subject. As Robert Herbert has discussed, Millet communicated the reality of the peasant's life: the poverty, hardship, and "sense of the grueling wearing tasks" he performed.[117]

Millet's *The Gleaners*, one of the most famous images of nineteenth-century art, was originally created in the form of an etching (FIG. 95). Gleaners came from the ranks of the poorest landless peasants, who followed the harvesters to salvage for their families the last kernels of grain missed by the reapers. Backbreaking, tedious labor, scrounging for ears of grain amid the sheaves and dirt, gleaning was the last bulwark between the peasant and starvation. Some landowners resented gleaning, suspecting that reapers might do a less than thorough job in order to leave more grain behind for these scavengers. In fact, one historian notes that farm workers opposed the replacement of sickles with scythes because the more efficient scythes left less behind.[118]

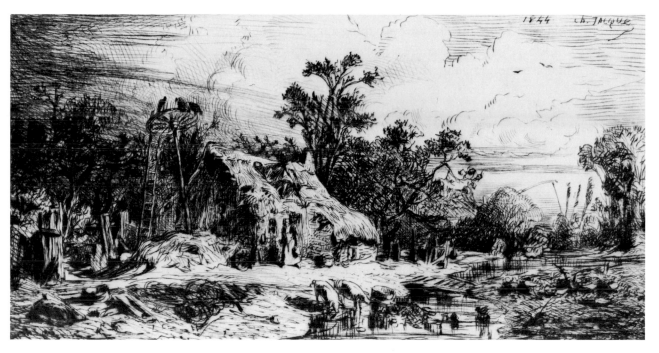

94. CHARLES JACQUE. *The Cottage*, 1844. Drypoint

Millet's earliest drawings for *The Gleaners* depict the women close to the earth, some on hands and knees, groveling on the ground like hungry animals.[119] The scene appears unembellished and without idealization. In the print, however, Millet transformed his downtrodden subjects into beautiful forms, and the women bend toward the ground rather than crawling. Their bodies form graceful arcs; the figures are statuesque. Raising the horizon line, Millet created a landscape to contain the figures, like Daubigny in *The Small Sheepfold* (FIG. 76). Furthermore, he established a formal relationship between the gleaners' bent bodies and the mounds of the haystacks in the distance, to communicate even more vividly the closeness of the gleaners to the earth and the harvest. Clearly, although Millet focused on the poorest of the poor, he nevertheless endowed them with a nobility and a heroic and natural quality. Although he was inspired by a fatalistic view of the peasant's ties to the land, and sought to document the grim labor that was the peasant's lot,[120] these poor gleaners appear less victimized than heroic, not so much real people threatened by starvation as exemplars of an age-old tradition.

The printmaker who comes closest to documenting the more unpleasant realities of peasant life is Alphonse Legros.[121] One of the most prolific French-born printmakers of the second half of the century, he created over seven hundred prints of rural labor and landscape. Legros settled in England in 1863, and lived in London for the rest of his life. Unlike the other artists we have examined in this chapter, he evidently felt no need for a refuge from the city, or for contact with the countryside that he incessantly depicted. Working in London and depending for his subjects on memories of his earlier life in France, Legros developed a printed imagery of solitary woodcutters and faggot gatherers, aged peasants, and disenfranchised beggars and vagabonds in desolate landscapes that offer the viewer neither comfort nor contemplation. His *Woodcutter* (FIG. 96) depicts an awkward figure who labors with obvious difficulty. (Legros was probably influenced by the uncompromising realism of Gustave Courbet; his treatment of the worker recalls Courbet's 1849 painting *The Stone-Breakers*.) Even while establishing a sense of the woodcutter working against the land, Legros maintained a separation of worker and landscape: the woodcutter does not become as totally at one with the earth as do the workers of Millet, Rousset, or Daubigny. The landscape

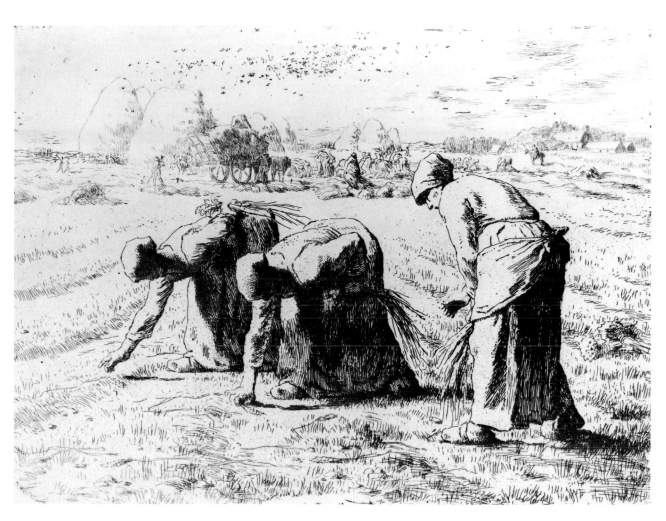

95. JEAN FRANÇOIS MILLET. *The Gleaners*, 1855. Etching

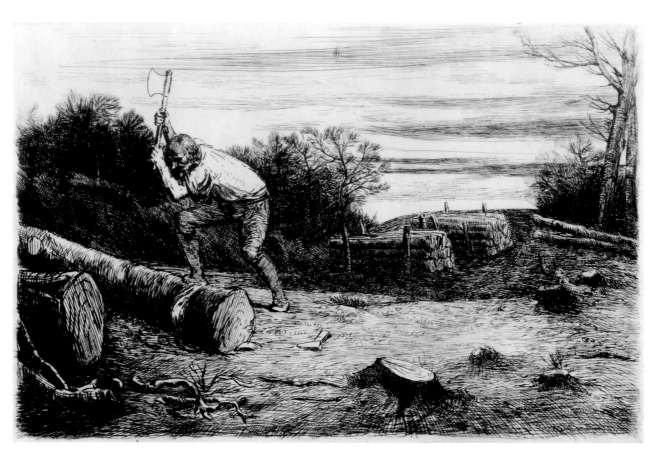

96. ALPHONSE LEGROS. *The Woodcutter,* about 1865. Etching

97. ALPHONSE LEGROS. *The Village in Flames,* about 1890. Etching

itself is hard and arid in the foreground, with random stumps and shrubs or leafless trees totally devoid of the sensuous appeal, the inviting softness, of Jacque's or Corot's Arcadias. An uncomfortable, harsh place, Legros's landscape is the setting for eking out a living, not for contemplation.

In *The Village in Flames* (FIG. 97), Legros turned the destruction of a village by fire into a universal statement of the tragedies wrought upon man by the elemental forces of nature. Legros's treatment of the landscape and burning huts as vast swelling forms, undulating like the sea, and his placement of the peasants in the foreground, as if hurled there by some power, evoke images of the Biblical deluge. He has given little indication of a particular time or place, but rather blends the forms of the landscape into one moving element, which effectively communicates a drama of almost cosmic proportions. With epic grandeur this scene records human vulnerability before the forces of nature.

However, even Legros's prints show little that compares in savagery to Emile Zola's novel *Earth* (1887). Just as novelists rather than artists had most fully exploited the horrors of city life, so too it was left to a novelist to create the most relentless anti-pastoral of the century. Beginning with the harmonious relationship of two peasant sisters, Lise and Françoise, Zola's story traces the degeneration of their love into constant bickering and conflict and documents a penurious, immoral, and bestial life. To reinforce his destruction of the pastoral myth, Zola introduced into the country an urban artisan, Jean Macquart, who believes in the myth and succeeds briefly in living it, after his marriage to Françoise:

In less than a year, the former artisan became a good farm-worker, ploughing, sowing and reaping in the peaceful atmosphere of the land where he hoped to satisfy at last his search for quiet.... At first he was delighted and was able to enjoy the countryside in a way that peasants never can, and he enjoyed it, too, through what he remembered of sentimental books and the ideas of simplicity, virtue and perfect happiness that can be found in little moral tales for children.[122]

At the novel's conclusion, after the chilling murder of the pregnant Françoise by her sister, Jean leaves the country with no illusions about rural life. Zola's anti-pastoral runs almost as great a risk of degenerating into stereotype as the

pastoral myth itself. By the time the novel was published, the mythic opposition of infernal city and heavenly countryside had already ceased to interest the younger generation of artists and writers. A new vision of city and country was coming into being.

98. FÉLIX BRACQUEMOND. *The Pont des Saints-Pères*, 1877. Etching

The Marriage of City & Country

I N 1867, one year before Charles Meryon's death, George Sand contributed an essay to a new Paris guidebook that could be taken to symbolize the passing of Meryon's pessimistic vision of a decaying city. Her essay, "La Rêverie à Paris," is a panegyric to the joy and charm of strolling through the city: "In truth, I know of no city in the world where walking dreamily [*la rêverie ambulatoire*] is more delightful than in Paris."[123] Sand's "walking reverie" recalls the ideas of Jean Jacques Rousseau, who found walking the perfect stimulus to thought and whose last book is entitled *Les Rêveries du promeneur solitaire (The Reveries of the Solitary Walker).*[124] But Rousseau's favorite walks had been through forest and field;[125] Sand's reveries were stimulated by the new urban landscape. She quickly dismissed its "one hundred" perils (the dangers of heavy street traffic that mingled pedestrians, horses, and vehicles) to expatiate on its "one hundred thousand" pleasures: landscaped squares, exotic flowers, greenhouses, and waterworks. These were all calculated to gratify the natural human desire for "an unlimited space, fields, valleys, the vast sky stretched out over the horizon of the meadow."[126] The modern urban park, she wrote, had been perfected "so as to realize within a limited space the appearance of the natural landscape."[127]

While Paris inspired in Sand dreams of nature, rather than the urban nightmares of Doré and Meryon, parts of the countryside correspondingly stimulated dreams of urban pleasures, rather than the rural contemplation idealized by Daubigny and Le Gray. The coastal resort of Trouville had long renounced the "village simplicity" depicted by Hervier in 1848 (FIG. 37) when a late nineteenth-century guidebook described it:

Here life is the gayest of the gay.... Here we can combine the refinements and "distractions" of Paris with northern breezes... the ball-room with the sanatorium, and the opera with any amount of ozone.[128]

107. EDOUARD VUILLARD. *The Avenue*, 1899. Color lithograph

129. ANONYMOUS. *Panorama of Paris Seen from the Gondola of the Great Balloon*, 1878.
Color lithograph

143. CAMILLE PISSARRO. *Twilight with Haystacks*, 1879.
Aquatint with etching and drypoint (color impression not in exhibition)

144. PAUL SIGNAC. *Les Andelys,* 1897. Color lithograph

145. HENRI RIVIÈRE. *The Baie de Launay,* 1891. Color woodcut

149. EDGAR DEGAS. *Landscape,* about 1890-93.
Pastel over monotype in oil colors (not in exhibition)

150. PIERRE BONNARD. *Boating*, 1897. Color lithograph

151. FÉLIX BRACQUEMOND. *The Rainbow*, 1893. Etching and watercolor

99. FÉLIX BUHOT. *A Squall at Trouville*, 1874. Etching

City and country are no longer seen as opposites; each has absorbed some of the characteristics of the other. The city in Felix Bracquemond's *The Pont des Saints-Pères* (FIG. 98) and the seacoast of Felix Buhot's *A Squall at Trouville* (FIG. 99) graphically illustrate this cross-fertilization.

The Pont des Saints-Pères (1877) presents a city that evokes nature, in contrast to Meryon's sinister *Pont-au-Change* (FIG. 66). Blanketed by mist and atmosphere, Paris appears as a skyline in the distance, beyond the bridge, while the broad Seine and the open expanse of sky dominate the view. The river opens toward the viewer, and falling rain energizes the vast sky, irradiated by a distant light on the right, while a passing storm sweeps by on the left, leaving a rainbow. The man-made structures that characterize the city are not altogether ignored, but they are clearly subordinated to the city's natural elements. The bridge is light and delicate in its iron and stone construction, two boats nestle unobtrusively under luxuriant trees, and a small steamboat in midstream appears too minor an intrusion to challenge the glories of nature.

A Squall at Trouville (1874) reveals the socialized landscape that mixed opera and ozone, civilized comfort with natural scenery. The fashionable life of the resort, temporarily disrupted by a summer storm, is epitomized by the pavilions and banners, and the large resort hotels in the distance. These two prints share an interest in transient weather conditions and a sense of lively, fluttering movement, but it is the natural elements of water and foliage which are actuated in Bracquemond's urban print, while the elements of civilization, a dense crowd and the wind-blown chairs, are activated in Buhot's coastal scene. It is as if the two artists had deliberately agreed to exchange the natural attributes of city and countryside.

As Sand's essay and the guide to Trouville indicate, city and countryside literally were exchanging their attributes in the second half of the nineteenth century. The massive public works begun by Napoleon III and his Prefect of the Seine, the Baron Haussmann, introduced unprecedented open space and greenery into the city, while the expansion of railways, roads, and tourist resorts produced miniature replicas of urban life in the mountains and along the seashore. But Bracquemond and Buhot not only documented these new urban and rural landscapes, they also developed an artistic vocabulary expressive of those conditions. While examining in detail the new aspects of city and countryside shown in prints and photographs of the later nineteenth

century, we shall repeatedly be made aware not only of the transformed environments that are depicted but also of the way they are seen—the new vision of city and country. Eventually it will be necessary to define the new aesthetic interpretation of the landscape that these works share.

PARIS, AN URBAN EDEN

Under Napoleon III, the medieval Paris of Meryon became the modern capital capable of inspiring George Sand's reveries and a new art. Only a powerful regime could have accomplished a transformation on such a scale: the entire city was raw material for the gigantic works that Napoleon and Haussmann conceived and executed. There is no idiomatic English equivalent for the term *percement* that was used to describe Haussmann's extensive demolition for new boulevards, literally piercing through the old fabric of the city like a spear through flesh. And each new chasm created by the demolition was lined with new buildings, miles upon miles of uniform gray facades six and seven stories high. Trees transplanted almost fully grown lined the new boulevards. Beneath them artificial rivers brought fresh drinking water to the Parisians, while other new channels carried away their waste and sewage. The modern tourist seldom realizes how much of the Paris he experiences as the City of Light— from the imposing buildings to the famous sewers, from the grand boulevards to the elegant parks—was created little more than a century ago and within the space of two decades.

While practical considerations spurred Napoleon's vast undertaking—the boulevards, for instance, provided convenient avenues for the deployment of troops through working-class quarters—an aesthetic vision inspired the transformation of Paris. During Napoleon's exile in London, he had been entranced with the greenery and open space provided by parks and squares. On a more philosophical level, he was indebted to the utopian thought of Henri de Saint-Simon.[129] (Many Saint-Simonians assumed influential positions in the administration of the Second Empire, earning Napoleon himself the nickname "Saint-Simon on horseback.")[130] The Saint-Simonians and other utopian theorists advocated a union of city and country which would eliminate the

100. CHARLES MERYON. *The Solar Law,* 1855. Etching and drypoint

worst aspects of each: urban congestion, filth and decay, and rural isolation, poverty and ignorance. Saint-Simon had written, "The whole of French soil should become a superb English park, embellished with everything that the fine arts can add to the beauties of nature."[131]

Doubtless inspired by such utopian dreams which were current in mid-century, Meryon etched his poem "The Solar Law" (FIG. 100) in 1855 in which he envisioned this ideal city:

> *If I were*
> *Emperor or King*
> *of some powerful state*
> *(which I neither would nor could be);—*
> *Seeing that the Great Cities are born only*
> *For Sloth, Greed, Fear*
> *Luxury and other evil passions;*
> *I would establish a law determining as precisely as possible, a portion of land, cultivated or not to surround, of necessity, every dwelling place of desired size required for a given number of human beings; in such a way that the Air and the Sun, these two essential life principles, be always there to be generously portioned out. This law, source of all well-being, both material and consequently moral, would be called*
> *The Solar Law.*[132]

Meryon's dream, like most dreams, far surpassed the reality which was to take shape. Haussmann had no intention of providing every dwelling with its own green space, and his operations were as much concerned with the details of real-estate speculation as with the realization of an ideal city. Nevertheless, the squares and boulevards which he created and the demolition of vast numbers of old (and historic) buildings opened the center of the city to unprecedented space, parks, sun, and air. A Daumier print (FIG. 101) caricatures a couple rejoicing in the sunlight that is finally reaching their shriveled house plant because of the demolition of adjacent buildings. Says one spouse to the other, "I'll finally find out whether it's a rose or a carnation."

Beginning in the early 1850s, each of Haussmann's campaigns swept away a host of buildings and streets such as Meryon and Marville recorded, and thereby focused attention not only on the Paris that was vanishing and the new

101. HONORÉ DAUMIER
"There, my flower-pot will have some sunshine . . .
I'll finally find out whether it's a rose or a carnation," 1852. Lithograph

city under construction, but also on the process of change itself. Baudelaire's lament

> The old Paris is no more (the form of a town
> Changes more swiftly, alas! than the heart of a mortal)

arises in "The Swan," a poem which expresses his disorientation in a landscape where so much that is familiar has vanished.[133] On the right bank of the Seine, the Rue de la Vieille Lanterne (FIGS. 61, 62) disappeared with the extension of the Rue de Rivoli in 1852 and the clearing away of the noxious slums around the Louvre and the Hotel de Ville. The Rue des Marmousets (FIG. 69) was only one of many that vanished when the Ile de la Cité was almost entirely rebuilt.

On the left bank, the Boulevard Saint-Germain, the Boulevard Saint-Michel, and five or six subsidiary streets cut through the Latin Quarter, whose student population had habitually taken a leading role in the uprisings against the government, and where the June uprising of 1848 had witnessed desperate fighting (FIG. 63). The Rue des Mauvais Garçons (FIG. 65) and the Rue Traversine (FIG. 54) were among the many tiny old streets eliminated by these demolitions.

By 1865, when Sand wrote her "Reverie," walking in Paris was already becoming both a common and popular urban pastime, in contrast to the old city where one rarely strayed far from his home or working quarter. In Zola's *L'Assommoir* (1877), set at the beginning of the Second Empire, the laundress Gervaise has never ventured beyond her own neighborhood until the day of her marriage when the wedding party makes a trip to the Louvre.[134] They must follow a time-consuming, circuitous route to get there. It rains and the streets turn to mud, which soils the women's dresses and almost spoils the excursion. Under Napoleon, eighty-five miles of streets and boulevards were constructed and paved with asphalt and blocks of hard stone.[135] Construction of the grand underground sewers, with storm drains on the sides of the streets engineered to slope toward the drains, meant that walking in Paris was no longer the unhealthy, hazardous, or simply unpleasant event it had been in the recent past.[136]

Zola's later novel *The Masterpiece,* which opens in the early 1860s, paints a very different picture of central Paris, as it is seen by the young artist Claude Lantier, Gervaise's son. In an intensely visual series of descriptions, Zola leads

the reader along the Seine, reveling in great open vistas and the play of light and shade on the buildings:

In no ancient forest, on no mountain road, above the fields of no plain will there ever be such triumphant sunsets as behind the dome of the Institute. It is Paris going off to sleep in her glory. Each time they [Claude Lantier and his sweetheart] took the walk, the conflagration changed, new furnaces added their glowing coals to that crown of flames. One day when a shower had taken them by surprise the sun, reappearing behind the rain, lighted up the whole cloud and nothing remained above their heads but that burning mist, changing from blue to pink.[137]

The enthusiasm for the landscape of Paris that infuses Zola's description is also reflected in the flood of publications about the city that began to appear in the fifties and sixties, ranging from sumptuous albums in the tradition of the *Voyages pittoresques* to inexpensive portable guidebooks. *Paris dans sa splendeur* (see FIG. 122), published in 1863, approaches the *Voyages pittoresques* in magnificence: three folio volumes of lithographs and an ample descriptive text devoted to the urban landscape, its old and new buildings and monuments. A similar mixture appears in Charles Soulier's album of photographs, *Paris et ses environs* (see FIGS. 114, 120). Adolphe Alphand's *Les Promenades de Paris* (FIGS. 109-112, 115) is a work of a different sort; written by the landscape architect responsible for the design of the new parks and squares, it records not so much the discovery as the invention of a landscape. But even before Alphand's book was published, the parks were documented in photographic publications such as Charles Marville's monumental *Album of the Bois de Boulogne* (FIGS. 119, 146) and Ildefonse Rousset's small handsome book on the Bois de Vincennes (FIG. 121). Smaller buidebooks to Paris range from the *Paris-Guide*, a comprehensive guide with over two thousand pages of essays and illustrations by notable writers and artists (including George Sand's "La Rêverie à Paris") to standard pocket guides intended to be carried by the tourist, such as *Paris-Diamant* by Adolphe Joanne.[138]

It is hardly a coincidence that these albums and guides to the city began to be published at the same time as the last and least inspired volumes of the *Voyages pittoresques*. The enthusiasm that once drew artists and writers to the isolated provinces of France now brought them to Paris, for the city in its new

193

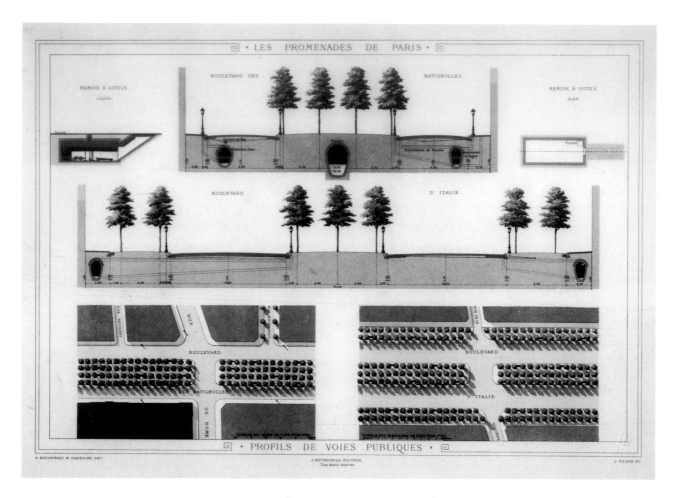

102. JEAN JOSEPH SULPIS, after EMILE HOCHEREAU and LOUIS DARDOIZE
Street Cross-Sections, about 1870, from *Les Promenades de Paris* by Adolphe Alphand.
Steel engraving (not in exhibition)

form was an unexplored region as France as a whole had been in the 1820s. The transformed city invited discovery through walking and awakened a "topophilia," a love of place, in its inhabitants and visitors alike.[139] This was reflected in the guidebooks at the same time, widening the city's appeal and helping to make it more accessible.

Among the most significant aspects of the new city in the development of urban landscape art and cultural ideals are the tree-lined boulevard and the public park and square. The first of these was not a radical break with tradition but the extension of one of the most successful existing forms of Parisian urbanism. The Grands Boulevards, running from the Place de la Madeleine to the Place de la Bastille, became Haussmann's model for the network of new streets cut through central Paris. His inclusion of trees in the new boulevards, planted in large numbers at great expense,[140] was one of the idealistic aspects of his urban planning, and points to the need to see the boulevards as more than transport routes for troops or as a means to split up the working-class quarters. Broad streets alone would have solved the practical problems of traffic and security, usually cited as the motive for the new streets.[141] The trees (FIG. 102) were a purely aesthetic element. As the English visitor P. G. Hamerton wrote of Paris:

Trees are not an absolute necessity, but next to space, air, and light, they are the greatest of all luxuries, not only for their shade, but for the delightful refreshment afforded by the green of their foliage in a wilderness of stone and mortar. With the blue sky and the passing clouds above, and the fresh green leaves on the trees, it seems as if nature were not quite banished yet.[142]

An anonymous photograph from the Place de la Madeleine (FIG. 103)—a view later popularized in tourist postcards—shows continuous walls of foliage extending for blocks into the distance. The trees recall those along country lanes or in formal gardens. Buildings are hidden, and only their tops appear above the trees, like cliffs in the background.

Auguste Lepère organized the composition of his *Boulevard near the Vaudeville* (FIG. 104) to make the balance between the natural and the man-made world still more evident. In the foreground are large trees whose abundant leaves hide the sky from view, and further down the street they almost entirely conceal the architecture. Where buildings do appear, their sunlit

195

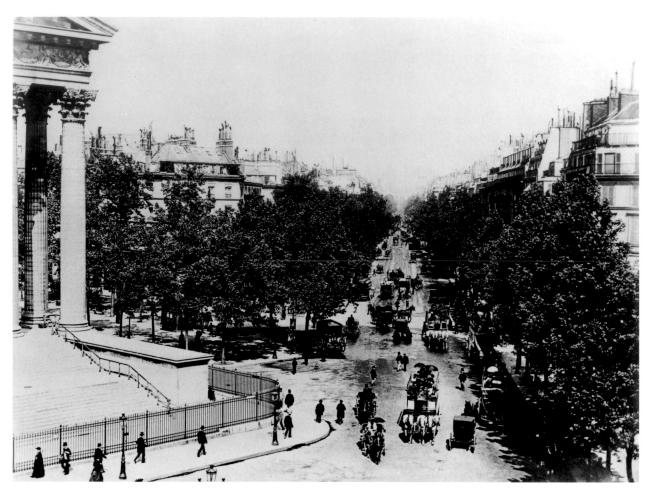

103. ANONYMOUS. *The Boulevard de la Madeleine,* about 1885. Photograph

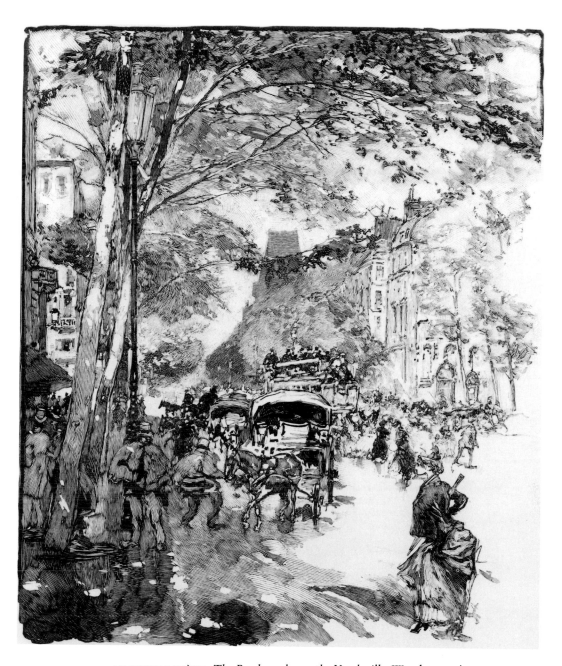

104. AUGUSTE LEPÈRE. *The Boulevard near the Vaudeville.* Wood engraving

105. CAMILLE PISSARRO. *The Boulevard Montmartre*, about 1899. Lithograph

facades have the same light texture as the foliage and blend into it. Despite the presence of a dense crowd in the middle distance, the print is characterized by lightness, brightness, and openness.

Camille Pissarro depicted the Boulevard Montmartre from an upper-story window (FIG. 105). From this perspective he gives a general view of the boulevard as a whole, frankly admitting its geometrical regularity—even monotony—but capturing the visual excitement of the life that fills it. As he wrote:

Perhaps it isn't very aesthetic, but I am delighted to be able to try to show these streets of Paris which people usually call ugly, but which are so silvery, luminous and lively.[143]

In the paintings he made of the boulevard in 1897, Pissarro used color to emphasize the effects of light at different seasons and times of day. When he returned to the motif in this lithograph two years later, he concentrated instead on the almost liquid movement of the street—a river of traffic flowing between the banks of trees. The hard-edged solidity of the city has been transmuted into an image of fluid softness.

The theme of Norbert Goeneutte's etching *Boulevard Clichy in the Snow* (FIG. 106) is the transformation of the urban landscape by falling snow[144] which has veiled and softened the buildings. Just as in Bracquemond's *The Pont des Saints-Pères* (FIG. 98) or Zola's description of the Seine, the city is seen almost entirely in terms of the poetic effects of weather. The elegantly dressed young woman, strolling through the snow, recalls George Sand's "walking reverie," for the snow gives the whole landscape a dreamlike quality.

But a more striking example of this quality is Vuillard's color lithograph *The Avenue* (FIG. 107 color section), from the series *Landscapes and Interiors*. Without the aid of a special weather condition, Vuillard transmuted an ordinary sidewalk into an extraordinary image of urban space in which people dreamily move. The drama of this print is due in large part to the unusual perspective: the high horizon line places the focus downward, directly on the street and grass. While Vuillard's startling orientation toward the ground might have created a sense of closure, he generated instead a feeling of expansiveness, of luminosity, and of movement, in which our eyes are guided continually upward by the lines of the print. The pavement and grass are

articulated by the alternating pattern of sunlight and shadow, colored in greens and yellow, which create pleasing visual rhythms and movement. Verdant leaves float on the tree trunks at the street's end. Flat, unmodeled figures appear buoyant as though they glide through space. Vuillard discovered beauty and color in an unexpected downward glance. We may well appreciate Hamerton's words in *Paris Old and New* of 1885: "True lovers of Paris... tell me that the mere sensation of the Parisian asphalt under the feet is an excitement itself."[145]

The streets of Lepère, Pissarro, or Vuillard give no hint that there might be a dark side to life in the rejuvenated city, that many streetscapes of Paris remained dismal, with poverty and crime behind the facades. Instead there was a fascination with the marvel of broad, open vistas, of tree-lined boulevards, of a beautiful city. Pierre Vidal's cover design for a book by Georges Montorgueil, *Life on the Boulevards* (FIG. 108), does manage to suggest the social inequalities which lay behind the brilliant facade Haussmann had placed on the city.[146] Showing a single stretch of boulevard running across both covers of the book, but changing the time from the afternoon on the front cover to the dead of night on the back, Vidal contrasted a crowd of strollers and pleasure-seekers with a street deserted except for police and a band of street cleaners. But even Vidal's nocturnal image is one of order and peace with the darker picture only implicit—the sweepers are at least employed and the police are on guard against violence. The tone of Montorgueil's text is analogous to Vidal's cover: he notes the poor habitués of the boulevard but does not dwell on their misery. To Montorgueil the poor on the boulevard are resigned to their lot: the status quo may be inequitable, but it is stable—and comfortable for those as well-off as Montorgueil and Vidal. The chaos of an image like Chigot's *Stock Exchange* (FIG. 50) or the despair of Meryon's *Morgue* (FIG. 68) have no place here.

The thin lines of greenery that Napoleon's boulevards and their trees drew through the city were complemented by a vast system of new parks and squares. As the real countryside retreated before the expansion of the city, Haussmann and Alphand provided an artificial substitute: a ring of parks in the districts beyond the old customs barrier. Together with a few public gardens that existed before 1850—the Champs-Elysées, the Tuileries, and the Luxembourg Gardens—these gave Paris more than 4,500 acres of public

106. NORBERT GOENEUTTE. *Boulevard Clichy in the Snow.* Drypoint

108. PIERRE VIDAL. *Life on the Boulevards, 1895.* Color lithograph

109. AUGUSTE ALEXANDRE GUILLAUMOT, after ÉMILE HOCHEREAU
Frontispiece to *Les Promenades de Paris* by Adolphe Alphand, about 1870. Steel engraving

parks.[147] In addition twenty-two new landscaped squares were scattered through the city, many of them created from residual spaces alongside the new boulevards, and some of them large enough to be effectively small parks.[148] Paris had a new "built-in" landscape.

The frontispiece to Alphand's book *Les Promenades de Paris* (FIG. 109) presents the city as a garden. Through a frame of trees and park architecture, we see an assortment of Parisian monuments: on the left the medieval Tour Saint-Jacques and the Rennaissance Fontaine des Innocents (for which Alphand had provided new landscaped squares); on the right, nineteenth-century fountains including the fountain of the Place du Châtelet (which Alphand had transplanted and rebuilt). Finally, in the background appears the temple-crowned rock of the Parc des Buttes-Chaumont, Alphand's most spectacular manipulation of the landscape. The image is a collage of old and new Parisian landscapes, grouped together in a setting of trees and flowing water.

The text of *Les Promenades de Paris* and its wood-engraved illustrations provide a vivid sense of the immense technology and engineering behind the theatrical illusion of nature that the parks offered. Some rocks were imported from the Forest of Fontainebleau, others were manufactured out of concrete; cascades were turned on and off at appointed hours, and the fences were mass-produced castings in the shape of tree branches.[149] As one contemporary writer described the park landscape: "Apart from the ground and trees, everything is artificial . . . all that is missing is a mechanical duck."[150] Even the ground and trees of the parks were cultivated, if not artificial. Land was irrigated, pipes laid underground, and sprinkling systems installed. Trees were cut down, and others transplanted by cumbersome machines designed especially for that purpose.[151] In a handful of these vignettes, the park employees who maintained the grounds are represented; however, they rarely occur in the art of the period. The green oases of nature in the city were envisioned as though they just happened to be there: we see the image of pleasure, not the work behind the image.

The parks were, thus, a refined and idealized form of nature, in which the Parisian could experience *bein-être*, well-being, in a most pleasant, artificial landscape. As Gustave Claudin wrote at the time, he preferred "this artificial beauty to the repulsive realities of our fields and woods."[152] Alphand's parks presented a beautiful, bountiful welcoming image of a natural pleasure gar-

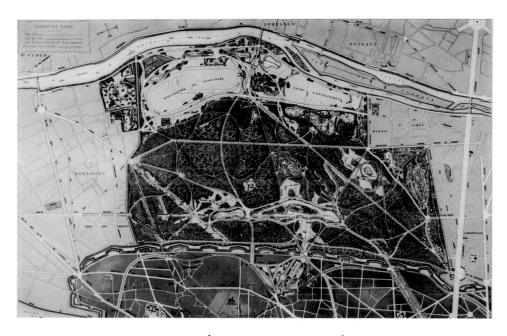

110. F. LEFEVRE, after LOUIS DARDOIZE and ANTOINE
The Bois de Boulogne (after transformation), about 1870, from *Les Promenades de Paris*
by Adolphe Alphand. Steel engraving

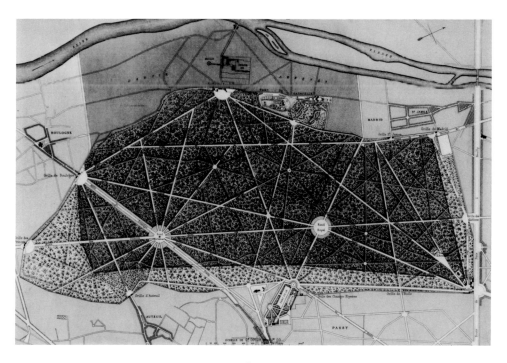

111. L. CHAUMONT, after EMILE HOCHEREAU
The Bois de Boulogne (former state), about 1870, from *Les Promenades de Paris*
by Adolphe Alphand. Steel engraving (not in exhibition)

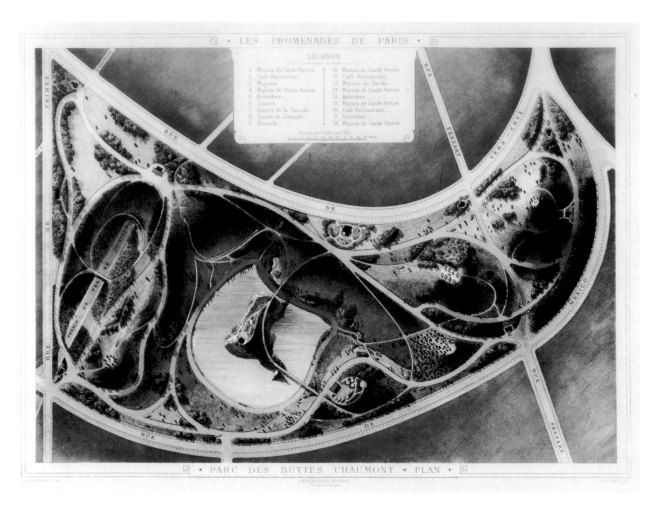

112. H. DUREAU, after EMILE HOCHEREAU
Plan of the Parc des Buttes-Chaumont, about 1870, from *Les Promenades de Paris*
by Adolphe Alphand. Steel engraving

den, ideally ordered, well-maintained, and entertaining. Theatrical, delightful, and alluring, these park landscapes became the urban pleasure grounds of Paris in the Second Empire, and they remain that today. They offer complete, self-contained worlds where urban dwellers find a green oasis, open space and fresh air, and the illusion of a peaceful, undisturbed nature. Bernard de Saint Pol Lias wrote in 1899 of the Bois:

It is a place of repose, of pleasures and of health where Paris relaxes her nerves, calms her fever, refreshes herself, cheers herself.... It is an Eden where nature and art are married.[153]

The plate volume of Alphand's book contains wood-engraved views and steel-engraved plans and elevations of the parks and squares and their architecture and furniture (as well as a series of color lithographs of exotic plants). These latter include kiosques, fences, fountains, and many other structures manufactured solely for the parks (FIG. 115). While the wood engravings are comparatively small and undistinguished, the steel engravings are full or double page and technically superb.

Alphand's plan of the Bois de Boulogne (FIG. 110) shows the artful curvilinear patterns of paths and carriage roads which he laid out in the style of the English garden to simulate nature. By comparison, a plan of the Bois before he began his work (FIG. 111) shows straight avenues neatly intersecting each other. But the old Bois had been a true forest, only cut through by the avenues; the new park with its mounded-up hills and excavated lakes is less natural while masquerading as something that had come about naturally.

The plan of the Parc des Buttes-Chaumont (FIG. 112) makes the artificiality of landscape architecture still clearer. The details of the park's contouring, planting, and buildings are depicted minutely, but its urban context is reduced to a few schematic streets, giving it somewhat the appearance of an elaborate piece of jewelry hung against a featureless background. Photographs by Charles Marville and Charles Soulier (FIGS. 113, 114) reveal how drastic an alteration in the landscape was required to produce this jewellike artifact from the quarries and cesspits of Montfaucon. Marville showed the stone quarries before or during their transformation, an arid and sterile wasteland. In Soulier's photograph, evidently taken shortly after the completion of the park, this desert has become a garden. A lake has been created at the base of the

113. CHARLES MARVILLE. *The Buttes-Chaumont,* 1863. Photograph

114. CHARLES SOULIER. *The Parc des Buttes-Chaumont.* Photograph

115. ALEXANDRE MARIE SOUDAIN, after EMILE HOCHEREAU and LOUIS DARDOIZE
Booths and Kiosque for the Street, about 1870, from *Les Promenades de Paris*
by Adolphe Alphand. Steel engraving

116. PELLERIN ET CIE (publisher). *Park Kiosque*, about 1870. Hand-colored lithograph

rocks, grass and trees have been planted on their summit, and they now evoke memories of the seacoast. The natural rock was carved and in some places additional pinnacles were mortared on, imitating the naturally sculptured cliffs like Etretat in Normandy (FIG. 147).

The luxury and detail of Alphand's publication, and the long list of distinguished subscribers included in the first volume, indicate the existence of an international audience with a profound interest in the development of the parks of Paris. But landscape architects, city planners and political figures were not the only ones to be interested in the new parks. Other types of prints suggest the fascination of the parks for the ordinary men, women, and children who used them, and attest to the evolving concept of the modern city and its amenities. The Pellerin publishing house of Epinal, which issued cut-and-paste paper models of all sorts for children, included among its offerings a park kiosque (FIG. 116), an amusing counterpart to Alphand's meticulous plates (FIG. 115). Popular illustrators, too, seized upon the new parks and the new aspects of social life which they fostered almost as soon as they were completed. A new periodical press, typified by the journal *Le Monde illustré*, depicted not only news events but also the daily life of the wealthy and leisure classes.[154] The Bois de Boulogne, located in the fashionable western part of Paris and a favorite haunt of the imperial family (Napoleon III had actually participated in laying out certain parts of it), appears repeatedly in *Le Monde illustré* from its completion in 1858 to the turn of the century.[155]

One of the earliest such images of the new Bois de Boulogne, a double-page engraving after a drawing by Gustave Janet (FIG. 117), shows Alphand's spectacular hydraulic set piece, the Grande Cascade. Janet depicted well-dressed men, women, and children as they circulate around this artificial waterfall which was turned on at the fashionable hour for promenading. A woman in one carriage flirts with a soldier on horseback, gentlemen tip their hats to ladies. Examining the details of the print, one senses that this promenade is a social ritual rather than a trip to visit the marvelous cascade. In fact, the cascade seems to go unnoticed at its most theatrical moment, when its water has been turned on full force. The artist himself ignored the waterfall, clearly subordinating it to the splendor of the social ritual. Later images in *Le Monde illustré* continue to document the recreational activities of this environment: walking, running, boating, ice-skating, bicycling, horse racing, and

211

117. W. MEASOM, after GUSTAVE JANET
The Bois de Boulogne (Grande Cascade), 1857. Wood engraving

118. LOUIS JEAN DELTON. *Woman on Horseback, Taking a Jump*, 1884. Photograph

even such exotic amusements as the elephant ride and an ostrich-drawn cart in the Jardin d'acclimatation.[156]

Photographers too eventually came to document these activities, setting up small studios in the park to portray the illustrious men, women, and children who went riding there.[157] By 1884, when Louis Jean Delton published a collection of such portraits in *Le Tour du Bois*,[158] it was even possible technically to depict riders in motion. The dramatic image of a woman on horseback leaping a stone wall stands out from the rather mediocre average of Delton's work (FIG. 118). The blurring of all objects in the image except for the stone wall creates a perhaps accidental but nonetheless moving image of speed and freedom—leaping the obstacle, the woman penetrates into a world of space and movement. Delton's modest photograph persuasively conveys the excitement of an active sport.

Long before Delton's album, however, more serious photographers had been at work in the parks. In fact, photographic albums provide the first serious artistic coverage of the park landscape. In Paris as in the provinces (see the first chapter), photographers had taken up the challenge set by the early volumes of the *Voyages pittoresques*, of combining topographic accuracy with artistic distinction. Photographers like Marville and Soulier did not depict social rituals and sports like the popular illustrators and later photographers such as Delton. (Indeed in the 1850s and 1860s the representation of motion in photography was not yet technically feasible, had these photographers wanted to capture the activity of the parks.)

In his imposing *Album of the Bois de Boulogne,* Marville emphasized equally scenes of the beauty of this man-made Eden and of its many civilized accoutrements—entry gates, fashionable restaurants, and elaborate boating platforms. But even the "pure" landscapes frankly reveal that the park is not virgin nature. An untitled view of a carriage road (FIG. 119) features a paved road, the low iron fencing in the foreground (a ubiquitous element in the parks separating lawns from promenades), and neatly trimmed lawns. The workman seated next to his cart reminds us that this is a nature carefully maintained. Where the worker is absent, his presence is felt: in one autumnal scene the ground is filled with leaves, but the walking paths are clear, having just been swept.[159] Janet's drawing of the Grande Cascade overtly shows the extravagance and artificiality of upper-class life in the Second Empire, while

214

119. CHARLES MARVILLE. *The Bois de Boulogne*, 1858. Photograph

120. CHARLES SOULIER. *The Grande Cascade in the Bois de Boulogne.* Photograph

LAC DE CHARENTON
(POINTE ORIENTALE)

121. ILDEFONSE ROUSSET. *Lac de Charenton, East End,* about 1865. Photograph

Marville's album more soberly reveals the meticulous control of nature that produced an appropriate environment for that life.

Charles Soulier's *Paris et ses environs* contains photographs of Paris old and new, urban and bucolic, religious and recreational. Views of Notre-Dame, the Pantheon, the Tour Saint-Jacques, and the Bourse appear side by side with views of the new Opera, the Buttes-Chaumont, and the Bois de Boulogne, in no particular order. Despite the topographical diversity of the album, there is a unity within; Paris is shown as a beautiful city articulated by dramatic monuments. In contrast to Marville's intimate views, Soulier deliberately selected the spectacular view, whether in depicting architectural grandeur or park scenery like the rock of the Buttes-Chaumont (FIG. 114) and the Grande Cascade of the Bois de Boulogne (FIG. 120).

For views of a modest park landscape, as well as a more modest presentation, one may turn to Ildefonse Rousset's small book *Le Bois de Vincennes*. This park, located on the east side of Paris, never became popular with the upper classes like the Bois de Boulogne, and hence was documented neither in a sumptuous album like Marville's (destined for an upper-class audience) nor in a popular journal like *Le Monde illustré* (which fed upon upper-class activities). Rousset's book was intended for the same middle-class Parisians who visited the Bois de Vincennes itself. Though smaller in scale than the albums of Marville and Soulier, the book is handsome and the photographs high in quality.

The content is consistent with the book's format: the photographs reveal the rich diversity of the many "ordinary" man-made pieces of nature as well as some of the park's more spectacular monuments such as a grotto crowned by a classical tholos. Perhaps the most striking feature of the photographs is the presence of people, who appear everywhere, relaxing on freshly mowed lawns, enjoying drinks outside a park bistro, boating and promenading. In one view of the Lac de Charenton (FIG. 121), Rousset posed over fifty men, women, and children, promenading along the paths and pretending to play on the grass in the foreground.

Many of the lithographs in *Paris dans sa splendeur* were done from photographs. Sumptuous as the publication is, the prints in it are too often weak, lacking both the imaginative draftsmanship of earlier, Romantic topography and the actuality of contemporary photographic publications. The best

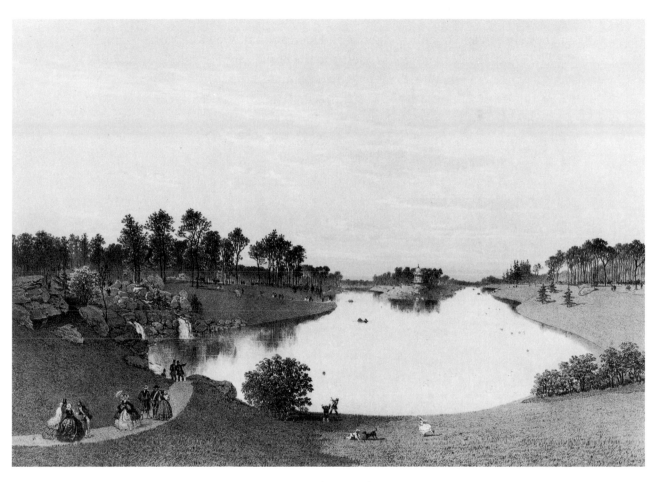

122. EUGÈNE CICÉRI
The Bois de Boulogne: The Grand Lac and Its Cascades, 1863. Color lithograph

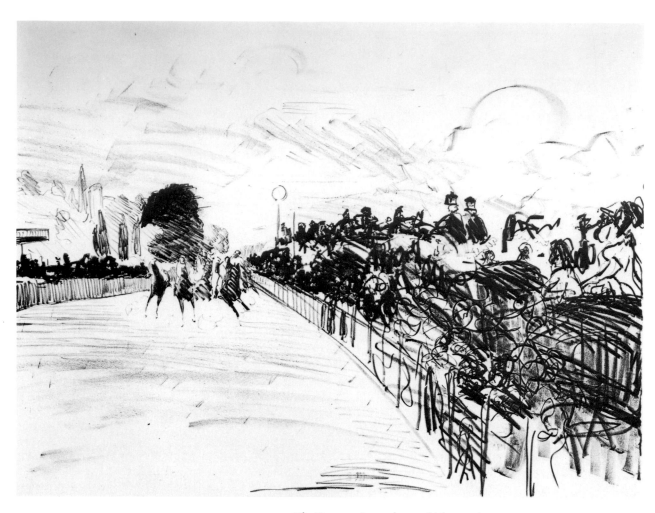

123. EDOUARD MANET. *The Races at Longchamp*. Lithograph

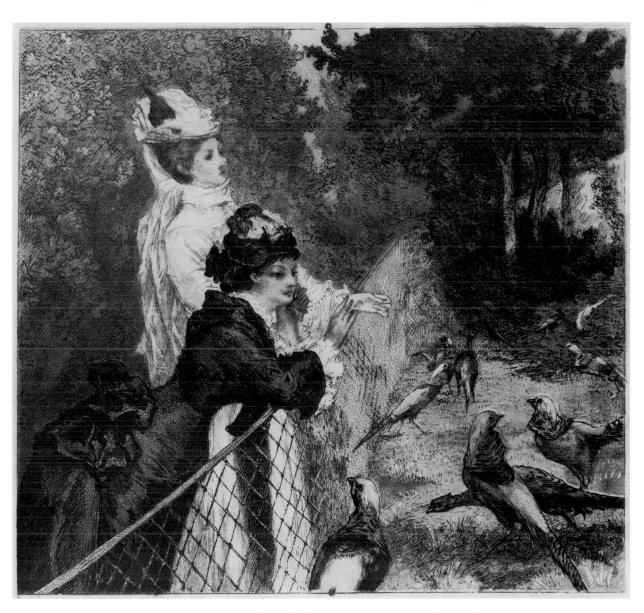

124. FÉLIX BRACQUEMOND. *At the Jardin d'acclimatation*, 1873. Color etching and aquatint

prints are those where color printing has been used to enliven the image such as Eugène Cicéri's *Bois de Bologne: The Grand Lac and Its Cascades* (FIG. 122). The delicate pink of the sky and water gives a sensuous quality to what would otherwise be a rather bare design.

Cicéri's is one of the last representatives of the tradition of topographic printmaking. By and large, the painters and printmakers who found inspiration in the parks did not concentrate on the park as pure landscape. Instead they focused, like the popular illustrators who preceded them, on the human activities that took place there. From Manet's painting *Concert in the Tuileries*, to Degas's studies of the Races at Longchamp and Renoir's of women and children in the Bois de Boulogne, it is the people in the landscape who give it its meaning, and the same is true of the most memorable prints set in the parks.

Manet's lithograph *The Races at Longchamp* (FIG. 123) shows a world neither city nor country, but partaking of both. The race course, on the outer edge of the Bois de Boulogne, had opened in 1857 and became fashionable overnight. The space and atmosphere of the print evoke the country, yet in a sense it is hardly a landscape at all—the scenery is composed of a mass of humanity on the grandstand. Felix Bracquemond's *At the Jardin d'acclimatation* (FIG. 124) depicts another adjunct to the Bois, a zoological garden opened in 1860 and dedicated to the experimental domestication of exotic animals. For *Paris-Guide*, Bracquemond had already provided a documentary illustration of the Jardin.[160] This later print, free from any topographic function, is a vision of civilized nature in the service of man. The gestures of the two ladies, as they lean on the fence watching a flock of pheasants, communicate relaxation. In combination with the elaborate dresses of the ladies and the well cared for, exotic birds, the abundance of green foliage that surrounds them conveys comfortable luxuriance rather than uncontrolled nature. When Vuillard and Lepère depicted the Tuileries Gardens (FIGS. 125, 126) they too showed the park as a peopled landscape. To be sure, Bacler d'Albe in 1822 had drawn the same location with a similar emphasis on its patrons (FIG. 32), but comparison of his view with Vuillard's shows how the whole feeling of people and artists for the park had changed. For Bacler d'Albe, the garden was a sort of walled courtyard or an arcade of trees. The people promenade as if on the street, or sit

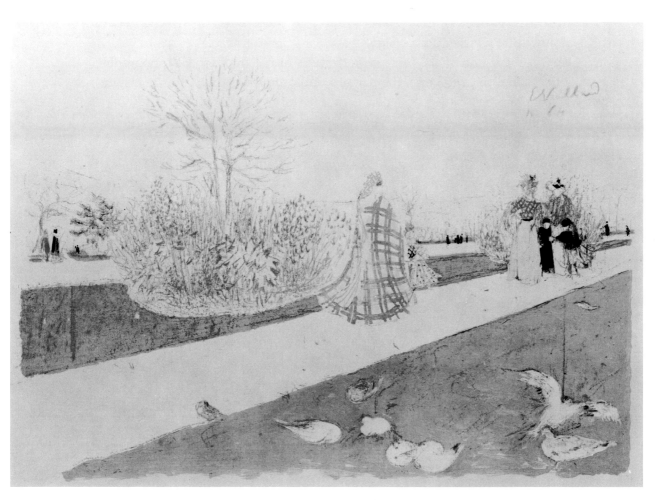

125. EDOUARD VUILLARD. *The Jardin des Tuileries*, 1896. Color lithograph

126. AUGUSTE LEPÈRE. *The Pond in the Tuileries*, 1898. Color woodcut

and talk or read as they would in a restaurant. For Vuillard, the park provides the excuse to dream of "an unlimited space, fields, valleys, the vast sky," in Sand's words. Only if we were familiar with the location would we even guess that the vague lines on the horizon indicate the buildings of the Rue de Rivoli, so carefully delineated by Bacler d'Albe. Lepère's wood engraving similarly screens out the city with a bank of trees and gives us only a distant glimpse of the Louvre. Rather than an open-air reading room, the park has become a playground of light and air, where mothers and nurses promenade with their children or allow them to play with their sailboats.

The city created by Napoleon III, Haussmann, and Alphand was in many respects a stage set. The pageants and performances that took place on this stage were public amusements of all kinds. The fashionable ride around the Grande Cascade, visits by foreign dignitaries, holidays, parades, the races at Longchamp—all were occasions for public gatherings for which the open spaces of park and boulevard provided an appropriate setting. The lake and island in the Bois de Boulogne, bare and empty in Cicèri's topographic view (FIG. 122), are transfigured in Lepère's *Fête at the Bois de Boulogne* (FIG. 127). It is not simply that the trees and other vegetation have grown up to soften the contours of the landscape but that the crowd, the Japanese lanterns, the boats on the lake, and the fireworks have "completed" the scene and inspired Lepère to treat the landscape as an ever-shifting patchwork of light and shade. The park itself is the theater. Similarly, Buhot's *Fête Nationale, First of July, Boulevard Clichy* (FIG. 128) shows the street as setting for an urban pageant. The "symphonic margins" with which Buhot surrounded his prints here add to the gaiety of the central scene. The series of little vignettes contains a multiplicity of incidents, perhaps observed over a whole day of celebration but commanding our attention simultaneously.

The ultimate festival, in late nineteenth-century Europe and America, was the international exhibition. Paris held five of these world's fairs between 1855 and 1900, one every eleven years, drawing visitors from all over the world, and whether the exhibition's buildings were on the Champs-Elysées or the Champ-de-Mars (both landscaped by Alphand), the city was part of the show for a visitor from elsewhere. A feature of the 1878 exhibition was ascensions in a giant captive balloon from the courtyard of the Tuileries, as advertised in a

127. AUGUSTE LEPÈRE
July 14: Venetian Fête in the Bois de Boulogne during the fireworks, 1881. Wood engraving

128. FÉLIX BUHOT. *The Fête Nationale, First of July, Boulevard Clichy*, 1878. Etching

poster (FIG. 129 color section). This exhibition was meant to demonstrate to the world France's recovery from the devastation of the Franco-Prussian War and the civil strife of the Paris Commune in 1870-71. Napoleon's regime had been swept away, and the Tuileries, his residence in Paris, was a fire-gutted shell, soon to be razed completely. But in the poster we are lifted above worldly events, to gaze over the prosperous western sector of Paris cut through and organized by Haussmann's boulevards and stretching out to the horizon.

The 1889 exhibition produced a permanent substitute for the balloon ascensions of 1878, and a piece of park furniture on a scale exceeding the wildest dreams of Alphand—the Eiffel Tower. The highest structure in the world, it was constructed with no other purpose than the giving of pleasure, like a garden "folly." Its subsequent adoption as the symbol of Paris for the tourist visitor is highly appropriate.

The Eiffel Tower was of course depicted abundantly in popular illustration. Its very popularity may have discouraged more serious artists from depicting it frequently—it was simply too obvious a landmark. But Henri Rivière's book *The Thirty-six Views of the Eiffel Tower* gives the structure a suitable artistic treatment. Unabashedly borrowing the style of drawing from Japanese prints and popular prints in *Le Monde illustré*,[161] Rivière showed the Tower from every conceivable view—now a gigantic presence, now a mere speck on the horizon. In *The Tower under Construction* (FIG. 130), as in Goeneutte's view of the Boulevard Clichy (FIG. 106), the falling snow beautifies an urban setting. The Tower appears to be a light and translucent skeleton set against the sky rather than a monumental iron work. *In the Tower* (FIG. 131) takes the viewer to a point high above the city. Through iron beams we look out across Paris. The city is extensive, but the buildings far below dissolve in the haze, the Seine is a river of light winding out to the horizon, and within the structure of technology we seem to be lifted into the natural world of the clouds. Rivière's image, like Baldus's photographs of railroad bridges, shows a landscape which technology has both altered and placed in a new relationship to the beholder.

130. HENRI RIVIÈRE. *The Tower under Construction.* Color lithograph

131. HENRI RIVIÈRE. *In the Tower.* Color lithograph

132. CHARLES DAUBIGNY
Illustrations to the guidebook *Voyage de Rouen au Havre*. Wood engravings

The development of France in the second half of the nineteenth century transformed the experience of the countryside almost as drastically as that of the city, and with it, artistic vision. Through his liberal economic policies, Napoleon III fostered dramatic commercial and industrial expansion, particularly of the railroads. From a little over 3,500 kilometers in 1851, the track increased fivefold by 1870,[162] and the Third Republic continued this expansion, doubling the mileage by the end of the century.[163] Such construction changed the face of the land itself, as it gradually tied remote areas into the political and economic structure of the nation. More immediately the development of railroad travel drastically altered the city dweller's experience of the landscape. The railroad, by encouraging and sponsoring the growth of resorts and spas, gave rise to the development of middle-class tourism. The hero of Stendhal's *Memoirs of a Tourist* of 1837, who faced uncomfortable travels and uncertain accommodations, was superseded by a more modern tourist who enjoyed relative security and assured lodgings, and who was insulated from the vagaries of nature and man. This new tourist not only found a landscape commercialized and developed, but also saw with new eyes the undeveloped, traditional landscape through which he passed. He traveled rapidly through the countryside to a resort destination, in sharp contrast to the explorer of the early part of the century. Anticipation of the known rather than discovery of the unknown marked his travels.

Travel guides now pointed out the attractive sites and lodgings on a trip. At times published by or for the railroads, these guidebooks prepared the traveler for his journey and are among the earliest printed representations of what might be called the landscape of tourism in France. They are in one sense the descendants of the *Voyages pittoresques* in that they chronicled the attractions of a particular region and made them available to a wider public. With the guidebooks, however, a small size afforded portability, so that the book became an essential part of the traveler's kit. The small format, combined with the common use of inexpensive wood engravings for illustrations, kept printing costs low and helped to make these guidebooks available to the new tourist. These two factors also presented the principal limitations in the

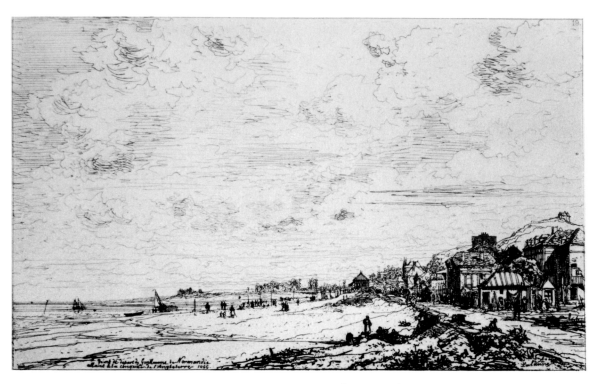

133. MAXIME LALANNE. *Beuzeval*, 1868. Etching

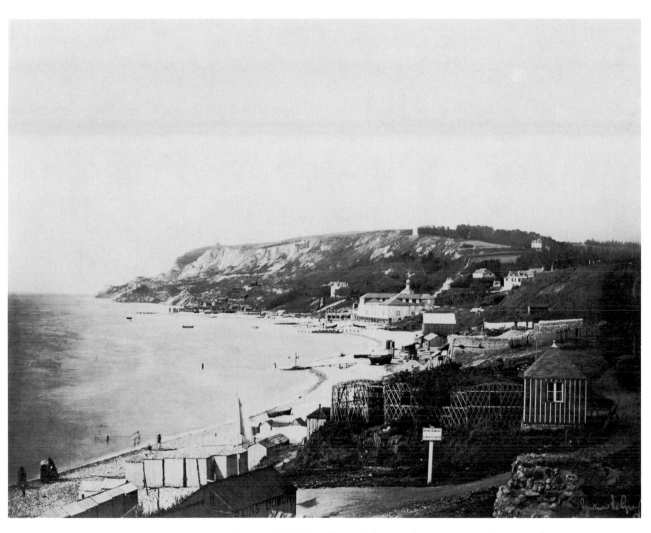

134. GUSTAVE LE GRAY. *Dumont's Baths at Sainte-Adresse,* about 1856-57. Photograph

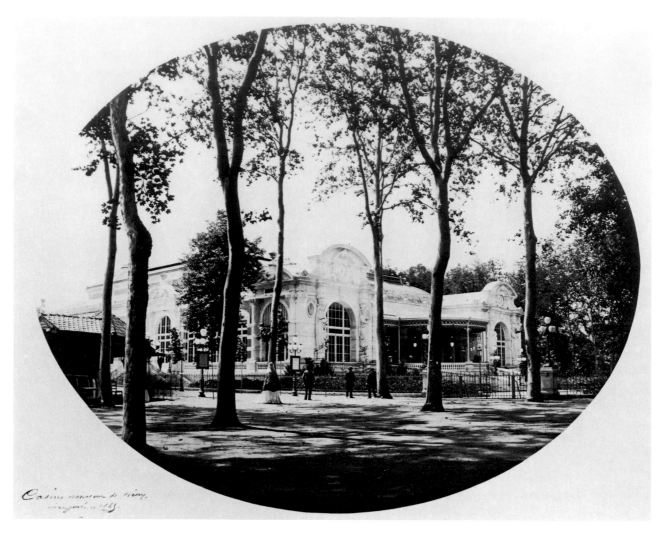

135. CLAUDIUS COUTON. *The New Casino at Vichy,* 1865. Photograph

printmaking associated with these guides. Even when designed by as talented an artist as Daubigny, who illustrated at least fourteen travel guides between 1851 and 1862,[164] the guidebook illustration was small in format and usually coarsened by a mediocre wood-engraver.

Perused en route, the guidebook illustrations of *Voyage de Rouen au Havre* (FIG. 132) would offer the tourist just enough information to let him identify the important monuments along the route or at journey's end. They do not draw the viewer into a deep communion with the landscape, or elicit an emotional reaction. Instead, the guidebook prosaically presents a fragment of the landscape as noteworthy, and the reader duly remembers to observe that particular landscape event. The guidebook as an artifact illustrates the concern with a direct, descriptive presentation of a landscape's features, preparing the traveler for a momentary, superficial encounter with a nature seen as entertaining or pleasurable. The illustration style might be called pragmatic realism.[165]

The tourist's experience of the landscape was typically conditioned and mediated by the products and amenities of civilization. What the traveler found at the end of his journey was a modern resort or country home which mixed city and country, whether the private summer dwellings of Maxime Lalanne's *Beuzeval* (FIG. 133), the larger establishment of Dumont's Baths at Sainte-Adresse seen in Gustave Le Gray's view (FIG. 134), or the extravagant casino of Claudius Couton's *New Casino at Vichy* (FIG. 135), the most elegant Second Empire resort.

Although Lalanne's etching *Beuzeval* bears an inscription identifying the scene as the place from which William the Conqueror launched his invasion of England in 1066, the print itself makes no effort to evoke historical memories. Instead, Lalanne focused on the natural qualities of the site, while minimizing the effects of man's intrusion. Drawing from the Dutch landscape tradition, Lalanne employed a low horizon line with the sky dominating three-quarters of the composition. A wide empty expanse of beach in the foreground greets the beholder, while the Second Empire beach houses lining the coast are compressed into a compact unit in mid-ground, its contours framed by the hill beyond and its details dimmed by dark shading.

On the other hand, Le Gray's *Dumont's Baths at Sainte-Adresse* (FIG. 134)[166] depicts the complete usurpation of the shore by commercial development. The natural contours of the sweeping coastline are punctuated by piers

and bathhouses. A large building appears in mid-ground, and several estates clutter the rocky landscape. Le Gray took his photograph from a vantage point looking down on this scene, yet still within the boundaries of the resort; a prominently located sign announces the establishment's name in both French and English, as if to mark this landscape as a commercial one. Here, in place of the solitary communion with nature that we find in his views of the Forest of Fontainebleau, Le Gray created an image which exhibits the visual noise of the commercialized coast.

Couton's photograph of the new casino at Vichy shows the extravagance of which Second Empire resort architecture was capable. Couton photographed the casino obliquely, to present its monumental Beaux-Arts facade at an informal, almost picturesque angle, seen behind a cluster of tall trees which frames the casino's end pavilion in a nearly symmetrical manner. While Vichy developed around its natural attraction, the mineral springs, it and similar spas became centers of legalized gambling in France early in the nineteenth century,[167] so that by the time of Couton's photograph the Parisian was attracted to such vacation spots by their combination of offerings, of which the curative was merely one. Vichy was one of the most lavish of spas, patronized by Napoleon III who built a chalet there and transformed the town by the construction of boulevards. A bustling rural metropolis, Vichy catered to the wealthy vacationer and was reputed to be a fine place for young women to hunt for husbands.[168]

The role the railroad played in the popularization and development of towns like Vichy may be seen in one of numerous railroad posters from the 1890s, this one advertising the resort at Enghien-les-Bains (FIG. 136).[169] Created for the Chemin de Fer du Nord by Gustave Fraipont, the large, multicolored poster features a rustic sign in the lower corner announcing the resort's attractions: mineral waters, casino, theater, racecourse, boating, fishing. (A later version of the same poster added an even more complete list of features, including a rose garden, a new casino, and an electric show.) The primary view is of a woman feeding swans from a small boat, in a beautiful setting of blue water, lily pads, and a brilliant blue sky. The resort is in the background, with piers, boats, sails, trees, the casino, and people strolling idly around. To balance this idyllic daytime view, and to represent the more urban life of the resort, a vignette in one corner depicts the casino floridly illuminated at night,

136. GUSTAVE FRAIPONT. *Enghien-les-Bains.* Color lithograph

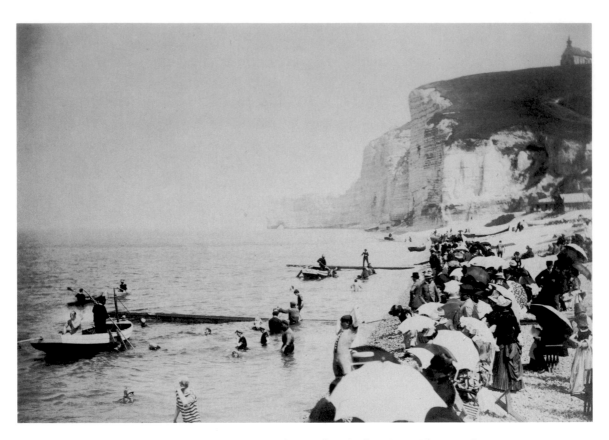

137. ANONYMOUS. *Etretat — The Beach at Bathing Time.* Photograph

with a bright artificial glow coming from beneath its roof, and with crowds of people congregating. This is a place, then, where one can both feed the swans in peaceful, well-appointed quiet, and enjoy a lively evening's entertainment.

Such crowds often figure prominently in resort images, in stark contrast to the solitary experience of landscape typical of the early nineteenth century. An anonymous photograph, *Etretat—The Beach at Bathing Time* (FIG. 137), shows bathers packed together like sardines, and appears as a visual parallel for Henry James's description of the beach at Etretat in "A French Watering Place." James wrote that crowds

sit upon the beach from morning till night; whole families come early and establish themselves, with umbrellas and rugs, book and work. The ladies get sunburnt and don't mind it; the gentlemen smoke interminably; the children roll over on the pointed pebbles and stare at the sun like young eagles. . . . The whole beach seems to be a large family party.[170]

Buhot's *Squall at Trouville* (FIG. 99), as noted earlier, shows a crowd aroused to movement when a summer storm appears on the horizon. These densely packed beaches, so familiar today, are best known in the paintings of Eugene Boudin, who specialized in depicting well-dressed urbanites enjoying themselves on the sun-drenched beaches of Normandy.

Other prints of this period depict the less crowded rural recreation that attracted increasing numbers to country houses outside the city. Vuillard's *Across the Fields* (FIG. 138) captures a party strolling through the countryside decked out in multicolored outfits. Fourteen figures stride through the field on a rural outing, well-dressed urbanites who have come to the "wilds" for a taste of nature.

An earlier example of this sort of portrayal occurs in a photograph by Edouard Baldus (FIG. 139). At first glance this is a somewhat puzzling photograph. Four men and a woman are posed in the open air, but their distance from the photographer is such that the image is not immediately definable as a portrait. Yet they are not mere staffage in a landscape. The landscape itself is a large expanse of lawn bordered by trees with an unidentifiable structure at the right. A second photograph by Baldus (FIG. 140) clarifies the situation. The structure is part of a country house, and the lawn is part of its extensive and well-kept grounds. This is openly a portrait of a piece of property. Like the

239

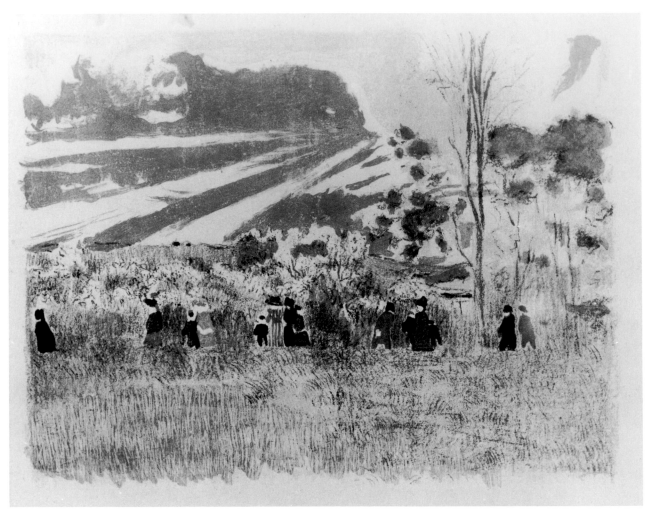

138. EDOUARD VUILLARD. *Across the Fields*, 1899. Color lithograph (see color, cover)

139. EDOUARD BALDUS. *Group Portrait in a Landscape*, about 1855. Photograph

young woman in Gavarni's *Solitude* (FIG. 9), these sitters are well-dressed members of civilization transplanted into a rural setting, but unlike her they do not commune with it. Instead they dominate it. They have cushioned their experience with lawn furniture, so that civilization mediates between them and nature.

Baldus's country house is elegant and formal in its architecture, making no pretense of rural informality. In contrast, a design for a smaller country house by Victor Petit illustrates the urban architect's idea of rustic charm. Calling on the tradition of the picturesque cottage, this house in Enghien (FIG. 141) is an eclectic collage of rustic elements, a thatched roof and half-timbering, along with many more urban details including the masonry ground floor with arched openings, the dormers on the thatched roof, and the two-story height of the house itself—an atypical feature of peasant houses until later in the century.

Although tourists enjoying themselves in the landscape are a significant new subject in prints and photographs of the late nineteenth century, the traditional landscape retained a fascination for the artist, while embodying as we shall see a change in artistic vision and cultural values. Many landscapes, if not the majority, lacked any overt reference to the transformed countryside in subject matter, and in some respects continued the heritage of the Barbizon artists. The serene water in Charles Dulac's lithograph (FIG. 142) shares a contemplative nature with an etching by Daubigny (FIG. 83); the staffage of peasants and washerwomen in the landscapes of Pissarro, Signac, and Rivière (FIGS. 143, 144, 145, color section) continues motifs familiar in Daubigny and Millet (FIGS. 76, 87); the reverie evoked in Degas's landscape monotypes (FIG. 149 color section) directly recalls Corot's *clichés-verres* (FIG. 90). Yet, despite these links to the pastoral tradition, the later landscapes bear the mark of a new aesthetic vision. The change in perception is all the more easily perceived when an artist employed motifs similar to those used by the Barbizon artists. Pissarro's *Twilight with Haystacks* (FIG. 143), a peaceful landscape with two peasants on the road at day's end, is a descendant of a landscape such as Daubigny's *Sheepfold* (FIG. 76), in subject and size, but in style and effect it is essentially different. The most striking quality of the Pissarro is the homogeneous granular texture of the aquatint which defines fields, path, haystacks, and clouds alike, in contrast to the realistic detail of the Daubigny which invites us to examine every furrow of the field. Pissarro's peasants are so

140. EDOUARD BALDUS. *Country House,* about 1855. Photograph

141. VICTOR PETIT. *Rustic House near Enghien,* about 1848. Hand-colored lithograph

vague in description that only close scrutiny reveals the sacks they carry and thereby identifies them as workers. Treated formally no differently than the other elements of the landscape, these peasants function not as a thematic focal point, like Daubigny's shepherd, but as a compositional device.

Signac's *Les Andelys* (FIG. 144 color section) recalls the motif of washer-women on the banks of the Seine which appeared so often in Daubigny's paintings. Yet Signac's is a scene of decorative pattern and optical pleasure rather than emotional identification, despite the fact that his left-wing politics would seem to have made him more concerned about the lives of the rural inhabitants than an artist like Daubigny.[171] We are not made to think of the details of a washerwoman's life and labor, any more than we are made to think of the historical associations of the location – only the title and some knowl-edge of local geography will inform us that the ruins of the Château Gaillard (FIG. 2) look down on this river bank. We are struck neither by the character of the place nor by the character of its inhabitants, but by the excitement of Signac's orchestration of color and the abstract patterns in the landscape. Signac rejected the previous generation's commitment to plein air painting and was not interested in evoking a sense of place. He wrote in his diary:

This mania for painting from nature is quite recent. We should collect mate-rial, not just copy.... What a difference there is between the one who goes out for a walk, stops at random in a shady corner and "imitates" what he finds in front of him, and the one who tries to recall on a sheet of paper or a canvas, by means of beautiful lines and colors, the feelings he experienced at a given moment before a beautiful landscape.[172]

Even when rural workers figure prominently in a late print, as in Rivière's *Baie de Launay* (FIG. 145 color section), the overall effect is not of the artist's concern for the character of the peasant or his ties to the soil. Deriving his color and composition from Japanese prints, Rivière produced a beautiful arrange-ment in which the harvesting peasants function primarily as aesthetic objects. The two bent workers recall Millet's *Gleaners* (FIG. 95) but Rivière effectively divested them both of their identities as workers and of their humanity by making their figures, faces, and hands too vague to convey the tactile quality of their work. This is an especially important aspect of Millet's *Gleaners*, for although he concealed their faces, it was to make them anonymous, elevating

142. CHARLES DULAC. *The Canal*, 1893. Color lithograph

143. CAMILLE PISSARRO
Twilight with Haystacks, 1879. Aquatint with etching and drypoint (see also color section)

them to the universal. Millet took great care to make us empathize with their work, not only in the prominent placement of their heavy bodies in the foreground, but also in such details as their hands reaching for or touching the soil. Through these we experience their fundamental relatedness with the land.

Rivière's figures do not appear to labor, but are compositional elements in the landscape whose forms contribute to its overall decorative effect and spatial organization. The foreground figure, in particular, functions as a vertical unit, while her hay, tilted at a diagonal, creates a visual bridge across the river to the pattern of fields on the opposite shore. Thus, even though the figure is close to our pictorial space, her humanity is denied. Her head is tilted downward so we do not relate to her as an individual; she is psychologically distanced from us. Furthermore, we seem to be raised above her and the landscape, as if we were glimpsing the scene from a train window.

Rivière's detachment may not have been literally facilitated by train travel, but Degas's was. Of a group of landscape monotypes done in the early 1890s, he wrote that

[they] are the fruit of my travels this summer. I would stand at the door of the coach and as the train went along I could see things vaguely. That gave me the idea of doing some landscapes.[173]

Degas did not feel any need to be physically present in the landscape, or even to know it intimately, in order to depict it. In his early work he differed with the Impressionists in part through his emphasis on the role of memory and imagination in the creation of art, and in his landscape monotypes of the 1890s he achieved a liberation of color and form which transcends any literal representation of the landscape.

It is not surprising that artists should have seen the landscape with the eyes of tourists, for they themselves were participating in the tourist experience of nature. Some indeed attempted to find a landscape that they could still experience as explorers. The popularity of Brittany as a territory for artists in the last quarter of the century was due to its comparative backwardness, at a time when the Norman coast and the Forest of Fontainebleau were the regular haunts of tourists. But just as by 1880 the comforts of civilization could be found halfway up Mont Blanc, so in Brittany the artists were only the vanguard of a wave of tourism, not isolated explorers or hermits.

248

Spending one summer here and another there, the artist as tourist would not form the kind of bond with the landscape experienced by those who had settled in Barbizon in a previous generation. Whereas the Barbizon artist presented nature as a regenerative quasi-religious presence, the artist as tourist invites us to visual recreation and delight, whether or not his landscapes actually show people at play or at leisure. The result is a new type of landscape, equally distinct from the explorer's landscape of the Romantic era and from the landscape of pastoral refuge which dominated the middle of the century. The primary content of this new landscape, expressed in a variety of ways, is pleasure.

THE AESTHETICS OF PLEASURE

The expression of pleasure through the art of landscape, between 1860 and 1900, transcends stylistic boundaries. The formal qualities that suggest it most frequently—sparkling light, fluttering or dancing motion, and brilliant color—are those we associate primarily with Impressionism, and indeed the content of Impressionist landscape is almost invariably one of pleasure. Some or all of these qualities, however, appear in many works that cannot be classed as Impressionist. In the media of printmaking and photography, where the influence of Impressionism as a movement was peripheral, this is especially noticeable.

More than a decade before Impressionist painting came to maturity, some of the basic formal constituents of the new landscape can be seen already in one of Charles Marville's photographs of the Bois de Boulogne (FIG. 146). Like Gustave Le Gray in his landscape in the Forest of Fontainebleau (FIG. 88), Marville depicted slender trees with sunlight filtering through their leaves, but his photograph is quite different from Le Gray's in both form and mood. In Le Gray's photograph one is struck by the dark tree trunks standing like pillars in a Gothic church and the light filtering down in the clearing as if from clerestory windows, reinforcing the sensation that the forest is not merely a refuge but a sanctuary. In Marville's photograph, however, the dominant motif is a screen of foliage that continues without interruption across the entire surface. The brilliant white of the sky sparkles between leaves and branches, and this

146. CHARLES MARVILLE. *The Bois de Boulogne,* 1858. Photograph (not in exhibition)

147. ALPHONSE DAVANNE. *Etretat – Côte d'Amont, the Cauldron,* about 1864. Photograph

sparkling pattern is repeated at the bottom of the photograph by reflections in the still water. The lines of the tree trunks cross the boundary between reality and reflection, formally blending the two worlds into one. In looking at the photograph we tend first to perceive a planar surface composed of dancing patterns of light and dark. Quickly we notice that this is partly real and partly a reflection, but we only gradually become aware of the composition, with its water which extends continuously from the foreground to the sunny lawn in the distance. Nonetheless, the effort of perception is not one that makes intellectual or emotional demands on us; it is more like play than work.

Alphonse Davanne's photograph *Etretat–Côte d'Amont, the Cauldron* (FIG. 147) engages in a similar kind of play with the variegated textures of rock. Cliffs and seacoast are a subject well-suited to Romanticism, as in Isabey's *The Environs of Dieppe* (FIG. 19), but Davanne's print negates the awesome aspects of his subject. His vantage point makes us look neither up at the cliffs nor down from them, but out along their length, and the main indication of distance is the pattern of the rock which grows finer as each successive buttress of the cliff recedes behind the last. The pale tonalities of the photograph not only suggest warm summer sunshine, but also weaken our sense of the mass of the rock. These weatherworn rocks do not inspire thoughts of titanic forces as Isabey's do; they form a vista which pleases by the curiosity of its shapes and textures.

The patterns of light and dark that Marville and Davanne captured with their cameras are characteristic of Impressionism in the strict sense of the word, and there are obvious affinities between Marville's photograph of the Bois de Boulogne and Camille Pissarro's *Wooded Landscape at the Hermitage, Pontoise* (FIG. 148). The print, however, has an additional element; a sense of textural richness deriving not simply from the subject but from the characteristics of the medium, the granular aquatint textures that Pissarro used. It would be going too far to say that the artist was simply playing with the medium—the long and complicated technical development of this print indicates Pissarro's seriousness.[174] The apparent freedom and spontaneity of these flecks and patches of tone, however, do give us a sense of enjoyment, very different from the effect produced by the austere line of a print like Daubigny's *Small Sheepfold* (FIG. 76) or the uniform texture of Corot's *clichés-verres* (FIGS. 89, 90).

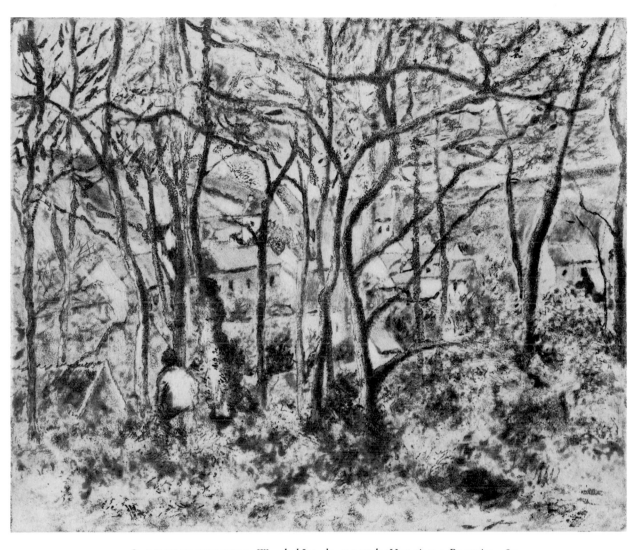

148. CAMILLE PISSARRO. *Wooded Landscape at the Hermitage, Pontoise,* 1879.
Soft-ground etching, aquatint, and drypoint

The landscape monotypes that Degas created in the 1890s evoke a feeling of delight which is both sensuous and profound. *Landscape* (FIG. 149 color section) is not sparkling and lively like the images we have just seen, but calm, even meditative. Done from memory, it is devoid of specific detail and yet gives a strong sense of place, like a countryside that one has dreamed of vividly. Degas's reverie is distinguished from Corot's both by this specificity and by the rich and sensuous harmonies of its color.

There is an apparent lack of artifice and effort inherent in the monotype technique. Ink or oil paint is simply smeared about on a metal plate to get the desired image, and then one print (or two or three at most) can be made from the plate. In reality, it is just the sort of medium where consummate skill is required to produce the appearance of ease. Degas's mastery of the technique and his profound understanding of the bases for harmonious composition result in an image whose forms appear to have floated naturally into place. Without pastoral or transcendental overtones, the print is a landscape of refreshment, recreation in its original sense of regeneration.

Color is of course a powerful agent in the evocation of visual pleasure, and it is not surprising that the printmakers who worked in the late nineteenth century resorted to its use. It is not a question of technical advance, for the methods of color lithography did not change substantially between the time of Boys and that of Bonnard. When printmakers wished to produce color prints, and when patrons wished to buy them, the technical resources were available. Isolated experiments preceded the wave of color printing in the 1890s. For the *Jardin d'acclimatation* (FIG. 124) Bracquemond revived the eighteenth-century technique of color aquatint.[175] Pissarro tried printing different impressions of *Twilight with Haystacks* (FIG. 143) in different single colors, to suggest variants of sunset and twilight.[176] Degas not only made his monotypes in colored inks but worked them up extensively in pastel, virtually turning *Landscape* into a painting on paper.

Above all, however, it was color lithography that appealed to the artists of the 1890s. Just as in the 1820s black-and-white lithography had allowed the Romantic artist to infuse topographic landscape with drama, so in the 1890s color lithography allowed the artist to infuse landscape with visual delight. Edouard Vuillard and Pierre Bonnard took full advantage of these possibilities. The two artists have much in common. Both were profoundly influenced by

Impressionism, but they are not Impressionists. Rather than basing their art directly on the natural world, they took what they saw and reorganized it in structures of their own creation, and in this they were part of the reaction against Impressionism which included both Neo-Impressionists like Signac and Symbolists.

A primary source for the ordered structures of Bonnard and Vuillard was the Japanese print. It is appropriate that the prints of Japan, dedicated to recording the "floating world" of pleasure, should have become so popular in France in the late nineteenth century.[177] But Bonnard and Vuillard did not take over the style of Japanese prints as Rivière so obviously did; rather they combined the principles of decorative composition and the flat bright color of Japanese prints with a painterly handling of the lithographic medium derived from Impressionist painting.

In *Across the Fields* (FIG. 138) Vuillard seems to have used almost every possible way of drawing on the stone—crayon strokes blend with splotches of color seemingly dabbed on with a rag, and lines have been scratched through the color to print white. The variety of texture, the rough edges of each color area, and the simplification of detail give the print an air of relaxation and freedom. There is quiet humor as well, in the way Vuillard's seemingly shapeless blots of color are instantly recognizable not just as people, but as characters: the woman in the striped dress who keeps a firm hand on her child, or the man in green who turns and bends with just the right balance of intimacy and formality to engage the couple behind him. Alongside the humor and the seeming informality is a strong decorative organization; the rhythmical procession of strollers, the tree at the left, and the diagonal sunbeams divide the picture in a manner that is both harmonious and lively. Vuillard may be at play, but if so he is playing a very serious game, with rules partly of his own devising and partly imported from Japan.

Bonnard's *Boating* (FIG. 150 color section) is both more overtly arranged in its composition and broader in its humor than *Across the Fields*. A rectangle of water is neatly framed by two other rectangles—the shore at the left and the truss bridge at the top. Within this rectilinear organization is a patchwork of shapes, spots, and flecks. A mood of recreation and playfulness operates at many different levels here. Literally, the people on the shore and on the water are amusing themselves. To us, the spectators on the shore are comical in their

awkward poses and proportions, but on another level their irregular outlines make a pleasing contrast with the regular diamond shapes of the truss bridge. In addition Bonnard obviously delighted in the unexpected shapes made by the foreshortened or half-concealed boats on the river. The effort required to decipher these shapes draws us into the spirit of play.

Bonnard expressed delight in the visual world, a world which contains the pleasures of boating, green lawns, and sunlit water. Simultaneously he expressed a delight in the power of artistic creation, a power that can take these simple pleasures and translate them into a life-enhancing vision.

UNDER THE RAINBOW

Just as the Romantic landscapists had made no distinction between the picturesque views that they found in city and country, the landscapists of the late nineteenth century made none between city and country as pleasurable environments. *Across the Fields* and *The Jardin des Tuileries* are interpreted in the same way by Vuillard, and at first glance it is impossible to say whether Bonnard's *Boating* is set in a Parisian park or on a stretch of river away from the city. In art, if not in reality, the Saint-Simonian vision of France transformed into a vast park would seem to have been realized.

In Félix Bracquemond's *The Rainbow* (FIG. 151 color section) city and country are included within the same composition. From a secluded point on the Seine, downstream from Paris at Meudon, we look back at the city. In the foreground, a nude is seated on a bank, surrounded by lush green vegetation and flocks of ducks. In the midground, at the left, is a primitive thatched structure—most likely a boathouse to judge from the cluster of boats moored nearby. Then comes an industrial suburb with belching smokestacks, a chain of barges on the river, and finally the expanse of Paris. We have progressed from a view of humanity in harmony with nature to one of industrial civilization with its commerce and its cultural edifices—the towers of Notre-Dame, the dome of the Pantheon, and the Eiffel Tower.

Bracquemond had already used the rainbow as part of an allegory in a gigantic ceramic mural of 1875.[178] There he had set personifications of water

and fire against a landscape of factories and railroads, overarched by a rainbow. A verse on the mural reads

> *Wild water, and Fire from the lava-filled volcano*
> *Become the docile slaves of Progress.*

The present etching seems intended to express a similar late nineteenth-century optimism. Rather than emphasizing man's dominion over nature, *The Rainbow* suggests that city and country, industry and pleasure coexist harmoniously, and the rainbow, heralding sunshine after the storm, extends a cosmic benediction over the whole landscape.

In reality, of course, all was not peace and harmony beneath the rainbow. Haussmann's rebuilding of Paris had destroyed slums but provided no new housing for the poor who had lived in them. Displaced to the outskirts of the city, they continued to live in squalor, though no longer so obviously visible to those who dwelt in the renovated central city.[179] In a poignant scene near the end of Zola's *L'Assommoir*, Gervaise searches angrily for her delinquent daughter Nana on the Boulevard Magenta, newly created by Haussmann. The grand new buildings irritate her for they represent an opulence and luxury in which she has no share. The air, space, and greenery of the new Paris did little to ameliorate the tragedy of lives like Gervaise's. In 1882, writing about the working-class suburbs of Paris, the Socialist journalist Jules Vallés commented that for the poor, the countryside was now farther away than it had been early in the century when it began at the customs barriers. Only those with the price of a railroad ticket could escape the city.[180] And in the country, nature seldom equaled the ideal liveliness which surrounds the near end of Bracquemond's rainbow.

Aware of problems like these, a modern viewer may be tempted to an ironic interpretation of Bracquemond's allegory. Overloaded with incident, the print is not ideally restful and harmonious. The rainbow, which should unite city and country, is fragmented into two disconnected segments, one interpreted naturalistically, the other allegorically as Iris's scarf. The short segment that appears over the city emerges from a storm cloud and vanishes into the urban pollution of factory smoke. Whereas in Bracquemond's earlier *Pont des Saints-Pères* (FIG. 98), the rainbow is not only unbroken, but is an almost perfect circle, completed by its reflection in the water, this later allegor-

ical rainbow seems more a suggestion of an impossible unity than a confirmation of a new synthesis.

What is certain is the attraction that Bracquemond and his contemporaries, from Lepère to Vuillard, found in the vision of city and country as pleasurable, complementary environments. Whereas the Barbizon artists abandoned the city for a countryside which they idealized, these later artists developed an idyllic vision encompassing both city and country. However, like the Romantic delight in dramatic scenery, like Meryon's image of the stony and pitiless city, and like the pastoral countryside of the Barbizon artists, this is a vision whose power derives both from what it emphasizes and from what it omits.

Notes

Unless otherwise indicated, translations of excerpts from French texts into English are by the authors.

1. General information on Romanticism in this chapter is based chiefly on the following: Hugh Honour, *Romanticism* (New York: Harper & Row, 1979); Geoffrey Hartman, "Reflections on Romanticism in France," in David Thorburn and Geoffrey Hartman, eds., *Romanticism: Vistas, Instances, Continuities* (Ithaca, 1973), pp. 38-61; Irving Babbitt, *Rousseau and Romanticism* (1919; reprint, Austin: University of Texas Press, 1977). On Romantic landscape prints, the following two works are particularly useful: Jean Adhémar, "Les Lithographies de paysage en France à l'époque romantique," *Archives de l'art français*, n.s. 19 (1938), pp. 189-364; Michael Twyman, *Lithography 1800-1850: The Techniques of Drawing on Stone in England and France and Their Application in Works of Topography* (London: Oxford University Press, 1970).

2. On the *Voyages pittoresques*, see Adhémar, "Les Lithographies de paysage"; Twyman, *Lithography*, pp. 226-53; Anita Louise Spadafore, "Baron Taylor's *Voyages pittoresques*" (doctoral dissertation, Northwestern University, Evanston, Ill., 1973).

3. Honoré de Balzac, *Les Paysans* (1844; reprint, Paris: Ernest Flammarion editeur, 1928), p. 30.

4. Eugen Weber, *Peasants into Frenchmen: The Modernization of Rural France 1870-1914* (Stanford, Calif.: Stanford University Press, 1976), pp. 3-22, 67-114.

5. Charles Nodier, *Voyages pittoresques et romantiques dans l'ancienne France: Normandie* I (Paris, 1820), p. 4.

6. Madame de Stael's book *De l'Allemagne* (reprint, Paris: Firmin Didot, 1853, pp. 574-89), first published in France in 1815, one of the major theoretical works for the aesthetics of Romanticism, contains a chapter extolling enthusiasm as a quality of mind.

7. Nodier, *Voyages pittoresques: Normandie* I, p. 10.

8. Twyman, *Lithography*, pp. 236-48; Spadafore, "Baron Taylor's *Voyages*," pp. 87-92.

9. Nodier, *Voyages pittoresques: Normandie* I, pp. 3, 8, 9; *Normandie* II (Paris, 1825), p. 4.

10. Nodier, *Voyages pittoresques: Franche-Comté* (Paris, 1825), p. 9.

11. Nodier, *Voyages pittoresques: Franche-Comté*, p. 8.

12. David Carey, *Life in Paris; Comprising the Rambles, Sprees, and Amours of Dick Wildfire of Corinthian Celebrity, and his Bang-up Companions, Squire Jenkins and Captain O'Shuffleton, with the Whimsical Adventures of the Halibut Family* (London, 1822), pp. 9-10.

13. On early nineteenth-century travel, see Adhémar, "Les Lithographies de paysage," pp. 210-12; Henri Cavaillès, *La Route française, son histoire, sa fonction; étude de géographie humaine* (Paris, 1946), pp. 226-62. J. Hilpert, *Le Messagiste* (Paris, 1840), a manual on the operation of a diligence service, details the types of accident and breakage that could occur (pp. 49-61) and the difficulties of securing reliable employees (pp. 44, 100-01).

14. Stendhal, *Memoirs of a Tourist*, first published 1838, trans. Allan Seager (Evanston, Ill.: Northwestern University Press, 1962).

15. Jean Vidalenc, *La Société française de 1815 à 1848. II. Le Peuple des villes et des bourgs* (Paris, 1973), pp. 264-74.

16. Pierre Miguel, *Paul Huet, de l'aube romantique à l'aube impressioniste* (Sceaux, 1962), p. 16.

17. Paul de Kock, "Une fête aux environs de Paris," in *Paris, ou le livre des cent-et-un* (Paris, 1831-34) I, pp. 249-80.

18. Jean Jacques Rousseau, *The Confessions*, first published 1781, trans. J. M. Cohen (Harmondsworth: Penguin Classics, 1953), p. 362.

19. Adhémar, "Les Lithographies de paysage," p. 218.

20. Claire Eliane Engel, *La Littérature alpestre en France et en Angleterre aux XVIII^e et XIX^e siècles* (Chambéry, 1930), pp. 18-24.

21. Nodier, *Voyages pittoresques: Franche-Comté*, pp. 9-10.

22. Rousseau, *Confessions*, pp. 167-68.

23. Nodier, *Voyages pittoresques: Franche-Comté*, p. 77.

24. Hartman, "Reflections on Romanticism," p. 48; Engel, *La Littérature alpestre*, p. 165.

25. The technical process used by Dupressoir, outlines in soft-ground etching and tones added in aquatint, recalls the combination of etching and mezzotint used by Turner for his great series of landscape prints, *The Liber Studiorum*, published between 1807 and 1819. Like Turner, Dupressoir etched only the outlines himself; a second artist, H. Berthoud, added the aquatint, probably following a wash drawing by Dupressoir.

26. Spadafore, "Baron Taylor's *Voyages*," p. 140.

27. Spadafore, "Baron Taylor's *Voyages*," p. 151.

28. Victor Hugo, "Oceano Nox" (from *Les Rayons et les Ombres*), in *Morceaux choisis de Victor Hugo; poésie* (Paris: Librairie Delagrave, n.d.), pp. 201-03.

29. John Constable, *Correspondance*, ed. with introductions and notes by R. B. Beckett (Ipswich, 1968) VI, p. 172. *Low Tide* invites comparison with *English Landscape Scenery*, the series of prints after landscapes by Constable that were published between 1830 and 1833. Constable's engraver, David Lucas, used mezzotint, an engraving technique in which subtle shading is achieved by roughening and polishing the plate. *Low Tide* is done in mezzotint lithograph, the lithographic stone being inked and scraped to give a similar rich variety of shading. In size and format *Low Tide* is very close to the prints in *English Landscape Scenery* – it could well have been made in deliberate rivalry of the English series.

30. Paul de Kock, "Une fête aux environs de Paris," p. 258.

31. Quoted in Richard Cobb, *Paris and Its Provinces 1792-1802* (London, 1975), p. 42.

32. Honour, *Romanticism*, pp. 240-43. Victor Hugo expresses the idea in *Les Misérables* (1862; reprint, Paris: Bibliothèque de la Pléiade, 1951, p. 90): "The cities produce ferocious men, because they make corrupt men. The mountain, the sea, the forest produce wild men. They develop the fierce side of a man's character, without destroying the human side."

33. Victor Hugo, "À Albert Dürer" (from *Les Voix intérieures*) in *Morceaux choisis*, pp. 153-54.

34. Rousseau, *Confessions*, pp. 362-63.

35. François René de Chateaubriand, *Atala, René, Le Dernier abencerage, Les Natchez* (Paris: Garnier, n.d.), pp. 85-88.

36. Miguel, *Paul Huet*, p. 17.

37. Barbara W. Tuchman, *A Distant Mirror: The Calamitous Fourteenth Century* (New York: Ballantine, 1979), p. 3.

38. Like Isabey in *Low Tide* (see note 29), Huet was probably courting comparison with the mezzotints of David Lucas after Constable. Huet's print, too, is a mezzotint lithograph, similar to the prints of Lucas in size and format.

39. Twyman, *Lithography*, pp. 238-39.

40. Vidalenc, *Société française*. I. *Le Peuple des campagnes* (1969), p. 35.

41. Vidalenc, *Société française* I, p. 35. In 1816 there were only nine cities in France with more than 50,000 inhabitants. Paris, with a population of 716,000, was larger than the other eight *combined*.

42. Louis Bacler d'Albe, *Promenades pittoresques et lithographiques dans Paris et ses environs* (Paris, 1822), preface.

43. Frédéric de Courcy, "Promenades de Paris" in Louis Lurine, ed., *Les Rues de Paris, Paris ancien et moderne, origines, histoire, monuments* (Paris, 1844) II, pp. 237-50.

44. Vidalenc, *Société française* II, p. 269.

45. Vidalenc, *Société française* II, p. 345.

46. Wolfgang Schivelbusch, *The Railway Journey: Trains and Travel in the Nineteenth Century*, trans. Anselm Hollo. (New York: Urizen Books, 1979), p. 47.

47. Schivelbusch, *Railway Journey*, pp. 58-59.

48. Weston J. Naef, "The Beginnings of Photography as Art in France," in *After Daguerre: Masterworks of French Photography (1848-1900) from the Bibliothèque Nationale* (New York: Metropolitan Museum of Art, 1980), pp. 15-20. Naef shows how technical experimentation in the 1840s laid the foundation for an artistic flowering in the following decades.

49. Quoted in Eugenia Parry Janis, "The Man on the Tower of Notre Dame: New Light on Henri Le Secq," *Image* 19, no. 4 (December 1976), p. 23.

50. Eugenia Parry Janis, "Photography," in *The Second Empire, 1852-1870: Art in France Under Napoleon III* (Philadelphia: Philadelphia Museum of Art, 1978), p. 404.

51. Naef, "Beginnings of Photography as Art," p. 58.

52. Charles Durier, *Le Mont Blanc* (Paris, 1880), pp. 280-84, discusses the improvement of accommodations at the Station des Grands Mulets between 1853 and 1880.

53. Hugo, *Les Misérables*, p. 486.

54. Alexandre Jean Baptiste Parent-Duchatelet, *De la prositution dans la ville de Paris considerée sous le rapport de l'hygiène publique, de la morale et de l'administration, ouvrage appuyé de documens* [sic] *statistiques* (Paris, 1836). On middle-class preoccupation with crime and the social conditions that produced it, see Louis Chevalier, *Labouring Classes and Dangerous Classes in Paris during the First Half of the Nineteenth Century* (London, 1973), pp. 1-10, especially.

55. Adele M. Holcomb, "Le Stryge de Notre Dame: Some Aspects of Meryon's Symbolism," *Art Journal* 31 (1971-72), p. 151.

56. Holcomb, "Le Stryge," pp. 155-56, discusses Meryon's identification of the demon with Luxuria, and the conception of the nineteenth-century city as a hotbed of sexual corruption.

57. Loys Delteil and Harold J. L. Wright, *Catalogue Raisonné of the Etchings of Charles Meryon* (New York, 1924), no. 19.

58. Delteil and Wright, *Meryon*, no. 20.

59. Jules Janin, "Asmodée," in *Paris, ou le livre des cent-et-un* (Paris, 1831-34) I, pp. 1-15.

60. Honoré de Balzac, *Splendeurs et misères des courtisanes* (1847; reprint, Paris: Gallimard, 1973).

61. Leslie Stephen, cited in Babbitt, *Rousseau and Romanticism*, p. 94.

62. William B. Sewell, *Work and Revolution in France, the Language of Labor from the Old Regime to 1848* (Cambridge: Cambridge University Press, 1980), pp. 138-42, discusses how the Revolution broke down structures that had formerly regulated trade, depriving the worker of the protection he had formerly enjoyed in relations with master or employer, and how, as a result, the possession or lack of capital became the dominant factor in relations between worker and employer.

63. Nucingen's financial operations are most extensively described by Balzac in *La Maison Nucingen* (first published, 1838).

64. Chevalier, *Labouring Classes*, p. 183.

65. Chevalier, *Labouring Classes*, p. 200.

66. Hugo, *Les Misérables*, p. 1700, n. 44. The elephant was finally demolished in 1846.

67. Hugo, *Les Misérables*, p. 978.

68. Quoted in Chevalier, *Labouring Classes*, p. 198.

69. Maria Morris Hambourg, "Charles Marville's Old Paris," in *Charles Marville, Photographs of Paris at the Time of the Second Empire on Loan from the Musée Carnavalet, Paris* (New York: French Institute/Alliance Française, 1981), pp. 7-11.

70. Chevalier, *Labouring Classes*, pp. 152-53.

71. David H. Pinkney, *Napoleon III and the Rebuilding of Paris* (Princeton, N.J.: Princeton University Press, 1958), pp. 105-07. River water (though not all from the Seine) accounted for 98 percent of the Parisian water supply in early 1850s.

72. "Recherches et considérations sur l'enlèvement et l'emploi des chevaux morts," *Receuil industriel, manufacturier, agricole et commercial, de la salubrité publique et des beaux-arts* 3 (1827), pp. 5-38, 159-77, 241-81; 5 (1828), pp. 42-54, 122-27, 231-68.

73. Chevalier, *Labouring Classes*, p. 211.

74. Sewell, *Work and Revolution*, pp. 160-61, 194-97.

75. Chevalier, *Labouring Classes*, pp. 227-29, 261-68.

76. Chevalier, *Labouring Classes*, pp. 110-28, 360-72.

77. Jean Pierre Seguin, *Canards du siècle passé* (Paris, 1969), unpaginated, gives a general history of the type of print.

78. Chevalier, *Labouring Classes*, pp. 288-92.

79. *Paris qui s'en va et Paris qui vient* (Paris, 1859-60), pl. 2, commentary.

80. Alfred Cobban, *A History of Modern France* (New York: George Braziller, 1965), II, pp. 143-45; Sewell, *Work and Revolution*, pp. 265-72.

81. Good basic accounts of Meryon's life and work are Delteil and Wright, *Meryon*, and James D. Burke, *Charles Meryon, Prints and Drawings* (New Haven: Yale University Art Gallery, 1974).

82. Foul biting occurs when the acid used to etch a plate marks it accidentally. In the final print it usually takes the form of mottled gray tones, made up of countless tiny dots. It can be eliminated or reduced by polishing the plate, but it may also be allowed to remain if it happens to be suitable to the general effect of the print.

83. Gustave Bourcard, *A travers cinq siècles de gravures* (Paris, 1903), quoted in Delteil and Wright, *Meryon*, no. 27.

84. Burke, *Meryon*, p. 3.

85. Janis, "The Man on the Tower...Henri Le Secq," pp. 20-23.

86. On Bayard see André Jammes, *Hippolyte Bayard, ein verkannter Erfinder und Meister der Photographie* (Lucerne, 1975).

87. Delteil and Wright, *Meryon*, no. 37.

88. By Fritz Novotny, *Painting and Sculpture in Europe 1780-1880*, Pelican History of Art (Harmondsworth: Penguin Books, 1971), p. 174.

89. Alfred Sensier, *La Vie et l'œuvre de J. F. Millet* (Paris, 1881), p. 44, quoted in Robert Herbert, "City vs. Country: The Rural Image in French Painting from Millet to Gauguin," *Artforum* 8, no. 6 (February, 1970), p. 49.

90. Etienne Moreau-Nélaton, *Corot raconté par lui-même* (Paris: Henri Laurens, Editeur, 1924), p. 40.

91. Robert Herbert, *Barbizon Revisited* (Boston: Museum of Fine Arts, 1962), p. 148.

92. Eugenia P. Janis observed the possible role of the seated woman as a symbolic muse.

93. Renato Poggioli, *The Oaten Flute: Essays on Pastoral Poetry and the Pastoral Ideal* (Cambridge, Mass.: Harvard University Press, 1975), p. 14.

94. Weber, *Peasants into Frenchmen*, p. 14.

95. Bonnie L. Grad, "Le Voyage en Bateau: Daubigny's Visual Diary of River Life,"

The Print Collector's Newsletter II, no. 4 (September-October 1980), pp. 123-26.

96. Leo Marx, *The Machine in the Garden: Technology and the Pastoral Ideal in America* (New York: Oxford University Press, 1964), p. 22.

97. Grad, "Le Voyage en bateau," p. 124.

98. Weber, *Peasants into Frenchmen*, p. 135.

99. Hippolyte Taine, *Notes sur Paris: Vie et opinions de M. Frédéric-Thomas Graindorge* (Paris: Hachette, 1867), p. 286.

100. Gaston Bachelard formulated the concept of "rêverie œuvrante" or working reverie, the necessary contemplation that prepares the poet's work in his phenomenological study of reverie. *The Poetics of Reverie: Childhood, Language and the Cosmos*, trans. Daniel Russell (Boston: Beacon Press, 1969), p. 182.

101. Bonnie L. Grad, "An Analysis of the Development of Daubigny's Naturalism Culminating in the Riverscape Period (1857-1870)" (doctoral dissertation, University of Virginia, Charlottesville, 1977).

102. Edmond About, *Salon de 1864* (Paris, n.d.), p. 87.

103. Although it has been assumed that the etching was made after the painting, it is more likely that the etching was the basis of the painting and actually influenced its style; Grad, "Daubigny's Naturalism," p. 63. On the influences of printmaking on Daubigny's painting, see also Madeleine Fidell, "The Graphic Art of Charles François Daubigny," (doctoral dissertation, New York University, 1974) I, pp. 60-87.

104. Ildefonse Rousset and Emile de la Bedollière, *Le Tour de Marne* (Paris, 1865), pp. 2-3.

105. The relationship between water imagery in art and the public need for fresh water in mid-century Paris was discussed by Grad in "Daubigny's Naturalism," pp. 100-02, and is the subject of her forthcoming essay "Le Luxe de l'eau: Water Pastorals in Second Empire France."

106. Pinkney, *Napoleon III*, "A Battle for Water," pp. 105-26.

107. Theodore Zeldin, *France, 1848-1945: Intellect and Pride* (New York, 1980), p. 92.

108. Weber, *Peasants into Frenchmen*, p. 146.

109. Claude François Denecourt, *Le Palais et la forêt de Fontainebleau, guide historique et descriptif* (Fontainebleau, 1856). This edition contains an autobiography, pp. 319-54.

110. Gustave Flaubert, *L'Education sentimentale* (1869; reprint, Paris: Classiques Garnier, 1964), p. 323.

111. See, for example, *Souvenir of the Bas Bréau*, in Loys Delteil, *Le Peintre-graveur illustré* (Paris, 1906-26) V, no. 73.

112. Bachelard, *Poetics*, p. 111.

113. L. P. Wilkinson, *Horace and His Lyric Poetry* (Cambridge: Cambridge University Press, 1968), p. 55. He notes that the Roman poet was "writing from experience, not from literary suggestion."

114. Michel Melot, *Graphic Art of the Pre-Impressionists* (New York, 1980), p. 17, has pointed out that because *clichés-verres* were never popular within the art-buying public, artists who made prints for a living only experimented briefly with the process.

115. Weber, *Peasants into Frenchmen*, pp. 162-63.

116. Weber notes that the health of rural people was poorer than that of urban dwellers, *Peasants into Frenchmen*, pp. 150-51.

117. Herbert, "City vs. Country," p. 48.

118. Weber, *Peasants into Frenchmen*, pp. 124, 129.

119. Robert Herbert, "Millet's *Gleaners*," in *Millet's Gleaners* (Minneapolis: Minneapolis Institute of Art, 1978), pp. 18-19.

120. Robert Herbert, "Millet Revisited, I," *Burlington Magazine* 104 (July 1962), p. 296.

121. Alexander Seltzer, "Alphonse Legros: The Development of an Archaic Visual Vocabulary," 2 vols. (doctoral dissertation, State University of New York at Binghamton, 1980).

122. Emile Zola, *Earth* (1887; reprint, London: New English Library, 1962), p. 37.

123. George Sand, "La Rêverie à Paris," ap-

pears in *Paris-Guide par les principaux écrivains et artistes de la France* (Paris, 1867), part 2, pp. 1195-203.

124. Jean Jacques Rousseau, *Les Rêveries du promeneur solitaire* (1782). The reveries do not so much describe walks as the thoughts that came to Rousseau while walking.

125. "There is something about walking which stimulates and enlivens my thoughts. When I stay in one place I can hardly think at all; my body has to be on the move to set my mind going. The sight of the countryside, the succession of pleasant views, the open air, a sound appetite and the good health I gain by walking, the easy atmosphere of an inn, the absence of everything that makes me feel my dependence, of everything that recalls me to my situation—all these serve to free my spirit, to lend a greater boldness to my thinking, to throw me, so to speak, into the vastness of things, so that I can combine them, select them and make them mine as I will, without fear or restraint." Rousseau, *Confessions*, pp. 157-58.

126. Sand, "La Rêverie," p. 1197.

127. Sand, "La Rêverie," p. 1198.

128. Henry Blackburn, *Artistic Travel in Normandy, Brittany, the Pyrenees, Spain and Algeria* (London: Sampson, Low, Marston & Co., 1892), p. 53.

129. Although Napoleon III was not a Saint-Simonian, numerous historians have noted the relationship between the theories of the utopian thinker and the dictator. Albert Guerard, in *Napoleon III* (Cambridge, Mass.: Harvard University Press, 1943), noted the prominent role of Saint Simonists such as Prosper Enfantin, Michel Chevaliers, and Emile and Isaac Perière in the major commercial enterprises of Napoleon's regime and discussed the relationship between the two leaders' ideas. Alfred Cobban, in *A History of Modern France*, states that Napoleon was attracted to "the promise of Saint-Simonian ideas," which provided him an economic program that included "the expansion of credit, railways, industry, trade,

even the rebuilding of Paris, for which there had been a Saint-Simonian plan in 1832" (II, pp. 162-63). Frank E. Manuel, in *The New World of Henri Saint-Simon* (Cambridge, Mass.: Harvard University Press, 1956), calls the empire of Napoleon III "self-consciously Saint-Simonian" (p. 315). See also: Donald Drew Egbert, *Social Radicalism and the Arts, Western Europe* (New York: Alfred A. Knopf, 1970), p. 187; Anthony Vidler, "The Reconstruction of Urban Utopias in Late Nineteenth-Century France," *Perspecta* 13-14 (1971), pp. 243-56; Bernard Marrey, "Saint-Simoniens, Fourieristes et Architecture," *Archives d'architecture moderne*, no. 20 (1981), pp. 74-99.

130. Guerard, *Napoleon III*, p. 214.

131. Manuel, *The New World*, p. 315.

132. Translation by James D. Burke, *Meryon*, pp. 108-09.

133. In Charles Baudelaire, *Oeuvres Complètes* (Paris: Bibliothèque de la Pléiade, 1961), p. 81.

134. Emile Zola, *L'Assommoir*, first published 1877, trans. L. W. Tancock (Baltimore: Penguin Books, 1970), pp. 85-87.

135. Pinkney, *Napoleon III*, p. 70.

136. This engineering appears in a sectional drawing through a street in Alphand's *Promenades de Paris* (Paris, 1867-73). (See FIG. 102.)

137. Emile Zola, *L'Oeuvre* (1886; reprint, Paris: Fasquelle Edition, 1980), p. 137.

138. The publishing firm L. Hachette et Cie specialized in guides to Paris, her environs, and resorts. Among its offerings from the period are *Petit guide de l'étranger à Paris* (1855) by Frederic Bernard; *De Paris à Saint-Germain, à Poissy et à Argenteuil* (1856); *Les environs de Paris illustrés, itineraire descriptif et historique* (1856); and *Paris-Diamant* (1867) by Aldolphe Joanne. Numerous other guides from the period may be found in the *Catalogue Général de la Librairie Française depuis 1840*, ed. Otto Lorenz (Paris, 1924), vol. 8. The listing also includes the prices of the books discussed in the text as follows: *Paris dans sa splendeur,*

published in 50 issues between 1858 and 1863: 200 fr; Alphand's *Promenades de Paris* (1867-73): 480 fr; Ildefonse Rousset's *Le Bois de Vincennes* (1865): 33 fr; *Paris-Guide* (1867): 20 fr. *Paris-Diamant* was published in several editions; the 1874 guide sold for 2 fr. 50 c.

139. Yi-Fu Tuan explores this geographical concept in *Topophilia: A Study of Environmental Perception, Attitudes and Values* (Englewood Cliffs, N. J.: Prentice-Hall, 1974).

140. Pinkney, *Napoleon III*, p. 70. G. E. Haussmann, *Mémoires du Baron Haussmann* (Paris, 1890), II, p. 513.

141. See, for instance, Lewis Mumford, *The City in History, Its Origins, Its Transformations and Its Prospects* (New York: Harcourt, Brace and World, 1961), pp. 369-70.

142. Philip Gilbert Hamerton, *Paris in Old and Present Times* (Boston, 1900), p. 220.

143. Camille Pissarro, *Letters to His Son Lucien*, ed. with the assistance of Lucien Pissarro by John Rewald (New York: Pantheon Books, 1943), letter dated December 15, 1897, pp. 315-16.

144. This print is based on his painting *The Boulevard de Clichy under Snow* (Tate Gallery, London) of 1875-76. Gabriel Weisberg has interpreted the painting as revealing the "effects of a dismal wintry day," in *The Realist Tradition: French Painting and Drawing, 1830-1900* (Cleveland: Cleveland Museum of Art, 1980), pp 260-61. The painting is less appealing because it lacks falling snow, the main feature of the print, which evokes the sense of a city blessed by nature.

145. Hamerton, *Paris*, p. 200.

146. Georges Montorgueil, *La Vie des Boulevards Madeleine-Bastille* (Paris, 1896).

147. Pinkney, *Napoleon III*, p. 104.

148. Antoine Grumbach, "The Promenades of Paris," *Oppositions* 8 (Spring 1977), pp. 51-67.

149. Alphand, "Texte," *Promenades de Paris;* for discussion and illustrations of fences imitating wood, see p. 10; the rocks, pp. 31-36. Pinkney discusses the ritual of the daily promenade around the cascade, *Napoleon III*, p. 97.

150. Victor Fournel, *Paris nouveau et Paris futur* (Paris, 1865), p. 115, cited by Joanne Richardson in *La Vie parisienne, 1852-1870* (New York: Viking Press, 1971), p. 208.

151. Alphand, "Texte," *Promenades de Paris.* For discussion and diagrams of wells, see pp. 10-11; for various types of sprinkling systems and their costs, pp. 17-25; the machinery used for the transplanting of trees, pp. 46-48.

152. Gustave Claudin, *Paris et l'exposition universelle* (Paris, 1867), p. 175.

153. Bernard de Saint-Pol Lias, "Le Bois de Boulogne," in *Le Monde moderne* 10 (1899), p. 47.

154. Other illustrated journals of the period which featured highlights of Parisian life include *Paris nouveau illustré* (1864-72) and *La Vie moderne: Journal illustré hebdomodaire* (1879-1902).

155. Among illustrations depicting the imperial family are two crowded ice-skating scenes on the lake from January of 1861 and 1867, with Eugenie being skated around the ice on a chair sleigh. The former view includes a carpet spread on the ice with chairs and a table set for a tea break. Other views show Napoleon promenading in the Bois (March 1864) and Haussmann with the viceroy of Egypt (June 1869).

156. Horse racing appeared October 16, 1858; jogging, July 9, 1887; an ostrich-drawn cart carrying children in the Jardin d'acclimatation was the cover illustration on May 15, 1880. Other illustrations include a pony pulling a wagonload of children, August 20, 1880, and a boat race, June 7, 1890.

157. Janet E. Buerger cites Disdéri as one photographer who established a "suburban temple" to photograph the elite riding in the Bois, in *Pierre Petit: Photographer* (Rochester: International Museum of Photography at George Eastman House, 1980).

158. Delton published three books entitled *Le Tour du Bois* in 1882, 1884, and 1885, each containing 25 photographs of various

esteemed personages riding on horseback through the Bois. The second and third books each include a list of the names of the featured riders, mostly of wealthy Parisians. In general, Delton's images are unimaginative—one might say pedestrian—and repeatedly feature horse and rider seen from the side on a bridal path.

159. See *Path in the Bois de Boulogne*, reproduced by Weston Naef in *After Daguerre*, cat. no. 99.

160. Jean-Paul Bouillon refers to Bracquemond's illustrations of the Jardin d'acclimatation for *Paris-Guide* in *The Crisis of Impressionism, 1878-1882* (Ann Arbor: University of Michigan Museum of Art, 1980), p. 52.

161. Rivière's *En bateau mouche* (pl. 17) shows a view of the tower (from the deck of a boat) which is quite similar to that shown in an illustration in *Le Monde illustré*, March 30, 1889.

162. Philippe Pinchemel, *France: A Geographical Survey*, trans. Christine Trollope and Arthur J. Hunt (New York: Praeger Publishers, 1969), p. 222.

163. Pinchemel, *France*, p. 222.

164. Fidell, "Graphic Art of Daubigny." The index of vol. 2 contains a complete list of these guides.

165. As a result of size, technique, and purpose, the guidebook illustrations were straightforward renditions of a scene, free of eclectic styling. The reader was assured that the prints were done "after nature." Assignments for such guidebook illustrations were among Daubigny's first work to abandon the eclecticism that characterized his early career. See Fidell, "Graphic Art of Daubigny," pp. 33-59.

166. The print in the exhibition comes from a bound volume with the title *Vistas del Mar*. In conversation with authors, Eugenia P. Janis pointed out that this is not a published album, since Le Gray's photographs were issued singly, and that presumably it was assembled by a Spanish tourist or collector.

167. Zeldin, *Intellect and Pride*, pp. 92-93.

168. Zeldin, *Intellect and Pride*, pp. 94-95.

169. Posters of related subjects in the collection of the Musée des Affiches, Paris, include: Jules Cheret (1836-1932), *Plage de Boulogne sur Mer*; Ferdinand Lunel (born 1857), *Chemins de fer de l'ouest, Etretat*; Eugène Le Mouel (1859-1934), *Hippodrome de Donville-Longueville*; Clementine-Helene Dufau (1869-1937), *Tous les jardins et dimanches*.

170. Henry James, "A French Watering Place," letter to the *New York Tribune*, August 26, 1876, reprinted in *Parisian Sketches* (London: Rupert Hart-Davis, 1958), pp. 202-03.

171. See Robert L. and Eugenia W. Herbert, "Artists and Anarchism: Unpublished Letters of Pissarro, Signac and Others, I," *Burlington Magazine* 102 (November 1960), p. 480.

172. From Signac's unpublished diary, reprinted in Linda Nochlin, *Impressionism and Post-Impressionism, 1874-1904* (Englewood Cliffs, N.J.: Prentice Hall, 1966), p. 128.

173. Daniel Halévy, *My Friend Degas*, trans. Mina Curtiss (Middletown, Conn.: Wesleyan University Press, 1964), p. 66.

174. Barbara Stern Shapiro, "Prints," in *Pissarro* (London: Arts Council of Great Britain, 1980), p. 202.

175. Bouillon, in *The Crisis of Impressionism*, p. 52.

176. Shapiro, in *Pissarro*, pp. 205-06.

177. See Colta Feller Ives, *The Great Wave: The Influence of Japanese Woodcuts on French Prints* (New York: Metropolitan Museum of Art, 1979).

178. Reproduced in *The Crisis of Impressionism*, p. 51.

179. Norma Evenson, *Paris: A Century of Change, 1878-1978* (New Haven: Yale University Press, 1979), pp. 201-05.

180. Jules Vallés, "La banlieue morte," *Le Tableau de Paris* (1882; reprint, Paris: Editions des Delphes, 1964), pp. 227-31.

Bibliography

About, Edmond. *Salon de 1864.* Paris, n.d.

Adhémar, Jean. "Les Lithographies de paysage in France à l'époque romantique." *Archives de l'art français,* n.s. 19 (1938), pp. 189-364.

Alphand, Adolphe. *Les Promenades de Paris.* Paris, 1867-73.

Arts Council of Great Britain, and Museum of Fine Arts, Boston. *Pissarro: Camille Pissarro, 1830-1903.* Exhibition catalogue. London, 1980.

Audiganne, M. M., and Bailly, P. *Paris dans sa splendeur. Monuments, rues, scènes historiques, descriptions et histoire.* Paris: H. Charpentier, 1863.

Babbitt, Irving. *Rousseau and Romanticism.* First published, 1919. Austin: University of Texas Press, 1977.

Bachelard, Gaston. *The Poetics of Reverie: Childhood, Language and the Cosmos.* Translated by Daniel Russell. Boston: Beacon Press, 1969.

Bacler d'Albe, Louis. *Promenades pittoresques et lithographiques dans Paris et ses environs.* Paris, 1822.

Bailly-Herzberg, J. "French Etching in the 1860s." *Art Journal* 31, no. 4 (Summer 1972), pp. 382-86.

Balzac, Honoré de. *La Maison Nucingen.* First published, 1838. Paris: Calmann-Levy, n.d.

————. *Les Paysans.* First published, 1844. Paris: Ernest Flammarion editeur, 1928.

————. *Splendeurs et misères des courtisanes.* First published in full, 1847. Paris: Gallimard, 1973.

Barrell, John. *The Dark Side of the Landscape: The Rural Poor in English Painting, 1730-1840.* New York: Cambridge University Press, 1980.

Baudelaire, Charles. *Art in Paris, 1845-1862.* Translated and edited by Jonathan Mayne. London, New York: Phaidon Press, 1965.

————. *Oeuvres Complètes.* Paris: Bibliothèque de la Pléiade, 1961.

Benevolo, Leonardo. *The Origins of Modern Town Planning.* Translated by Judith Landry. Cambridge, Mass.: M. I. T. Press, 1971.

Bibliothèque Nationale. *Une Invention du XIXe siècle, expression et technique, la Photographie.* Exhibition catalogue. Paris, 1976.

Blackburn, Henry. *Artistic Travel in Normandy, Brittany, the Pyrenees, Spain and Algeria.* London: Sampson, Low, Marston & Co., 1892.

Bouillon, Jean-Paul. "Une visite de Félix Bracquemond à Gaston la Touche." *Gazette des Beaux-Arts* 75 (March 1970), pp. 161-77.

Burke, James D. *Charles Meryon, Prints and Drawings.* Exhibition catalogue. New Haven: Yale University Art Gallery, 1974.

Carey, David. *Life in Paris; Comprising the Rambles, Sprees, and Amours of Dick Wildfire of Corinthian Celebrity, and His Bang-*

up Companions, Squire Jenkins and Captain O'Shuffleton, with the Whimsical Adventures of the Halibut Family. London, 1822.

Cate, P. D. "Japanese Woodcut and the Flowering of French Color Printmaking." *Art News* 74 (March 1975), pp. 27-29.

Cavaillès, Henri. *La Route française, son histoire, sa fonction; étude de géographie humaine.* Paris, 1946.

Chadwick, George. *The Park and the Town: Public Landscape in the Nineteenth and Twentieth Centuries.* New York: Praeger Publishers, 1966.

Chapman, Brian. "Baron Haussmann and the Planning of Paris." *Town Planning Review* 24, no. 3 (October 1953), p. 177-92.

Chateaubriand, François René de. *Atala, René, le dernier abencerage, les Natchez.* Paris: Garnier, n.d.

Chevalier, Louis. *Labouring Classes and Dangerous Classes in Paris during the First Half of the Nineteenth Century.* Translated by Frank Jellinek. London, 1973.

Choay, Françoise. *The Modern City: Planning in the 19th Century.* Translated by Marguerite Hugo and George R. Gillins. New York: George Braziller, 1969.

Clark, T. J. *The Absolute Bourgeois: Artists and Politics in France, 1848-1851.* Greenwich, Conn.: New York Graphic Society, 1973.

Claudin, Gustave. *Paris et l'exposition universelle.* Paris, 1867.

Cleveland Museum of Art. *The Realist Tradition: French Painting and Drawing, 1830-1900.* Exhibition catalogue. Cleveland, 1980.

Clough, Shepard Bancroft. *France, a History of National Economics, 1789-1939.* New York: Charles Scribner's Sons, 1939.

Cobb, Richard. *Paris and Its Provinces 1792-1802.* London, 1975.

Cobban, Alfred. *A History of Modern France.* New York: George Braziller, 1965.

Constable, John. *Correspondance.* Edited, with introduction and notes, by R. B. Beckett. Vol. 6. Ipswich, 1968.

Delteil, Loys. *Le Peintre-graveur illustré.* 31 vols. Paris, 1906-26.

————, and Wright, Harold J. L. *Catalogue Raisonné of the Etchings of Charles Meryon.* New York, 1924.

Denecourt, Claude François. *Le Palais et la forêt de Fontainebleau, guide historique et descriptif.* Fontainebleau, 1856.

Durier, Charles. *Le Mont Blanc.* Paris, 1880.

Egbert, Donald Drew. *Social Radicalism and the Arts, Western Europe.* New York: Alfred A. Knopf, 1970.

Engel, Claire Eliane. *La Littérature alpestre en France et en Angleterre aux XVIIIe et XIXe siècles.* Chambéry, 1930.

Evenson, Norma. *Paris: A Century of Change, 1878-1978.* New Haven: Yale University Press, 1979.

Fidell, Madeleine. "The Graphic Art of Charles François Daubigny." 3 vols. Doctoral dissertation, New York University, 1974.

Fidell-Beaufort, Madeleine, and Bailly-Herzberg, Janine. *Daubigny.* Paris: Editions Geoffroy-Dechaume, 1975.

Flameng, Léopold, and others. *Paris qui s'en va et Paris qui vient.* Paris, 1859-60.

Flaubert, Gustave. *L'Education sentimentale.* First published, 1869. Paris: Classiques Garnier, 1964.

Fournel, Victor. *Paris nouveau et Paris futur.* Paris: Lecoffre, 1865.

French Institute/Alliance Française. *Charles Marville, Photographs of Paris at the Time of the Second Empire on Loan from the*

Musée Carnavalet, Paris. Exhibition catalogue. New York, 1981.

Getscher, Robert H. *Félix Bracquemond and the Etching Process.* Exhibition catalogue. Wooster, Ohio: The College of Wooster, 1974.

Grad, Bonnie. L. "An Analysis of the Development of Daubigny's Naturalism Culminating in the Riverscape Period (1857-1870)." Doctoral dissertation, University of Virginia, Charlottesville, 1977.

———. "Le Voyage en bateau: Daubigny's Visual Diary of River Life." *The Print Collector's Newsletter* 11, no. 4 (September-October 1980), pp. 123-26.

Grumbach, Antoine. "The Promenades of Paris." *Oppositions: A Journal for Ideas and Criticism in Architecture* 8 (Spring 1977), pp. 50-67.

Guerard, Albert. *Napoleon III.* Cambridge, Mass.: Harvard University Press, 1943.

Halévy, Daniel. *My Friend Degas.* Translated by Mina Curtiss. Middletown, Conn.: Wesleyan University Press, 1964.

Hamerton, Philip Gilbert. *Paris in Old and Present Times.* Boston: Little, Brown, and Co., 1900.

Handlin, Oscar, and Burchard, John, eds. *The Historian and the City.* Cambridge, Mass.: M.I.T. Press, 1967.

Hanson, Anne Coffin. *Manet and the Modern Tradition.* New Haven: Yale University Press, 1977.

Harris, J. C. "Manet's Racetrack Paintings." *Art Bulletin* 47 (1966), pp. 78-82.

Haussmann, G. E. *Mémoires du Baron Haussmann.* Paris, 1890.

Herbert, Robert. *Barbizon Revisited.* Exhibition catalogue. Boston: Museum of Fine Arts, 1962.

———. "City vs. Country: The Rural Image in French Painting from Millet to Gauguin." *Artforum* 8, no. 6 (February 1970), pp. 44-55.

———. *Jean-François Millet.* Exhibition catalogue. Paris: Editions des Musées Nationaux, 1975.

———. "Millet Revisited." *Burlington Magazine* 104, part 1 (July 1962), pp. 294-305; part 2 (September 1962), pp. 377-85.

———, and Herbert, Eugenia W. "Artists and Anarchism: Unpublished Letters of Pissarro, Signac and Others, 1." *Burlington Magazine* 102 (November 1960), pp. 473-82.

Hilpert, J. *Le Messagiste.* Paris, 1840.

Holcomb, Adele M. "Le Stryge de Notre Dame: Some Aspects of Meryon's Symbolism." *Art Journal* 31 (1971-72), pp. 151-57.

Honour, Hugh. *Romanticism.* New York: Harper & Row, 1979.

Huizinga, John. *Homo Ludens: A Study of the Play-Element in Culture.* Boston: Beacon Press, 1950.

Huysmans, J. K. *Parisian Sketches.* Translated by Richard Griffiths. London: Fortune Press, 1962.

Hugo, Victor. *Les Misérables.* First published, 1862. Paris: Bibliothèque de la Pléiade, 1951.

———. *Morceaux choisis de Victor Hugo; Poésie.* Paris: Librairie Delagrave, n.d.

International Museum of Photography at George Eastman House. *Pierre Petit: Photographer.* Rochester, 1980.

Isaacson, Joel. *The Crisis of Impressionism, 1878-1882.* Exhibition catalogue. Ann Arbor: Univeristy of Michigan Museum of Art, 1980.

Ives, Colta Feller. *The Great Wave: The Influence of Japanese Woodcuts on French*

Prints. Exhibition catalogue. New York: Metropolitan Museum of Art, 1974.

James, Henry. "A French Watering Place." Letter to the *New York Tribune,* August 26, 1876. Reprinted in Henry James. *Parisian Sketches.* London: Rupert Hart-Davis, 1958.

Jammes, André. *Hippolyte Bayard, ein verkannter Erfinder und Meister der Photographie.* Lucerne, 1975.

Jammes, Marie-Thérèse, and Jammes, André. *Niepce to Atget: The First Century of Photography.* Exhibition catalogue. Chicago: Art Institute of Chicago, 1977.

Janis, Eugenia Parry. "An Autumnal Landscape by Edgar Degas." *Metropolitan Museum of Art Bulletin* 31 (1972), pp. 178-79.

———. *Degas Monotypes.* Exhibition catalogue. Cambridge, Mass.: Fogg Art Museum, 1968.

———. "The Man on the Tower of Notre Dame: New Light on Henri Le Secq." *Image* 19, no. 4 (December 1976), pp. 13-25.

———. "The Role of the Monotype in the Working Method of Edgar Degas." *Burlington Magazine* 109, part 1 (January 1967), pp. 20-27; part 2 (February 1967), pp. 71-81.

Lethève, Jacques. *Daily Life of French Artists in the Nineteenth Century.* Translated by Hilary E. Padden. New York: Praeger Publishers, 1972.

Levy, Howard G. "Degas at Durand-Ruel, 1892: The Landscape Monotypes." *The Print Collector's Newsletter* 9, no. 5 (November-December 1978), pp. 142-47.

Lurine, Louis, ed. *Les Rues de Paris, Paris ancien et moderne, origines, histoire, monuments.* 2 vols. Paris, 1844.

Manuel, Frank E. *The New World of Henri Saint-Simon.* Cambridge, Mass.: Harvard University Press, 1956.

———, and Manuel, Fritzie P. *Utopian Thought in the Western World.* Cambridge, Mass.: The Belknap Press of Harvard Univeristy Press, 1979.

Marrey, Bernard. "Saint-Simoniens, Fourieristes et Architecture." *Archives d'architecture moderne,* no. 20 (1981), pp. 74-99.

Marx, Leo. *The Machine in the Garden: Technology and the Pastoral Ideal in America.* New York: Oxford University Press, 1964.

Melot, Michel. *L'Estampe impressioniste.* Exhibition catalogue. Paris: Bibliothèque Nationale, 1974.

———. *Graphic Art of the Pre-Impressionists.* New York, 1980.

Metropolitan Museum of Art. *After Daguerre: Masterworks of French Photography (1848-1900) from the Bibliothèque Nationale.* Exhibition catalogue. New York, 1980.

———. *The Painterly Print: Monotypes from the Seventeenth to the Twentieth Century.* Exhibition catalogue. New York, 1980.

Miguel, Pierre. *Paul Huet, de l'aube romantique à l'aube impressioniste.* Sceaux, 1962.

Minneapolis Institute of Arts. *Millet's Gleaners.* Exhibition catalogue. Minneapolis, 1978.

Moreau-Nélaton, Etienne. *Corot raconté par lui-même.* Paris: Henri Laurens, Editeur, 1924.

Mumford, Lewis. *The City and History: Its Origins, Its Transformations, and Its Prospects.* New York: Harcourt, Brace and World, 1961.

Nochlin, Linda. *Impressionism and Post-Impressionism, 1874-1904.* Englewood Cliffs, N.J.: Prentice Hall, 1966.

Nodier, Charles; Taylor, Baron Isidore; and others. *Voyages pittoresques et romantiques*

dans l'ancienne France. 20 vols. Paris, 1820-78.

Novotny, Fritz. *Painting and Sculpture in Europe 1780-1880.* Pelican History of Art. Harmondsworth: Penguin Books, 1971.

Palm, Franklin. *England and Napoleon III: A Study of the Rise of a Utopian Dictator.* Durham, N.C.: Duke University Press, 1948.

Parent-Duchatelet, Alexandre Jean Baptiste. *De la prostitution dans la ville de Paris considerée sous le rapport de l'hygiène publique, de la morale et de l'administration, ouvrage appuyé de documens [sic] statistiques.* Paris, 1836.

Paris-Guide par les principaux écrivains et artistes de la France. Paris: Lacroix, Verboeckhoven et Cie, 1867.

Paris, ou le livre des cent-et-un. 15 vols. Paris, 1831-34.

Philadelphia Museum of Art. *The Second Empire, 1852-1870: Art in France Under Napoleon III.* Exhibition catalogue. Philadelphia, 1978. Translated for the exhibition at the Grand Palais, Paris, 1979, as *L'Art en France sous le Second Empire.*

Pinchemel, Philippe. *France: A Geographical Survey.* Translated by Christine Trollope and Arthur J. Hunt. New York: Praeger Publishers, 1969.

Pinkney, David H. *Napoleon III and the Rebuilding of Paris.* Princeton, N.J.: Princeton University Press, 1958.

————. "The Imperial Plan: Haussmann and the Paris of Napoleon III." *Landscape* 7 (1957-58), pp. 15-20.

Pissarro, Camille. *Letters to His Son Lucien.* Edited with the assistance of Lucien Pissarro by John Rewald. New York: Pantheon Books, 1943.

Poggioli, Renato. *The Oaten Flute: Essays on Pastoral Poetry and the Pastoral Ideal.*

Cambridge, Mass.: Harvard University Press, 1975.

"Recherches et considérations sur l'enlèvement et l'emploi des chevaux morts." *Receuil industriel, manufacturier, agricole et commercial, de la salubrité publique et des beaux-arts.* Vols. 3 (1827) and 5 (1828).

Rewald, John. "Excerpts from the Unpublished Diary of Paul Signac: I, 1894-1895" and "II, 1897-1898." *Gazette des Beaux-Arts* 36 (July-September 1949), pp. 166-74; and 39 (April 1952), pp. 298-304.

————. *The History of Impressionism.* 4th rev. ed. New York: Museum of Modern Art, 1973.

Richardson, Joanna. *La Vie parisienne, 1852-1870.* New York: Viking Press, 1971.

Rousseau, Jean Jacques. *The Confessions.* First published, 1781. Translated by J. M. Cohen. Harmondsworth: Penguin Classics, 1953.

Rousset, Ildefonse, and de la Bedollière, Emile. *Le Tour de Marne.* Paris, 1865.

Saint-Pol Lias, B. de. "Le Bois de Boulogne." *Le Monde moderne* 10 (1899), pp. 47-64.

Scharf, Aaron. *Art and Photography.* Baltimore: Penguin Books, 1974.

Schivelbusch, Wolfgang. *The Railway Journey: Trains and Travel in the 19th Century.* Translated by Anselm Hollo. New York: Urizen Books, 1979.

Seguin, Jean Pierre. *Canards du siècle passé.* Paris, 1969.

Seltzer, Alexander. "Alphonse Legros: The Development of an Archaic Visual Vocabulary." 2 vols. Doctoral dissertation, State University of New York at Binghamton, 1980.

Sewell, William B. *Work and Revolution in France, the Language of Labor from the Old*

Regime to 1848. Cambridge: Cambridge University Press, 1980.

Shapiro, Barbara S. "Four Intaglio Prints by Camille Pissarro." *Boston Museum Bulletin* 69 (1971), pp. 131-41.

Spadafore, Anita Louise. "Baron Taylor's *Voyages pittoresques.*" Doctoral dissertation, Northwestern University, Evanston, Ill., 1973.

Stael, Madame de. *De l'Allemagne.* First published in France, 1815. Paris: Firmin Didot, 1853.

Stendhal (Henri Beyle). *Memoirs of a Tourist.* First published, 1838. Translated by Allan Seager. Evanston, Ill.: Northwestern Univeristy Press, 1962.

Sutcliffe, Anthony. *The Autumn of Central Paris: The Defeat of Town Planning, 1850-70.* London: Edward Arnold, 1970.

Taine, Hippolyte. *Notes sur Paris: Vie et opinions de M. Frédéric-Thomas Graindorge.* Paris: Hachette, 1867.

Thompson, James. *The Peasant in French 19th-Century Art.* Exhibition catalogue. Dublin: Douglas Hyde Gallery, 1980.

Thorburn, David, and Hartman, Geoffrey, eds. *Romanticism: Vistas, Instances, Continuities.* Ithaca: Cornell University Press, 1973.

Tuan, Yi-Fu. *Topophilia: A Study of Environmental Perception, Attitudes and Values.* Englewood Cliffs, N.J.: Prentice Hall, 1974.

Twyman, Michael. *Lithography 1800-1850: The Techniques of Drawing on Stone in Eng-land and France and Their Application in Works of Topography.* London: Oxford University Press, 1970.

Vallés, Jules. "La banlieue morte." In *Le Tableau de Paris.* First published, 1882. Paris: Editions des Delphes, 1964.

Vidalenc, Jean. *La Société française de 1815 à 1848.* I. *Le Peuple des campagnes.* II. *Le Peuple des villes et des bourgs.* Paris, 1969, 1973.

Vidler, Anthony. "The Reconstruction of Urban Utopias in Late Nineteenth-Century France." *Perspecta* 13-14 (1971), pp. 243-56.

Weber, Eugen. *Peasants into Frenchmen: The Modernization of Rural France 1870-1914.* Stanford, Calif.: Stanford University Press, 1976.

Wilkinson, L. P. *Horace and His Lyric Poetry.* Cambridge: Cambridge University Press, 1968.

Williams, Raymond. *The Country and the City.* New York, 1973.

Zeldin, Theodore. *France, 1848-1945.* 3 vols.: *Ambition and Love; Politics and Anger; Intellect and Pride.* New York, 1979-80.

Zola, Emile. *L'Assommoir.* First published, 1877. Translated by L. W. Tancock. Baltimore: Penguin Books, 1970.

————. *Earth.* First published, 1887. Translated by Margaret Crosland. London: New English Library, 1975.

————. *L'Oeuvre.* First published, 1886. Paris: Fasquelle Edition, 1980.

Catalogue

The catalogue is arranged alphabetically by artist. The boldface number at the end of each entry is its figure number in the text.

We have indicated whenever a print was issued as part of a book, periodical, or series. The same print might also be issued separately, however, and the example in the exhibition is not always literally "from" the publication mentioned.

ANONYMOUS

Attacks on Diligences and Armed Robberies on the Main Roads, about 1823. Hand-colored woodcut broadside, 296 x 394 mm. Musée Carnavalet, Paris [5]

The Group of Bandits Called the Stranglers, about 1843. Woodcut broadside, 515 x 397 mm. Musée Carnavalet, Paris [60]

The Boulevard de la Madeleine, about 1885. Photograph, 210 x 280 mm. Collection Gerard-Levy, Paris [103]

Panorama of Paris Seen from the Gondola of the Great Balloon, 1878. Color lithograph, 821 x 632 mm. The Library of Congress, Washington, D.C. [**129** color section]

Etretat—The Beach at Bathing Time. Photograph, 221 x 326 mm. Worcester Art Museum; Gift of Mrs. Albert W. Rice [137]

VICTOR ADAM (1801-1866)

The Trip to Saint-Cloud by Steamboat, 1830. Lithograph, 166 x 194 mm. The Library of Congress, Washington, D.C. [7]

ADOLPHE ALPHAND (1817-1891)
Plates from *Les Promenades de Paris* (Paris, 1867-73)

Jean Joseph Sulpis (1826-1911), after Emile Hochereau (born 1828), and Louis Dardoize. *Street Cross-Sections*. Steel engraving, 432 x 622 mm. Princeton University, Marquand Library of Art and Archaeology [102; not in exhibition]

Auguste Alexandre Guillaumot (1815-1892), after Emile Hochereau. *Frontispiece*. Steel engraving, 622 x 432 mm. Princeton University, Marquand Library of Art and Archaeology [109]

F. Lefevre, after Louis Dardoize and Antoine. *The Bois de Boulogne* (after transformation). Steel engraving, 622 x 876 mm. Princeton University, Marquand Library of Art and Archaeology [110]

L. Chaumont, after Emile Hochereau. *The Bois de Boulogne* (former state). Steel engraving, 432 x 622 mm. Princeton Univeristy, Marquand Library of Art and Archaeology [111; not in exhibition]

H. Dureau, after Emile Hochereau. *Plan of the Parc des Buttes-Chaumont*. Steel engraving, 432 x 622 mm. Princeton University, Marquand Library of Art and Archaeology [112]

Alexandre Marie Soudain (born 1833), after Emile Hochereau and Louis Dardoize. *Booths and Kiosque for the Street*. Steel engraving, 432 x 622 mm. Princeton University, Marquand Library of Art and Archaeology [115]

ANTOINE: see Adolphe Alphand

JEAN BAPTISTE ARNOUT (born 1788)

Pont du Carrousel, 1839. From *Paris et ses souvenirs* (Paris, 1839). Lithograph, 291 x 287 mm. I.F.F. 1, p. 170. Private collection [33]

LOUIS ATTHALIN (1784-1856)

The Cascade de l'Abyme, 1825. From the *Voyages pittoresques: Franche-Comté* (Paris, 1825), pl. 59. Lithograph, 268 x 208 mm. I.F.F. 1, p. 197. Boston Public Library, Print Department [13]

CHARLES AUBRY (active 1818-1836)

The Diligence, 1823. Lithograph, 235 x 333 mm. I.F.F. 1, p. 209. Philadelphia Museum of Art; Purchased, Print Revolving Fund [4]

LOUIS BACLER D'ALBE (1761-1824)

The Jardin des Tuileries, 1822. From *Promenades pittoresques et lithographiques dans Paris et ses environs* (Paris, 1822), pl. 18. Lithograph, 213 x 143 mm. Beraldi 3; I.F.F. 1, pp. 261-62. Private collection [32]

EDOUARD BALDUS (1820-1882)

Viaduct at La Voulte, about 1855. From *Album des chemins de fer de Paris à Lyon et à la Méditerranée*. Photograph, 310 x 421 mm. Sam Wagstaff [44]

Aigues-Mortes, about 1855. From *Album des chemins de fer de Paris à Lyon et à la Méditerranée*. Photograph, 297 x 430 mm. Sam Wagstaff [45]

Group Portrait in a Landscape, about 1855. Photograph, 489 x 638 mm. Private collection [139]

Country House, about 1855. Photograph, 320 x 417 mm. Collection Gerard-Levy, Paris [140]

HIPPOLYTE BAYARD (1801-1887)

The Rooftops of Paris (seen from the Rue Castiglione), 1845. Photograph (modern print from original negative), 190 x 248 mm. Philadelphia Museum of Art; Purchased, Print Revolving Fund [52]

The Pont Neuf, the Quays, the Baths "à la Samaritaine" and the Tour St. Jacques, 1847. Photograph (modern print from original negative), 171 x 229 mm. Philadelphia Museum of Art; Purchased, Print Revolving Fund [67]

H. BERTHOUD:
see François Joseph Dupressoir

EUGÈNE BLÉRY (1805-1887)

Coltsfoot, 1843. Etching, 350 x 486 mm. Beraldi 144. The Baltimore Museum of Art; Garrett Collection (BMA 46.112.10862) [27]

KARL BODMER (1809-1893) and
JEAN FRANÇOIS MILLET (1814-1875)

Tall Timber, about 1851. Lithograph, 632 x 500 mm. Delteil (Millet) 24. Davison Art Center, Wesleyan University, Middletown, Connecticut [87]

RAIMOND BONHEUR: see E. Grezel

RICHARD PARKES BONINGTON
(1801-1828)

The Rue du Gros-Horloge in Rouen, 1824. From the *Voyages pittoresques: Normandie* II (Paris, 1825), pl. 173. Lithograph, 265 x 249 mm. Curtis, *Bonington* 16. Worcester Art Museum [31]

PIERRE BONNARD (1867-1947)

Boating, 1897. From *Album d'estampes originales de la Galerie Vollard* (Paris, 1897). Color lithograph, 260 x 470 mm. Roger-Marx, *Bonnard* 44. The Baltimore Museum

of Art; Print Purchase Fund (BMA 50.138) [150 color section]

FRÉDÉRIC BOUCHOT (active 1827-1856)

The Elephant of the Bastille, 1844. From *Les Embellissements de Paris*, pl. 6. Hand-colored lithograph, 292 x 215 mm. I.F.F. III, p. 196. Musée Carnavalet, Paris [51]

THOMAS SHOTTER BOYS (1803-1874)

Pavillon de Flore, Tuileries, 1839. From *Picturesque Architecture in Paris, Ghent, Antwerp, Rouen, etc.* (London, 1839), pl. 23. Color lithograph, 343 x 291 mm. Groschwitz 24 w. The Library of Congress, Washington, D.C. [34]

Notre-Dame, Paris, 1839. From *Picturesque Architecture in Paris, Ghent, Antwerp, Rouen, etc.* (London, 1839), pl. 24. Color lithograph, 368 x 266 mm. Groschwitz 24 x. The Cleveland Museum of Art; Gift of Mrs. Ralph Perkins in memory of Coburn Haskell [35]

FÉLIX BRACQUEMOND (1833-1914)

The Pont des Saints-Pères, 1877. Etching, 199 x 249 mm. Beraldi 217 iii. Worcester Art Museum [98]

At the Jardin d'acclimatation, 1873. Color etching and aquatint, 187 x 200 mm. Beraldi 214 vii. Museum of Fine Arts, Boston; Frederick Keppel Memorial Fund, gift of David Keppel (13.5094) [124]

The Rainbow, 1893. Etching and watercolor, 410 x 537 mm. Delteil, "Bracquemond" 12. Rutgers University Fine Arts Collection, New Brunswick, New Jersey; Gift of the Friends [151 color section]

ADOLPHE BRAUN (1811-1877)

Station des Grands Mulets, Savoy, 1860s. Photograph, 410 x 756 mm. Private collection [46]

LOUIS ALPHONSE DE BRÉBISSON (1798-1872)

Ruins of the Château de Falaise, 1851. From *Album photographique de l'artiste et de l'amateur* (Lille, 1851-55). Photograph, 207 x 156 mm. Collection Gerard-Levy, Paris [43]

RODOLPHE BRESDIN (1825-1885)

Stream in the Woods, 1880. Etching, 170 x 244 mm. Van Gelder 145. Private collection [28]

FÉLIX BUHOT (1847-1898)

A Squall at Trouville, 1874. From *L'Illustration nouvelle*, 1875. Etching, 160 x 238 mm. Bourcard and Goodfriend 122 iv. Worcester Art Museum; Gift of Louis W. Black [99]

The Fête Nationale, First of July, Boulevard Clichy, 1878. Etching, 321 x 238 mm. Bourcard and Goodfriend 127 v. The Baltimore Museum of Art; Garrett Collection (BMA 46.112.7259) [128]

L. CHAUMONT: see Adolphe Alphand

ALPHONSE CHIGOT

The Stock Exchange, 1857. Lithograph, 438 x 540 mm. I.F.F. IV, p. 528. Musée Carnavalet, Paris [50]

EUGÈNE CICÉRI (1813-1890), after A. MAYER

Dolmen at Parc-ar-Dolmen, about 1845. From the *Voyages pittoresques: Bretagne* III (Paris, 1846), pl. 759. Lithograph, 215 x 318 mm. I.F.F. IV, p. 557. The Cleveland Museum of Art; A 25th Anniversary Gift—The Mr. and Mrs. Lewis B. Williams Collection [29]

EUGÈNE CICÉRI

General View of Quimper, about 1845. From the *Voyages pittoresques: Bretagne* III (Paris, 1846), pl. 827 or 828. I.F.F. IV, p. 557. Litho-

graph, 262 x 375 mm. The Cleveland Museum of Art: A 25th Anniversary Gift—The Mr. and Mrs. Lewis B. Williams Collection [30]

The Bois de Boulogne: The Grand Lac and Its Cascades, 1863. From *Paris dans sa splendeur* (Paris, 1863), pl. 89. Color lithograph, 249 x 390 mm. I.F.F. IV, p. 568. Private collection [122]

CHARLES LOUIS CONSTANS
(active 1803-1840),
after JEAN CHARLES DE VELLY

Afternoon—The Lantern of Demosthenes in the Parc de Saint-Cloud. Lithograph, 195 x 255 mm. The Library of Congress, Washington, D.C. [8]

CAMILLE COROT (1796-1875)

The Mill at Cuincy, 1871. Lithograph, 212 x 259 mm. Delteil 28 ii. The Art Institute of Chicago (1940.946/2) [72]

Horseman and Man on Foot in the Forest, 1854. Cliché-verre, 147 x 180 mm. Delteil 48. National Gallery of Art, Washington, D.C.; Andrew W. Mellon Fund, 1975 [89]

The Gardens of Horace, 1855. Cliché-verre, 365 x 295 mm. Delteil 58. The Art Institute of Chicago (1926.2211) [90]

CHARLES COURTRY (1846-1897),
after VICTOR HUGO (1802-1885)

The Lightning Flash, about 1868. From *Sonnets et eaux-fortes* (Paris, 1869). Etching, 219 x 146 mm. I.F.F. V, p. 274. Worcester Art Museum [18]

CLAUDIUS COUTON

The New Casino at Vichy, 1865. Photograph, 390 x 480 mm. Collection Gerard-Levy, Paris [135]

LOUIS DARDOIZE: see Adolphe Alphand

CHARLES DAUBIGNY (1817-1878)

The Storm, 1842. From *Chants et Chansons populaires de la France* (Paris, 1842-43). Etching, 225 x 162 mm. Delteil 26. The George A. Lucas Collection, The Maryland Institute College of Art, courtesy of The Baltimore Museum of Art (L.33.53.3920) [75]

The Small Sheepfold, 1846. Etching, 139 x 193 mm. Delteil 55. The George A. Lucas Collection, The Maryland Institute College of Art, courtesy of The Baltimore Museum of Art (L.33.53.3971) [76]

The Boat-Studio, 1861. From *Voyage en bateau, croquis à l'eau-forte* (Paris, 1862). Etching, 116 x 151 mm. Delteil 111. The College of Wooster John Taylor Arms Collection; Gift of Ward M. and Miriam C. Canaday [77]

The Cabin Boy Fishing, 1861. From *Voyage en bateau, croquis à l'eau-forte* (Paris, 1862). Etching, 97 x 160 mm. Delteil 110. Museum of Fine Arts, Boston; Gift of David Keppel [78; not in exhibition]

The Iles Vierges at Bèzons, 1850. From *Eaux-fortes par Daubigny* (Paris, 1850-51), pl. 9. Etching, 178 x 145 mm. Delteil 75. The College of Wooster John Taylor Arms Collection; Gift of Ward M. and Miriam C. Canaday [83]

CHARLES DAUBIGNY (after)
by JOHN QUARTLEY (active 1835-1867)
and others

Illustrations from *Voyage de Rouen au Havre* (Paris, 1864?)

a. *Title page.* Wood engraving, 138 x 93 mm.
b. *Viaduct at Barentin.* Wood engraving, 84 x 107 mm.
c. *View of the Harbor, the Cours Boïeldieu, and the Hotel d'Angleterre.* Wood engraving, 84 x 107 mm.
d. *The Platform at Rouen on Opening Day, May 5, 1843.* Wood engraving, 87 x 108 mm.

e. *The Abbey of Saint-Ouen.* Wood engraving, 100 x 113 mm.
f. *Viaduct at Mirville.* Wood engraving, 87 x 109 mm.
The George A. Lucas Collection, The Maryland Institute College of Art, courtesy of the Baltimore Museum of Art (L.33.53.4483 a-f) [132]

HONORÉ DAUMIER (1808-1879)

The Determined Fisherman, 1840. From *La Caricature,* August 1, 1840. Lithograph, 222 x 164 mm. Delteil 817. Boston Public Library, Print Department [55]

"What time is it, please?" 1839. From *Le Charivari,* November 24, 1839. Lithograph, 270 x 202 mm. Delteil 695. Worcester Art Museum [59]

Landscape Painters at Work, 1862. From *Souvenirs d'artistes* (1862), pl. 309. Lithograph, 207 x 269 mm. Delteil 3251. The Art Institute of Chicago (1938.1256) [80]

"There, my flower-pot will have some sunshine... I'll finally find out whether it's a rose or a carnation," 1852. From *Le Charivari,* December 18, 1852. Lithograph, 191 x 264 mm. Delteil 2776. Boston Public Library, Print Department [101]

ALPHONSE DAVANNE (1824-1912)

Cascade in the Pyrenees, late 1850s. Photograph, 313 x 249 mm. Collection Gerard-Levy, Paris [41]

Etretat—Côte d'Amont, the Cauldron, about 1864. Photograph, 131 x 213 mm. Collection Gerard-Levy, Paris [147]

EDGAR DEGAS (1834-1917)

Landscape, about 1890-93. Pastel over monotype in oil colors, 254 x 340 mm. The Metropolitan Museum of Art, New York [149 color section; not in exhibition]

LOUIS JEAN DELTON (before 1820—after 1896)

Le Tour du Bois: c'est la nature surprise (Paris, 1884). Book illustrated with photographs, open to *Woman on Horseback, Taking a Jump.* International Museum of Photography at George Eastman House, Rochester [118]

GUSTAVE DORÉ (1832-1883)

The Rue de la Vieille Lanterne, 1855. Lithograph, 509 x 350 mm. I.F.F. VII, p. 48, no. 198. Davison Art Center, Wesleyan University, Middletown, Connecticut [61]

CHARLES DULAC (1865-1898)

The Canal, 1893. From *Suite de paysages,* (Paris, 1893). Color lithograph, 438 x 342 mm. I.F.F. VII, p. 160, no. 1. Worcester Art Museum [142]

JULES DUPRÉ (1811-1889)

Pastureland in the Limousin, 1835. From *L'Artiste* 9 (1835). Lithograph, 138 x 214 mm. Delteil 1. Boston Public Library, Print Department [81]

FRANÇOIS JOSEPH DUPRESSOIR (1800-1859), and H. BERTHOUD

The Pic de la Fare in Oisans, 1839. From *L'Artiste,* 2nd series, 4 (1839). Soft-ground etching and aquatint, 198 x 276 mm. Private collection [16]

H. DUREAU: see Adolphe Alphand

HIPPOLYTE FIZEAU (1819-1896), after an anonymous daguerreotype

Paris, the Ile de la Cité. Heliogravure (Fizeau process), 51 x 73 mm. Sam Wagstaff [53]

LÉOPOLD FLAMENG (1831-1911)

The Rue de la Vieille Lanterne, 1859. From *Paris qui s'en va et Paris qui vient* (Paris,

1859-60), pl. 2. Etching, 261 x 182 mm. I.F.F.
VII, p. 571, no. 60. Worcester Art Museum
[62]

ALEXANDRE EVARISTE FRAGONARD
(1780-1850)

Ruins of the Palace of Queen Blanche, 1824.
From the *Voyages pittoresques: Normandie*
II (Paris, 1825), pl. 178. Lithograph, 240 x
311 mm. I.F.F. VII, p. 150. Boston Public Library, Print Department [1]

GUSTAVE FRAIPONT (born 1849)

Enghien-les-Bains. Color lithograph, 1065 x
750 mm. Musée de l'Affiche, Paris [136]

FRANÇOIS LOUIS FRANÇAIS
(1814-1897)

The Landscape Painter, 1847. From *Les Artistes contemporains* I (1847), frontispiece.
Lithograph, 410 x 294 mm. The National
Gallery of Canada, Ottawa [73]

GAVARNI (Sulpice Guillaume Chevalier)
(1804-1866)

Solitude, 1833. From *L'Artiste* 8 (1833).
Lithograph, 117 x 175 mm. Armelhault and
Bocher 170; I.F.F. VIII, p. 475. Yale University Art Gallery, New Haven; Gift of Frank
Altschul, B.A. 1908 [9]

*Grotte d'Elais near Bagnères in the
Pyrenees*, about 1829. From *Souvenirs des
Pyrénées* (Paris, n.d.), pl. 5. Lithograph, 171
x 127 mm. Armelhault and Bocher 2027;
I.F.F. VIII, p. 468. Yale University Art Gallery, New Haven; Gift of Frank Altschul,
B.A. 1908 [14]

*M. Gontard from Clos-Gorju, wealthy
landowner, eligible voter, has been hunting
since dawn*, 1839. From *Types contemporains* (Paris, 1839). Lithograph, 198 x 157
mm. Armelhault and Bocher 2051; I.F.F. VIII,
p. 507. Yale University Art Gallery, New Haven; Gift of Frank Altschul, B.A. 1908 [79]

ANDRÉ GIROUX (1801-1879)

Cottage with Ducks, about 1855. Photograph, 260 x 323 mm. Collection Gerard-Levy, Paris [86]

NORBERT GOENEUTTE (1854-1894)

Boulevard Clichy in the Snow. Drypoint,
241 x 160 mm. The George A. Lucas Collection, The Maryland Institute College of Art,
courtesy of the Baltimore Museum of Art
(L.33.53.5195) [106]

FRANÇOIS GRENIER DE SAINT-
MARTIN (1793-1867)

The Amateurs, 1826. Lithograph, 172 x 137
mm. I.F.F. IX, p. 363, no. 18. The Library of
Congress, Washington, D.C. [10]

E. GREZEL and CHARLES SMITH, after
A. M. PERROT (born 1787) and RAIMOND
BONHEUR (died 1849)

Département du Doubs. From Victor Levasseur and others, *Atlas national illustré des
86 départements et des possessions de la
France* (Paris, 1856). Engraving, 298 x 420
mm. Private collection [39]

AUGUSTE ALEXANDRE GUILLAUMOT:
see Adolphe Alphand

JAMES DUFFIELD HARDING
(1798-1863)

The Château de la Roche, about 1825. From
the *Voyages pittoresques, Franche-Comté*
(Paris, 1825), pl. 130. Lithograph, 295 x 248
mm. Boston Public Library, Print Department [12]

W. H. HARRISON (1841-1897)

The Forest of Fontainebleau, about 1875.
Photograph, 185 x 185 mm. Collection
Gerard-Levy, Paris [92]

278

ADOLPHE HERVIER (1818-1879)

Coastal Scene, Storm, about 1843. From *Croquis de voyage de 1843.* Etching, 153 x 210 mm. Beraldi 1; I.F.F. x, p. 362, no. 11. The Library of Congress, Washington, D.C. [21]

Cul-de-Sac at Trouville, 1848. Lithograph, 343 x 244 mm. I.F.F. x, p. 373, no. 117. The George A. Lucas Collection, The Maryland Institute College of Art, courtesy of the Baltimore Museum of Art (L.33.53.13302) [37]

Barricade, June 1848. Etching and drypoint, 125 x 80 mm. Beraldi 12; I.F.F. x, p. 365, no. 40. The Library of Congress, Washington, D.C. [63]

EMILE HOCHEREAU:
see Adolphe Alphand

PAUL HUET (1803-1869)

The Smugglers, 1831. From *Huit sujets de paysage* (Paris, 1831), pl. 3. Lithograph, 230 x 170 mm. Delteil 58. Boston Public Library, Print Department [22]

Twilight, 1829. From *Paysages par Paul Huet* (Paris, 1829), pl. 7. Lithograph, 185 x 150 mm. Delteil 48. The Library of Congress, Washington, D.C. [23]

The Keeper's House, 1833. From *Six Eaux-fortes par Paul Huet* (Paris, 1835), pl. 3. Etching, 214 x 300 mm. Delteil 9. Boston Public Library, Print Department [24]

The Flood at the Ile Séguin, 1833. From *Six Eaux-fortes par Paul Huet* (Paris, 1835), pl. 2. Etching, 219 x 313 mm. Delteil 8. Boston Public Library, Print Department [25]

Panoramic View of Coucy-le-Château, 1833. Lithograph, 176 x 232 mm. Delteil 89. The George A. Lucas Collection, The Maryland Institute College of Art, courtesy of the Baltimore Museum of Art (L.33.53.7707) [26]

VICTOR HUGO: see Charles Courtry

EUGÈNE ISABEY (1803-1886)

Apse of the Church of Saint-Nectaire, Auvergne, 1831. From the *Voyages pittoresques: Auvergne* I (Paris, 1829), pl. 108. Lithograph, 325 x 241 mm. Curtis, *Isabey* 36 ii. The George A. Lucas Collection, The Maryland Institute College of Art, courtesy of The Baltimore Museum of Art (L.33.53.11558) [17]

The Environs of Dieppe, 1833. From *Six Marines* (Paris, 1833), pl. 1. Lithograph, 292 x 200 mm. Curtis, *Isabey* 64. The Art Institute of Chicago (1976.445) [19]

Low Tide, 1831. Lithograph, 152 x 165 mm. Curtis, *Isabey* 51 ii. Yale University Art Gallery, New Haven; Gift of Allen Evarts Foster, B.A. 1906 [20]

Harbor Scene, 1833. From *Six Marines* (Paris, 1833), pl. 5. Lithograph, 360 x 276 mm. Curtis, *Isabey* 68. The Art Institute of Chicago; Gift of the Print and Drawing Club (1925.362/3) [36]

CHARLES JACQUE (1813-1894)

Pastorale, 1864. Etching and drypoint, 280 x 210 mm. Guiffrey 180. The Baltimore Museum of Art; Riggs Collection (BMA 43.32.89) [74]

The Cottage, 1844. Drypoint, 106 x 210 mm. (to border line). Guiffrey 237. Worcester Art Museum [94]

GUSTAVE JANET: see W. Measom

ALEXIS VICTOR JOLY (1798-1874)

Ruins of the Château Gaillard, 1824. From the *Voyages pittoresques: Normandie* II (Paris, 1825), pl. 183. Lithograph, 324 x 252 mm. I.F.F. XI, p. 466. Boston Public Library, Print Department [2]

MAXIME LALANNE (1827-1886)

The Rue des Marmousets (Old Paris), 1862. From *Eaux-fortes modernes publiées par la*

société des aquafortistes, l^re année (1863), pl. 15. Etching, 260 x 181 mm. Beraldi 1; I.F.F. XII, p. 272. Private collection [69]

Demolition for the Creation of the Boulevard Saint-Germain, 1863. From *Eaux-fortes modernes publiées par la société des aquafortistes*, l^re année (1863), pl. 39. Etching, 321 x 242 mm. Beraldi 4; I.F.F. XII, p. 272. The Library of Congress, Washington, D.C. [70]

Beuzeval, 1868. From *L'Illustration nouvelle* (1868), pl. 19. Etching, 160 x 237 mm. Beraldi 52; I.F.F. XII, p. 274. College of Wooster John Taylor Arms Collection; Gift of Ward M. and Miriam C. Canaday [133]

F. LEFEVRE: see Adolphe Alphand

GUSTAVE LE GRAY (1820-1882)

The Forest of Fontainebleau, about 1855. Photograph, 297 x 375 mm. Sam Wagstaff [88]

Dumont's Baths at Sainte-Adresse, about 1856-57. Photograph, 317 x 410 mm. The Art Institute of Chicago; Hugh Edwards Photography Purchase Fund [134]

ALPHONSE LEGROS (1837-1911)

The Brick-Works, about 1860. Drypoint, 189 x 292 mm. Bliss 100. Boston Public Library, Print Department [58]

The Woodcutter, about 1865. Etching, 198 x 302 mm. Bliss 79. Boston Public Library, Print Department [96]

The Village in Flames, about 1890. Etching, 392 x 565 mm. Bliss 509 ii. Private collection [97]

AUGUSTE LEPÈRE (1849-1918)

The Boulevard near the Vaudeville. Wood engraving, 172 x 143 mm. Lotz-Brissonneau 201. The Library of Congress, Washington, D.C. [104]

The Pond in the Tuileries, 1898. Color woodcut, 218 x 337 mm. Lotz-Brissonneau 265 ii. Yale University Art Gallery, New Haven; Gift of Allen Evarts Foster, B.A. 1906 [126]

July 14: Venetian Fête in the Bois de Boulogne during the fireworks, 1881. From *Le Monde illustré*, July 22, 1881. Wood engraving, 312 x 457 mm. Lotz-Brissonneau, p. 274. Private collection [127]

HENRI LE SECQ (1818-1882)

Rocks at Montmirail, about 1853. Photograph, 225 x 324 mm. Sam Wagstaff [93]

VICTOR LEVASSEUR: see E. Grezel

EDOUARD MANET (1832-1883)

The Races at Longchamp. Lithograph, 386 x 508 mm. Guerin 72; Harris 41. S. P. Avery Collection, The New York Public Library, Astor, Lenox and Tilden Foundations [123]

CHARLES MARVILLE (1816-1878/9)

The Rue Traversine, about 1865. Photograph (modern print), 350 x 276 mm. Musée Carnavalet, Paris [54]

The Buttes-Chaumont, 1863. Photograph, 273 x 400 mm. Collection Gerard-Levy, Paris [113]

The Bois de Boulogne, 1858. From the *Album du Bois de Boulogne* (Paris, 1858). Photograph, 362 x 498 mm. Private collection [119]

The Bois de Boulogne, 1858. From the *Album du Bois de Boulogne* (Paris, 1858). Photograph. Bibliothèque Nationale, Paris [146; not in exhibition]

ADOLPHE MAUGENDRE (1809-1895)

Dieppe, View of the Bathing Beach. From *Dieppe et ses environs*. Color lithograph with additional hand coloring, 185 x 231

mm. Worcester Art Museum; Gift of Mrs. Albert W. Rice [40]

W. MEASOM, after GUSTAVE JANET (born 1829)

The Bois de Boulogne (Grande Cascade), 1857. From *Le Monde illustré,* April 18, 1857. Wood engraving, 388 x 517 mm. Musée Carnavalet, Paris [117]

CHARLES MERYON (1821-1868)

The Vampire, 1853. From *Eaux-fortes sur Paris par C. Meryon.* Etching and drypoint, 171 x 133 mm. Delteil and Wright 23 iv. Boston Public Library, Print Department [48]

Collège Henri IV, 1864. Etching, 295 x 482 mm. Delteil and Wright 43 xi. Private collection [64]

The Rue des Mauvais Garçons, 1854. From *Eaux-fortes sur Paris par C. Meryon.* Etching, 127 x 98 mm. Delteil and Wright 23 iii. Boston Public Library, Print Department [65]

The Pont-au-Change, 1854. From *Eaux-fortes sur Paris par C. Meryon.* Delteil and Wright 34 v. The Baltimore Museum of Art; Bequest of Marie Conrad Lehr (BMA 32.17.23) [66]

The Morgue, 1854. From *Eaux-fortes sur Paris par C. Meryon.* Etching and drypoint, 230 x 207 mm. Delteil and Wright 36 iv. Private collection [68]

The Solar Law, 1855. Etching and drypoint, 118 x 82 mm. Delteil and Wright 93. The Cleveland Museum of Art; The Milton Curtiss Rose Collection in Memory of Evelyn Curtiss Rose [100]

JEAN FRANÇOIS MILLET (1814-1875) (see also Karl Bodmer)

The Gleaners, 1855. Etching, 190 x 252 mm. Delteil 12 ii. Worcester Art Museum; Edward A. Bigelow Collection [95]

J. G. V. DE MOLÉON

Details of Some of the Slaughterhouse Operations at Montfaucon, 1828. From *Receuil industriel, manufacturier, agricole et commercial, de la salubrité publique et des beaux-arts* 5 (1828). Hand-colored lithograph, 260 x 383 mm. Musée Carnavalet, Paris [56]

HENRI MONNIER (1805-1877)

Quartier Saint-Denis, 1828. From *Six Quartiers de Paris* (Paris, 1828), pl. 4. Hand-colored lithograph, 149 x 194 mm. Beraldi 435. The Baltimore Museum of Art; Gift of Mr. J. Gilman D'Arcy Paul (BMA 64.165.6) [6]

CÉLESTIN NANTEUIL (1813-1873)

Paris and Its Progress, about 1861. From *Les Artistes anciens et modernes* IX, frontispiece. Lithograph, 232 x 180 mm. Private collection [71]

CHARLES NÈGRE (1820-1881)

Avignon — West Side of the Palace of the Popes, 1852. From the album *Le Midi de la France.* Photograph, 233 x 328 mm. The National Gallery of Canada, Ottawa [42]

PELLERIN ET CIE (publisher)

The Railroad, about 1837. Hand-colored woodcut, 381 x 570 mm. Worcester Art Museum [38]

Park Kiosque, about 1870. Hand-colored lithograph, 380 x 480 mm. Cooper-Hewitt Museum, The Smithsonian Institution's National Museum of Design, New York [116]

AUGUSTE PÉQUÉGNOT (1819-1878)

Old Montfaucon, 1846. From *Douze Eaux-fortes par Péquégnot.* Etching, 111 x 144 mm. Beraldi 1. Private collection [57]

A. M. PERROT: see E. Grezel

VICTOR PETIT (born 1817)

Rustic House near Enghien, about 1848. From *Habitations champêtres* (Paris, 1848), pl. 68. Hand-colored lithograph, 265 x 355 mm. The Garden Library, Dumbarton Oaks, Washington, D.C. [141]

CAMILLE PISSARRO (1831-1903)

The Boulevard Montmartre, about 1899. Lithograph, 146 x 114 mm. Delteil 191. Private collection [105]

Twilight with Haystacks, 1879. Aquatint with etching and drypoint printed in black, 103 x 180 mm. Delteil 23 iii. The Art Institute of Chicago (1921.217) [143]

Twilight with Haystacks, 1879. Aquatint with etching and drypoint printed in red, 103 x 180 mm. Delteil 23 iii. The Art Institute of Chicago; The Clarence Buckingham Collection (1979.650) [143 color section; not in exhibition]

Wooded Landscape at the Hermitage, Pontoise, 1879. Soft-ground etching, aquatint, and drypoint, 220 x 269 mm. Delteil 16 vi. The Art Institute of Chicago (1977.400) [148]

ACHILLE QUINET (active 1864-1879)

Riverscape with Poplars. From *Études d'après nature.* Photograph, 184 x 248 mm. Sam Wagstaff [84]

HENRI RIVIÈRE (1864-1951)

Les Trente-six vues de la Tour Eiffel (Paris, 1888-1902). Book of color lithographs, open to pl. 3, *The Tower under Construction.* Toudouze, pp. 64-65. The Houghton Library, Harvard University, Department of Printing and Graphic Arts; Gift of Peter A. Wick [130]

Les Trente-six vues de la Tour Eiffel. Second copy, open to pl. 25, *In the Tower.* Rutgers University Art Gallery, New Brunswick, New Jersey; Gift of the Friends [131]

The Baie de Launay, 1891. Color woodcut, 222 x 349 mm. Toudouze, p. 161, no. 33. Rutgers University Fine Arts Collection, New Brunswick, New Jersey [145 color]

FÉLICIEN ROPS (1833-1898)

Satan Sowing Evil Grain. Soft-ground etching, 279 x 209 mm. Exteens 783. Worcester Art Museum [49]

THÉODORE ROUSSEAU (1812-1867)

The Plain of La Plante-à-Biau, about 1862. Cliché-verre, 240 x 310 mm. Delteil 6. The Art Institute of Chicago; Gift of the Print and Drawing Club (1926.174) [82]

Oak Tree Growing among Rocks, 1861. From the *Gazette des Beaux-Arts* XI (1861). Etching, 124 x 170 mm. Delteil 4. The Baltimore Museum of Art; Garrett Collection (BMA 46.112.4403) [91]

ILDEFONSE ROUSSET

Le Tour de Marne (Paris, 1865). Book illustrated with photographs (text by Emile de la Bedollière), open to *The Islands and Wood of Chènevières.* International Museum of Photography at George Eastman House, Rochester [85]

Le Bois de Vincennes (Paris, 1865). Book illustrated with photographs (text by Emile de la Bedollière), open to *Lac de Charenton, East End.* International Museum of Photography at George Eastman House, Rochester [121]

LÉON JEAN BAPTISTE SABATIER (died 1887)

The Lac d'Oo near Luchon in the Pyrenees, about 1835. From the *Voyages pittoresques: Languedoc* II, part 2 (Paris, 1835), pl. 235. Lithograph, 410 x 318 mm. Boston Public Library, Print Department [15]

PAUL SIGNAC (1863-1935)

Les Andelys, 1897. Color lithograph, 298 x 451 mm. Kornfeld and Wick 10. Philadelphia Museum of Art; Purchased, McIlhenny Fund [144 color section]

CHARLES SMITH : see E. Grezel

ALEXANDRE MARIE SOUDAIN: see Adolphe Alphand

CHARLES SOULIER (before 1840-after 1875)

Mont Blanc, Savoy, 1869. Photograph, 193 x 249 mm. Collection Gerard-Levy, Paris [47]

The Parc des Buttes-Chaumont. From *Paris et ses environs.* Photograph, 190 x 249 mm. The Art Institute of Chicago; Restricted gift of Mr. and Mrs. Gaylord Donnelley [114]

The Grande Cascade in the Bois de Boulogne. From *Paris et ses environs.* Photograph, 192 x 249 mm. The Art Institute of Chicago; Restricted gift of Mr. and Mrs. Gaylord Donnelley [120]

JEAN JOSEPH SULPIS: see Adolphe Alphand

JEAN CHARLES DE VELLY: see Charles Louis Constans

PIERRE VIDAL (1848-1929)

Life on the Boulevards, 1895. Cover for Georges Montorgeuil, *La Vie des boulevards, Madeleine-Bastille* (Paris, 1896). Color lithograph, 290 x 503 mm. Worcester Art Museum [108]

LOUIS JULES FRÉDÉRIC VILLENEUVE (1796-1842)

Mills at the Headwaters of the Loue, about 1825. From the *Voyages pittoresques: Franche-Comté* (Paris, 1825), pl. 119. Lithograph, 267 x 368 mm. Boston Public Library, Print Department [3]

The Fort de l'Ecluse, about 1825. From the *Voyages pittoresques: Franche-Comté* (Paris, 1825), pl. 49. Lithograph, 202 x 270 mm. Boston Public Library, Print Department [11]

EDOUARD VUILLARD (1868-1940)

The Avenue, 1899. From *Paysages et intérieurs* (Paris, 1899), pl. 2. Color lithograph, 308 x 413 mm. Roger-Marx, *Vuillard* 33. Private collection [107 color section]

The Jardin des Tuileries, 1896. From *L'Album des peintres-graveurs* (Paris, 1896). Color lithograph, 292 x 432 mm. Roger-Marx, *Vuillard* 28. The Metropolitan Museum of Art, New York; Harris Brisbane Dick Fund, 1936 [125]

Across the Fields, 1899. From *Paysages et intérieurs* (Paris, 1899), pl. 3. Color lithograph, 260 x 356 mm. Roger-Marx, *Vuillard* 34. Yale University Art Gallery, New Haven; Gift of Bruce B. Dayton, B.A. 1940 [138]

Publications Cited

Armelhault and Bocher
Armelhault, J. (J. Maherault), and Bocher, E. *L'Oeuvre de Gavarni, lithographies originales et essais d'eau-forte et de procédés nouveaux*. Paris, 1873.

Beraldi
Beraldi, Henri. *Les graveurs du XIXe siècle, guide de l'amateur d'estampes modernes*. 12 vols. Paris, 1885-92.

Bliss
Dodgson, Campbell. *A Catalogue of the Etchings, Dry-points and Lithographs by Professor Alphonse Legros (1837-1911) in the Collection of Frank E. Bliss*. London, 1923.

Bourcard and Goodfriend
Bourcard, Gustave. *Félix Buhot, catalogue descriptif de son oeuvre gravé, with additions and revisions by James Goodfriend*. New York, 1979.

Curtis, *Bonington*
Curtis, Atherton. *Catalogue de l'oeuvre lithographié et gravé de R. P. Bonington*. Paris, 1939.

Curtis, *Isabey*
Curtis, Atherton. *Catalogue de l'oeuvre lithographié de Eugène Isabey*. Paris, 1939.

Delteil
Delteil, Loys. *Le Peintre-graveur illustré*. 31 vols. Paris, 1906-26.

Delteil, "Bracquemond"
Delteil, Loys. "Bracquemond." *L'Artiste*, nouvelle per. 13 (1897), pp. 424-32.

Delteil and Wright
Delteil, Loys, and Wright, Harold J. L. *Catalogue raisonné of the etchings of Charles Meryon*. New York, 1924.

Exteens
Exteens, Maurice. *L'Oeuvre gravé et lithographié de Félicien Rops*. 4 vols. Paris, 1928.

Groschwitz
Groschwitz, Gustave von. "The Prints of Thomas Shotter Boys." In *Prints: Thirteen Illustrated Essays on the Art of the Print, Selected for the Print Council of America by Carl Zigrosser*. New York, 1962, pp. 191-215.

Guérin
Guérin, Marcel. *L'Oeuvre gravé de Manet*. Paris, 1944.

Guiffrey
Guiffrey, J. J. *L'Oeuvre de Ch. Jacque; catalogue de ses eaux-fortes et pointes-sèches*. Paris, 1866.

Harris
Harris, Jean C. *Edouard Manet, Graphic Works: A Definitive Catalogue Raisonné*. New York, 1970.

I.F.F.
Paris, Bibliothèque Nationale (Jean Laran and others). *Inventaire du fonds français après 1800*. 14 vols. (A-Lys). Paris, 1930-67.

Kornfeld and Wick
Kornfeld, Eberhard W., and Wick, Peter A. *Catalogue raisonné de l'oeuvre gravé et lithographie de Paul Signac*. Bern, 1974.

Lotz-Brissonneau
Lotz-Brissonneau, A. *L'Oeuvre gravé de Auguste Lepère; catalogue descriptif et analytique*. Paris, 1905.

Roger-Marx, *Bonnard*
Roger-Marx, Claude. *Bonnard lithographe*. Monte-Carlo, 1952.

Roger-Marx, *Vuillard*
Roger-Marx, Claude. *L'Oeuvre gravé de Vuillard*. Monte-Carlo, 1948.

Toudouze
Toudouze, George. *Henri Rivière, peintre et imagier*. Paris, 1907.

Van Gelder
Van Gelder, Dirk. *Rodolphe Bresdin*. 2 vols. The Hague, 1976.

Photograph Credits

All photographs, with the exception of those listed below, have been provided by the lenders to the exhibition. We gratefully acknowledge their cooperation.

E. Irving Blomstrann, New Britain, Conn., 61

Robert A. Costello, Wellesley, Mass., 107

Scott Hyde, New York, 116

George E. Landis, Cromwell, Conn., 87

Eric Mitchell, Philadelphia, 4, 52, 67, 144

Otto E. Nelson, New York, 28, 44, 45, 64, 68, 84, 88, 105

Ricardo Gomez Perez, London, 53, 93

Stein-Mason Studio, Inc., Boston, 1, 2, 3, 11, 12, 13, 15, 22, 24, 25, 48, 55, 58, 65, 81, 96, 101

Patricia Emmel Swarts, Wooster, Ohio, 133

Joseph Szaszfai, New Haven, 9, 14, 20, 79, 126, 138

Victor's Photography, Piscataway, N.J., 130, 131, 145, 151